The Negative

The New Ansel Adams Photography Series / Book 2

The Negative

Ansel Adams

with the collaboration of Robert Baker

LITTLE, BROWN AND COMPANY
A BULFINCH PRESS BOOK
BOSTON TORONTO LONDON

Frontispiece: *Clouds, East Side of the Sierra Nevada, ca. 1962*

This is the second volume of *The New Ansel Adams Photography Series*.
Eleventh printing, 1991

Library of Congress Cataloging in Publication Data

Adams, Ansel, 1902–1984
The negative.
 Includes index.
 1. Zone System (Photography) 2. Photography—Negatives.
I. Baker, Robert. II. Title
TR591.A3 770'.28'3 81–16808
ISBN 0-8212-1131-5 AACR2

Designed by David Ford
Technical illustrations by Omnigraphics
Printed and bound by Murray Printing Company

Bulfinch Press is an imprint and trademark of Little, Brown and Company (Inc.)
Published simultaneously in Canada by Little, Brown & Company
(Canada) Limited

PRINTED IN THE UNITED STATES OF AMERICA

Acknowledgments

The many books I have done on photography, technical and otherwise, have been made possible by the wise counsel and competent assistance of numerous friends and colleagues. In the technical and educational fields, the information that has come to hand over more than fifty years of work with the photographic process derives from countless sources, only a few of which can be remembered and acknowledged here. I do wish to recall the immense help I received from Dr. Walter Clark, Dr. C. E. K. Mees, and others at Eastman Kodak; from Dr. E. H. Land and his many associates at Polaroid Corporation, and from various manufacturers who, over many years, shared information generously in the course of conversation and the exchange of letters.

I have always made a definite effort to confirm Zone System concepts and other technical issues with knowledgeable scientists before publishing. I am aware of many weaknesses in the early Zone System approach that have been rectified over the years by experts and students alike. There is no one like a bright student to perceive a problem of logic in the most assured statement, and I have appreciated every comment and suggestion. The purpose of this technical series is to communicate ideas, presenting a workable philosophy and craft system for the understanding and practice of photography. To all who have helped me over all these fifty years—my appreciation and gratitude!

Specifically in relation to this volume, I wish to thank Robert Baker, my collaborator and editor, whose great ability and thoughtful perceptions have done so much to bring the books to completion.

Next, John Sexton, photographer and teacher, has helped enormously in making the studio photographs, and in performing the technical tests which were necessary to encompass fully the properties of contemporary materials. My sincere thanks also to James Alinder for his careful reading and perceptive comments on the manuscript of this book. Others around me in various capacities contributed in important ways as well: Mary Alinder, who keeps everything in order with schedules and communications; Victoria Bell, Peggy Sexton, Phyllis Donohue, and King Dexter — all deserve greatest appreciation.

I must also thank my publisher, New York Graphic Society, Floyd Yearout and his very competent staff, as well as the book designer, David Ford, and the technical illustrators, Omnigraphics.

Among the many other individuals and corporations whose assistance I gratefully acknowledge are Nikon Inc., Tri-Ess Sciences, Eastman Kodak Co. — in particular Jim Marron and Michael More — Ilford Inc., Calumet Photographic, MacBeth Instruments, Fred Picker of Zone VI Studios, Newfane, Vermont, and Messrs. Art Hall and Don Leavitt.

Any book is a real event, and dependent on many human and technical resources. Among all these interactions, I would not like to omit the reader, whom I invite to submit ideas, ask questions, and believe himself to be a participant in an educational experience.

A.A.

Contents

Introduction

This, the second volume of my revised series on photography, introduces a contemporary approach to the negative and considers the characteristics of modern films and processing. Throughout this series, visualization is the underlying objective; the craft and technical aspects, while important in themselves, should always be subservient to the expressive concepts of the photographer — necessary but not dominant!

It is important to realize that the expressive photograph (the "creative" photograph) or the informational photograph does not have directly proportional relationship to what we call reality. We do not perceive certain values in the subject and attempt to duplicate them in the print. We may simulate them, if we wish to, in terms of reflection density values, or we may render them in related values of emotional effect. Many consider my photographs to be in the "realistic" category. Actually, what reality they have is in their optical-image accuracy; their *values* are definitely "departures from reality." The viewer may accept them as realistic because the visual effect may be plausible, but if it were possible to make direct visual comparison with the subjects, the differences would be startling.

The key to the satisfactory application of visualization lies in getting the appropriate information on the negative. This can be compared to the writing of a musical score, or the preparation of architectural designs and plans for a structure. We know that musicianship is not merely rendering the notes accurately, but performing them with the appropriate sensitivity and imaginative

communication. The performance of a piece of music, like the printing of a negative, may be of great variety and yet retain the essential concepts.

The first step of visualization is *image management,* presented in Book 1 *(The Camera),* which relates to point-of-view and the optical and camera-adjustment control of the image up to the moment of exposure. In this volume we shall be discussing the control of *image values* as determined by exposure and development of the negative, and other related functions. Of course, since our ultimate objective is the print, we will be considering and illustrating the concepts of negative-value control in terms of the final positive image. Book 3 *(The Print)* will describe the specific refinements of printing and enlarging. Our purpose in this volume is to consider the visualization of the image values, and to describe appropriate procedures that make it possible to secure the optimum negative for the print as we visualize it.

Although we present the visualization and technical procedures in separate stages, it should be understood that in practice we must consider the entire process in a unified manner from the start. Photography is a complex and fluid medium, and its many factors are not applied in simple sequence. Rather, the process may be likened to the art of the juggler in keeping many balls in the air at one time! Each element of photography must be clearly and separately understood — ultimately at the intuitive level — before it is possible for them to merge into a single coherent function. With practice we become proficient in handling the image-management and value-control procedures; the interval between our first perception of the subject and the completion of visualization and the required technical procedures becomes surprisingly short.

Before I understood the basics of applied sensitometry (which I later interpreted through the Zone System) I exposed my negatives by trial-and-error methods, supported by growing experience with my subjects and their subtle variations of lighting and contrast. Processing was usually "normal," although a subject known to be "contrasty" would receive less development and a "flat" subject would be given more. I would then try for the optimum print, usually compelled to experiment with different papers, print developers, and various manipulations in the printing process to counteract deficiencies in the negative. With luck I might achieve an image that pleased me. The process on the whole was empirical, uncertain, and often fraught with failure.

When I began teaching photography I found that I had little to impart other than the way *I* worked, and I was aware of the danger of merely encouraging groups of imitators. Only the strongest minds and imaginations can overcome this form of "parrot" education. It

became obvious to me that there must be some bridge between the basic theory of the medium and a potentially creative means of application. I felt it essential to translate the arcane principles of sensitometry into a system of applied craft which would be both precise and adaptable by the individual to any practical or expressive aspect of photography. Out of this need was born the Zone System, which I formulated at the Art Center School in Los Angeles with the cooperation of an important instructor, Fred Archer. We based our first plan on articles by John L. Davenport that appeared in *U.S. Camera* in the Autumn and Winter editions of 1940. Davenport presented development procedures to achieve similar densities from a variety of exposures by applying more or less development to the negative. His concept was purely technical, but we thought that such an approach could be imaginatively adapted in general work and would offer a considerable degree of negative exposure and development control for interpretive and expressive objectives. The Zone System proved to be more than helpful to the students and broadened the scope of their practical and expressive photography. I should add that, while there was considerable skepticism in the early days of the Zone System, I was honored by the approval of such important figures in photography as Dr. C. E. K. Mees, then director of the laboratories of Eastman Kodak Co., and by the technical staff of the Weston Electrical Instrument Co. I am forever in debt to these people for encouragement in what was then a precarious invasion of the accepted procedures.

Since the early 1940s the Zone System has been further developed in a practical approach to the practice and teaching of photography. It has been both embraced and scorned, and has been subjected to many variations and interpretations by my colleagues (and by me!). Not all have been valid, as they sometimes contradicted the principles of sensitometry (a branch of physical science). There have also been variations in the concept of the scale of zones, an indication that it is flexible enough to be adapted to different approaches. My experience with contemporary materials now leads me to work with a scale of zones and values from Zone 0 through Zone X (maintaining the convention of using Roman numerals to distinguish the zones and values from other quantities, such as the luminance numbers on exposure meter scales, etc.). On this scale, Zone 0 and Zone X represent full black and maximum white in the image, as explained in the text. This scale supports the location of Zone V as the geometric mid-point, using Zone I and Zone IX as the *limits* of the real value scale that convey the full range of texture and substance. I assure the reader that this refinement of earlier scales and designations in no way alters the basic concepts of the Zone System approach.

The Zone System has not been widely recognized by the scientific community. The reason appears to be that scientists are not concerned with the kind of photography that relates to intangible qualities of imagination, as distinct from the laboratory standards of exact physical values. It seems unfortunate that such precision of method and measurement as exists in manufacturers' laboratories should be diluted by the concepts of "average" application so obvious in current equipment and materials. There is today a severe gulf between the general public's awareness and use of photography (which can be described as casual and imprecise for the most part) and the acute precisions of the manufacturers' laboratories. There are a few exceptions, but the general trend today is to apply high laboratory standards to produce systems which are sophisticated in themselves, in order that the photographer need not be! This tendency toward fail-safe and foolproof systems unfortunately limits the controls the creative professional should have to express his concepts fully. I am grateful for the tremendous contributions of the photographic industry and its scientists, but I cannot help being distressed when "progress" interferes with creative excellence.

It is true, however, that for the casual photographer the fail-safe equipment and materials increase the likelihood of meeting with some success. It has been said at various times that the advent of certain materials obviates the need for such a vehicle of thought and control as the Zone System. Such a statement reflects the misconception that the Zone System is useful only for relating subject luminance with print values as they occur with a specific set of materials. If the materials change, we do not discard the Zone System any more than we discard sensitometry (or our exposure meters, for that matter). A change of materials often does require adaptation in the way we apply the Zone System, but in no way eliminates its principles or usefulness in creative visualization. As long as we must be able to work from a range of subject luminances that are to be represented *as we want them to be* by a range of gray values (or color values) in a print, the Zone System seems certain to provide an extremely useful framework.

Another misconception is that the Zone System emphasizes technique and craft at the expense of creativity. The Zone System itself does nothing of the kind, even if some of its practitioners do. It is an *enabling* system, and it should liberate, rather than restrict, the creative photographer. The creativity — functional or poetic — lies in applying the Zone System to achieve a visualized image, with almost no limitations on the visualization itself.

Assuming we do our part to learn good craftsmanship, the limitations that do exist rest with the equipment and materials — the nature of the photographic process as it exists at a given moment in

history and as practiced by each of us. The evolution of materials has brought us the current thin-emulsion films, for example, which are in some ways higher in efficiency and performance than earlier films, but less responsive to control in processing. We must always be prepared to adapt to such evolutionary changes, and methods are given in this text to replace those in my earlier Basic Photo Series which no longer apply. The principles remain the same, however: light affects film, developers affect exposed film, and the negative is translated into a positive print with about the same procedures and convictions. The variations that have evolved remain controllable, provided we make the effort to understand them.

I eagerly await new concepts and processes. I believe that the electronic image will be the next major advance. Such systems will have their own inherent and inescapable structural characteristics, and the artist and functional practitioner will again strive to comprehend and control them.

True freedom in concept and visualization demands a refined craft. I believe it is false to suggest that there are shortcuts and quick formulas for success in photography. I do believe, however, that the teaching and practice of photography can be far more efficient and comprehensive than they commonly are, and it is my hope that these books may be of some service in that direction.

Ansel Adams
Carmel, California
March 1981

Chapter 1

Visualization and Image Values

The concept of visualization set forth in this series represents a creative and subjective approach to photography. Visualization is a conscious process of projecting the final photographic image in the mind before taking the first steps in actually photographing the subject. Not only do we relate to the subject itself, but we become aware of its potential as an expressive image. I am convinced that the best photographers of all aesthetic persuasions "see" their final photograph in some way before it is completed, whether by conscious visualization or through some comparable intuitive experience.

It is impossible for a photographic print to duplicate the range of brightnesses (luminances) of most subjects, and thus photographs are to some degree *interpretations* of the original subject values. Much of the creativity of photography lies in the infinite range of choices open to the photographer between attempting a nearly literal representation of the subject and freely interpreting it in highly subjective "departures from reality." My work, for example, is frequently regarded as "realistic," while in fact the value relationships within most of my photographs are far from a literal transcription of actuality. I employ numerous photographic controls to create an image that represents "the equivalent of what I saw and felt" (to paraphrase a statement I heard on a number of occasions from Alfred Stieglitz — the great photographer of the early twentieth century). If I succeed, the viewer accepts the image as its own fact, and responds emotionally and aesthetically to it. It is safe to assume that no two individuals see the world about them in the same way.

In black-and-white photography we are recording a three-dimensional subject in two dimensions and values of gray. We have considerable freedom to alter values through controls of exposure and

Figure 1–1. *Stump and Mist, Cascade Pass, Washington.* I first visualized higher values for the foreground stump, but the effect was rather weak. The distant trees in the mist must have sufficient "body," but the mist must remain luminous. The optimum print density value for the mist (or any other subject, for that matter) must be achieved by sensitive selection in relation to a balanced aesthetic interpretation. A technically good negative is important, and it affords us a measure of latitude in printing to arrive at an appropriate balance.

development, use of filtration, and so on. The purpose of visualization is to consider and anticipate these controls starting from the first approach to the subject, in a way that contributes to the final expressive representation. The first step toward visualization — and hence toward expressive interpretation — is to become aware of the world around us in terms of the photographic image. We must examine and explore what lies before our eyes for its significance, substance, shape, texture, and the relationships of tonal values. We can teach our eyes to become more perceptive.

We must also consider the nature of a photograph. A black-and-white print has a maximum range of brightnesses (reflection densities) of about 1:100, or occasionally more. That is, the deep blacks of a print made on glossy paper reflect about 1/100 as much light as the lightest areas. No matter how great the scale of brightnesses in the original subject (which can be as high as 1:10,000) we have only this range of 1:100 in the print to simulate it. With some exceptions, a print generally uses most of this full range from black to white. However, just which areas of the subject are represented as black or as white, and the specific print values in between that represent other subject areas, are determined by the photographer. The determination can be either a conscious one to achieve the desired rendering, or, for the unskilled, it can occur haphazardly. Approximation by trial and error is costly in time and resource.

In a portrait, for example, the gray value in the print which represents the flesh of the subject may vary over a considerable range. We can train ourselves to visualize in our minds the print values we wish to use for the flesh tones from a wide range of possibilities. Our choice is partly dictated by the nature of the subject and environment, and partly by such subjective issues as the mood or feeling for the subject we wish to convey and the character of our visual response to it.

"Seeing" the alternative renderings of a subject in advance provides great latitude for creative interpretation by allowing us to apply appropriate measures at all stages of exposure and processing to fulfill our visualized image. Once you begin the process of visualization, the final image becomes of paramount importance, and you are less concerned with the subject per se than with your representation of it. The image becomes the "enlargement of experience" of the subject.

It takes some effort to learn to view a subject rich in colors and see it in black-and-white print values (just as it takes effort to learn to view the three-dimensional world of continual motion as a static two-dimensional image created by a lens, an aspect of visualization discussed in Book 1 of this series). We should first try to "feel" the black, white, and middle gray tonalities in the print that will represent the subject areas before us, using initially a simple subject

composed of a few broad areas of different luminance. Our practice should also include careful inspection of a wide variety of photographs and consideration of their tonal values. Studying prints, whether our own or others', helps in learning to recognize values and tonal separation and their relation to the subject, as well as our own responses to them. We can compare learning to identify image values to a musician's training for recognition of pitch, or a painter's awareness of subtle color values and relationships. Extensive practice is essential! A suggested plan for practice in awareness and visualization is as follows:

1. Choose a relatively simple subject and scan it for the darkest significant part. Take nothing for granted; at first glance a black cloth may appear to be the darkest area of the subject, but on more careful scrutiny deep shadow areas may be found that are darker than the black surface of the cloth. In fact, many objects that appear black are only deep shades of gray: school blackboards, black hats, black cats, are not truly black in the photographic sense, since they possess substance and tonal variation. Such objects seen alongside a deep shadow area — such as a ventilator aperture or other dark hole — will appear merely as a very dark gray. The same subject in an area without deeper shadows might very well be accepted as entirely black, and treated as such in the visualization and in printing. It is best at this point to consider all such "black" objects as merely dark gray. They can be rendered fully black in the print if so desired, but you should be concerned at first with "literal" values.

2. Scan the subject for the lightest significant part. Again, take nothing for granted. The lightest object in the scene may be a white cloth, but the glare from a polished metal surface has far greater intensity than the diffuse white surface ◁ under the same illumination.* If the metal surface is a polished silver spoon on a white cloth, the glare from the spoon should be distinctly brighter in the final print than the white cloth. A convincing representation will probably show the highlights of the spoon as very small areas of pure white, while the cloth will be a very light gray. But without the spoon, the cloth becomes the "whitest" object, and may be rendered lighter (but still with texture) in the print. In some situations, where such a cloth is a small area of the subject, it may be allowed to appear in the print as pure white without texture. Try throughout these practice stages to think of the subject values in terms of appropriate print values and the quality of textural rendering desired.

3. Having practiced observation of the extreme values, you can begin to visualize the middle of the scale. It may be helpful to begin by working from the extremes, that is, while visualizing the white areas, begin looking at the light grays. Similarly, work from the deep-

See page 14

*The ◁ pointer is used throughout to indicate a cross reference. Page number is given in the margin.

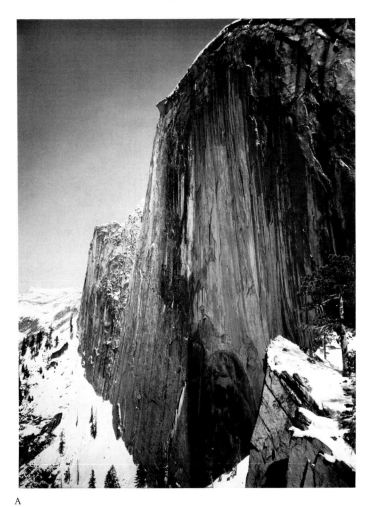

A

See page 33

est black values to the dark grays. There is also an essential key
reference point at the middle of the scale, known as "middle gray."
It can be visualized by holding a standard gray card (i.e., the Kodak
18 percent neutral gray card ◁) in the subject area and comparing its
value with the middle-range subject areas.

You will note that if you hold the gray card near a white object,
then near a dark object, and then near both together, the gray takes
on quite different appearances. No value has been changed, but the
different combinations introduce subjective effects. Similar, and
more stimulating, results may be observed by combining colors. For
example, place a green leaf on a red surface, then on a blue surface.
The subjective effects vary to an impressive degree, although the
colors themselves are not changed. It will become clear that the
appearance of a particular area depends as much on its relationship
to other values as on any intrinsic property. You must learn to rec-
ognize the importance of such relationships in your visualization.

Figure 1–2. *Monolith, The Face of Half Dome, Yosemite National Park, 1927.* I consider this my first visualization — seeing in my mind the image I wanted before making the exposure.

(A) Using a conventional yellow filter (#8), I realized after exposing that the image would not express the particular mood of overwhelming grandeur the scene evoked. I visualized a dark sky, deeper shadows, and a crisp horizon in the distance.

(B) With my one remaining plate I used the #29 dark red filter, achieving very much the effect I wanted.

The photographs were made on 6½ × 8½ panchromatic glass plates from the west ridge of Half Dome, about opposite the halfway point of the 2000-foot precipice.

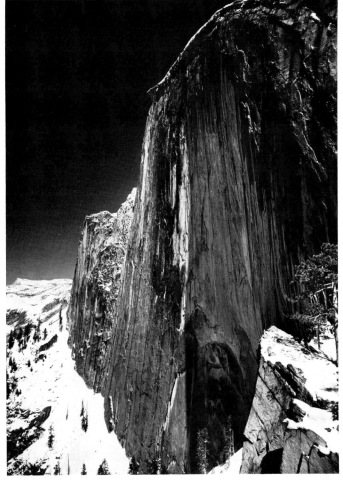

B

The beginner's problem is to become aware of light and tonal values in terms of print values, and the accuracy of perception increases with study and practice. Some people seem to be able to visualize black, white, and middle gray with ease, and others have learned to do so through extensive practice in photography without consciously attempting visualization as such. Others must work quite hard to learn to visualize something as abstract as a black-and-white photograph while viewing a subject.

There are two further aids to learning visualization. First, it will be a great help to view a photograph of a subject alongside the subject itself. The most immediate way to do this is using Polaroid Land black-and-white films, since there is minimal delay between the attempt at visualization and seeing a print of the subject. (The specific tonalities of the Polaroid print are not identical to those of a conventional print in the higher and lower values, but the differences are easily incorporated in the visualization process at a later stage.)

What the Polaroid print will do is help you bridge the distance from the tangible subject to the abstractness of the photograph. Even experienced photographers frequently find something in a Polaroid test print that they had overlooked while viewing the subject directly. As your ability to visualize "literal" renderings develops you can also depart from the normal exposure to observe the variations in value rendering and their effect on the subjective qualities of the image.

Second, I strongly recommend the use of a viewing filter. The Wratten #90 viewing filter provides a visual indication of the monochromatic relationships of color subjects as recorded by an unfiltered panchromatic emulsion. ◁ The filter does not completely neutralize the colors, but minimizes their visual significance, particularly colors of relatively low saturation (that is, low intensity of color ◁), like most color in natural environments. When colors of high saturation are encountered, such as vivid painted surfaces, the effectiveness of the viewing filter is somewhat reduced.

See pages 21–23

See pages 15–16

My preference is for the #90 filter used alone, without the added neutral density that is provided in some viewing filters. The added neutral density lowers the values of the image and, for me, increases the apparent subject contrast (there are also dark blue viewing filters which reveal subject contrast effects in color photography). I recommend for black-and-white a plain 2- or 3-inch gel #90 filter mounted for protection in a simple open frame. The filter should be held in front of the eye for short intervals only, since the eye will adapt to the filter in time and the filter's effectiveness in suggesting black-and-white rendition of colors is thereby reduced.

These aids may effectively be incorporated in the visualization exercises given above. First view the subject carefully and make a concerted effort to see its values in terms of the final print. Use the viewing filter at this stage to help eliminate dominant color effects. It can also help to view the subject with eyes nearly closed, to eliminate details and reduce it to broad areas of general value. Then, after again attempting to visualize the image, make a Polaroid photograph of the subject, adjusting the exposure if needed to obtain values that correspond to your sense of a "literal" recording. Study the print and the subject together, noting specific subject areas and the corresponding gray values in the print. Once you can clearly visualize the "literal" transcription of subject values, you can proceed to conscious departures from realism; with practice this becomes a swift and certain process.

The problems we confront in visualizing photographs include both concept and procedure. We are first aware of the subject for its factual or subjective content. We attempt to "see" the finished image

Figure 1–3. *Sun and Fog, Tomales Bay, California.* In planning the exposure I took into consideration the fact that the bright sun (obviously maximum white in the print) could be seen only if the value of the surrounding fog was considerably lower. The effect is a departure from reality in that the fog values are lower than might be considered "realistic." The white rendering of the sun and its glare on the water maintain the impression of light, but the shadowed hills and nearby shore are unavoidably underexposed.

through which we desire to express our concept of the subject, and perceive in our mind's eye certain print tonalities relating to important values in the subject. Only then do we undertake the technical steps required to produce the photograph. These are, simply stated, measuring the luminances of the subject and using this information to determine exposure and development, and considering possible further means to control or alter the values in accordance with our visualized image. We thus establish, *before making the exposure,* a plan for applying all technical controls in a manner that will contribute to the desired result.

Once visualization and plan of procedure are established, the actual exposure and development of the negative become matters of purely mechanical execution. The methods applied to realize the visualized image constitute the craft of photography, and as such, must be given due attention. Our ability to produce a finished image that lives up to the potentials of our visualization will be limited by our command of craft. By study and practice we can achieve mastery of the craft, which we can then employ according to our creative intentions. Much of the information in the following chapters relates to the craft aspects of photography; creativity itself ultimately rests with the "eye" and mind of the individual.

I cannot overemphasize the importance of continuous practice in visualization, both in terms of image values as described herein and also incorporating the image management considerations discussed in Book 1. We must learn to see intuitively as the lens/camera sees, and to understand how the negative and printing papers will respond. It is a stimulating process, and one with great creative potential.

Chapter 2

Light and Film

In learning to visualize image values we should understand that what we see with our eyes is not the same as what a photographic film "sees" in the camera. In Book 1 we considered the differences between the visual image and that of a camera in terms of *image management*. Similar distinctions must be understood between our visual images and the scale of values of a photograph. These arise from the nature of light itself and the way it is perceived by our eyes and recorded on film. If we fail to recognize these differences, we will be frequently disappointed that our photographs do not represent the subject as we saw it, or *thought* we saw it, when making the exposure.

THE ELECTROMAGNETIC SPECTRUM

Figure 2–1. *Madrone Bark, detail.* The subject values were measured with an averaging meter, and both the light and dark areas fell just within the exposure scale of the film. An exposure increase of about 50 percent was required because of the lens extension needed to make this "close-up." For aesthetic reasons I have "printed down" the image and sacrificed some detail in the deep shadows; a variety of expressive prints could be made from this negative.

Light is simply the type of electromagnetic radiation to which the human eye is sensitive. Such radiation can be considered in terms of a continuous spectrum which includes, in addition to light, radio waves, radar, X-rays, gamma rays, and other forms of radiant energy. What distinguishes each one of these forms of radiation is the *wavelength* — the distance from one wave "crest" to the next — which can be anywhere from many meters to less than a billionth of a meter. Only visible wavelengths are defined as *light*, and all others are simply termed radiation.

Figure 2–2. *The electromagnetic spectrum.* All forms of radiation have characteristic wavelengths. The radiation that our eyes respond to is *light*, which occupies a relatively small band within the entire spectrum. The wavelength of light determines its color, as shown on the graph of the visible spectrum.

Wavelength (Meters)

10⁻¹³ 10⁻¹² 10⁻¹¹ 10⁻¹⁰ 10⁻⁹ 10⁻⁸ 10⁻⁷ 10⁻⁶ 10⁻⁵ 10⁻⁴ 10⁻³ 10⁻² 10⁻¹ 1 10 10² 10³ 10⁴

| Gamma-Rays | X-Rays | Ultra-Violet | Infra-Red | Radar | Radio |

Wavelength (nanometers) Visible Spectrum

360 380 400 420 440 460 480 500 520 540 560 580 600 620 640 660 680 700 720 740 760 780

| Ultra-Violet | Violet | Blue | Blue-Green | Grn. | Yel-low-Grn. | Yel-low | Orange | Red | Deep Red | Infra-Red |

Visible radiation lies in the narrow band of wavelengths from roughly 400 to 700 nm.* Within this range, the wavelength determines the color of the light we perceive, beginning with violet at the shortest wavelengths and proceeding through blue, green, yellow, and red. Beyond the red end of the visible spectrum lies the invisible infrared region, and wavelengths shorter than violet are called ultraviolet, also invisible. Both ultraviolet and infrared radiation are capable of exposing most photographic emulsions, however, as are other forms of radiation such as X-rays.

INCIDENT AND REFLECTED LIGHT

When light strikes a surface, it can be transmitted through it, absorbed, or reflected. If the substance is transparent, like window

*One nanometer (nm) is 10^{-9} meters, or one billionth of a meter, or one millionth of a millimeter.

glass, most of the light will be transmitted, although some is inevitably lost to reflection and absorption. A translucent material, like white Plexiglas or tissue paper, has a considerably lower transmission and diffuses the light passing through it, while opaque substances transmit no visible radiation. The proportion of light that is transmitted, absorbed, or reflected is often a function of wavelength; if some wavelengths are transmitted or reflected in greater amounts than others, we perceive a characteristic color for that object. ◁

See Figure 2-6

Incident light

Objects that we see and photograph are illuminated by *incident light* falling on them from sun and sky, or from artificial light sources. The incident light, or *illuminance,* can be measured in units of *foot-candles,* which originally referred to the illumination provided by a "standard candle" located one foot from a surface.

See Book 1, page 166

An incident light meter ◁ is used to measure the amount of light falling on a subject as one means of determining camera exposure. Such meters contain a diffusing hemisphere or disc over the photocell to "average" all the light falling on them. The incident light meter is held at the subject and usually directed toward the camera, so that all light incident upon the side of the subject being photographed is integrated in the single reading.

Reflected Light

In most photography we record light reflected from the subject, rather than the light incident upon it. My approach to photography involves control of the relationship between the *luminances* (re-

Figure 2–3. *Incident and reflected light.* Incident light is the light that falls on a subject from one or more light sources. It is measured with an incident-light meter held at the subject and directed toward the camera. The light actually reflected by a subject is measured with a reflected-light meter, which is directed toward the subject from the direction of the camera. Since reflected light is what we see and photograph, such measurements are more informative and accurate, if the procedures are fully understood.

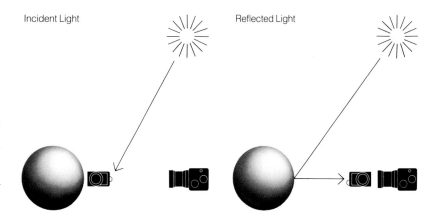

Figure 2–4. *Reflectance.* Reflectance is an inherent property of a material that indicates what proportion of the incident light it will reflect. A material we perceive as "dark" always reflects a lower percentage of the incident light than one we perceive as "light." The darkest natural materials may reflect only one or two percent of the incident light, while the "whitest" natural substances may reflect over 95 percent.

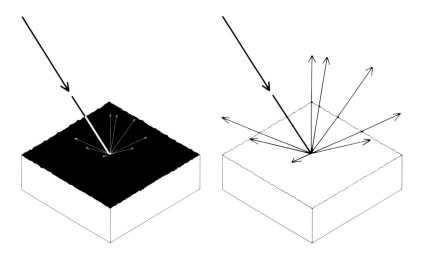

flected light) of the subject and the print values that I want to represent those areas. Using an incident light meter omits entirely measurement of the actual reflected light that forms the image on film, and thus severely limits the opportunity to evaluate individual subject areas and apply controls to achieve a creative, visualized image. Careful evaluation of reflected light is a far more positive approach.

The luminance of a subject area is measured in units of *candles-per-square-foot.** The total luminance of a surface is determined by the amount of light incident upon it and a property of the surface known as its *reflectance.* The reflectance of a substance is expressed as a percentage that indicates the proportion of incident light that is reflected by that material. It is because of differences in reflectance that we perceive some objects as "white" and others as "black," regardless of whether we are viewing them under bright daylight or low-level illumination. A deep black material may reflect less than 2 percent of the incident light, while a white substance may reflect over 95 percent; no material, however, has 100 percent reflectance since some light is inevitably lost to absorption and scatter.

Under uniform incident light the range of luminances in a subject is determined by the range of reflectances, which as stated above, can be from less than 2 percent to over 95 percent. Note that the ratio of these two figures is about 1:50, and thus this is about the maximum luminance ratio possible for diffuse surfaces if the incident light is totally uniform. Most subjects, however, include shad-

*Candles-per-square-foot are derived from foot-candles of incident light in the following manner: If 100 foot-candles fall upon a diffusing surface of 50 percent reflectance, 50 *foot-Lamberts* will be reflected, and this quantity divided by *pi* (3.1416) yields about 16 c/ft². Other units applied in scientific consideration of light do not relate as directly to photographic exposure, and thus are not considered here.

ows, and the actual range of luminances we are likely to encounter is much higher. If, for example, a deep black material were also in shadow and received only one-fourth the incident light of a bright white surface, the total range of luminances would be 1/4:50, or 1:200. We have already mentioned that a print can have a maximum range of reflectances of about 1:100, ◁ but a subject of 1:200 brightness range or greater can appear quite convincing within that shorter print scale even though the reflectances are clearly not "literal." A contrasty outdoor scene can have a luminance ratio of several thousand to one, and may require the use of special controls to reproduce successfully in a photograph.

See page 2

It should also be pointed out that, while luminance is an absolute quantity, our subjective interpretation of reflective surfaces based on *apparent* brightnesses is equally important in photography. An interesting demonstration of this phenomenon may be prepared as follows: take several identical pieces of white paper and place them at progressively greater distances from a light source, such as a small window in a large room. For the sake of clear description, assume that the papers are placed at 4, 8, 12, and 16 feet from the window. The relative actual luminances will then be 1, 1/4, 1/9, and 1/16 (because of the Inverse Square Law ◁), although these values may be modified slightly by reflections within the room. Standing at the window, you will observe that the nearest paper is brightest and the most distant one is the darkest gray. But you *know* that all the papers are the same, and thus you appreciate all of them as *white* even though you recognize that they have different actual values because of the differences in illumination. If you photographed all four, you would want the nearest paper to be white, and the others would be progressively lower values of light gray. If you now move away from the window and face the second paper, it will appear white (after a few moments for the eye to adapt), and you would now want this paper to appear white in the photograph. Similarly, viewing only the third and fourth paper, your eye will adjust to perceive the third paper as white and the fourth as a light gray. And finally, of course, the fourth paper viewed alone will itself be seen as clearly a "white" object. Our eye adapts to these changes in luminance, but our understanding of the material as "white" combines with our perception of its actual luminance.

See page 158

Another worthwhile demonstration is to consider an outdoor subject of great range of light and shadow. With such high contrast the areas in shadow appear low in luminance and internal contrast compared with the brightly illuminated areas. The eye makes these evaluations automatically, adjusting our perception of the extremes to the average luminance of the entire scene. However, try looking at the shadowed areas through a fairly long black mailing tube, exclud-

Figure 2–5. *Diffuse and specular reflection.* Light striking a textured surface is reflected about equally in all directions, called diffuse reflection. If the surface is smooth and polished, specular reflection occurs, where most of the light is reflected in a single direction. For specular reflection, the angle of reflection is equal to the angle of incidence. Most of what we see and photograph is light reflected in a diffuse manner, although surfaces that appear "shiny" or give off "glare" reflect both specular and diffuse light.

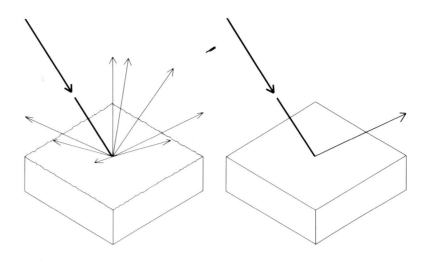

ing the bright areas. Immediately the shadowed areas will take on an elevated brightness and contrast, and shapes and textures come to life, approaching what we would experience if we were standing *within* the shaded area. What we are seeing through the tube is the "luminous world" of that area.

Diffuse and Specular Reflection

See Figure 2–2

Reflected light is usually *diffuse* in character, that is, the reflections occur about equally in all directions from a surface that has a matte or textured finish. Polished mirrorlike surfaces also yield *specular* reflections where most of the source light is reflected in a beam. The glare of sunlight on automobile chrome is an example, but less extreme examples occur in nature where many surfaces produce both diffuse and specular reflections. Any surface that appears "shiny," such as certain leaves or rock surfaces, or wet pavement, can produce specular highlights, as can crystalline substances like ice, sand, or snow.

Since all such scintillations are direct reflections of the light source, they are far brighter than a diffuse area, and they can lend a sense of brilliance to a photograph. Unless the specular areas are large, the diffuse and specular reflections combine to produce an average diffuse luminance value read by the meter. It is usually best in practical terms to try to direct the meter at areas that do not contain strong scintillations.

COLOR

See Figure 2–2

See page 100

What we call light is usually a mixture of radiation of different wavelengths within the visible spectrum. ◁ "White" light is made up of a distribution of all spectral colors, although very different mixtures can be perceived *by the eye* as white. For example, light from a blue sky contains a much higher proportion of blue light than the illumination from sunlight alone or standard indoor lighting, but due to adjustments of the eye-brain system, we may perceive all of these as *white.* This is a complex and profound physiological capability that has no counterpart in photography; color films will record tungsten light from a lamp in warm hues compared with the color of daylight. Even with black-and-white films, differences in the color of light can cause a shifting of the image values and alter the effects of color filters. ◁

When light is reflected, a truly neutral white or gray surface does not alter the distribution of wavelengths present in the incident light. Most materials, however, are not neutral and tend to reflect more of some wavelengths than of others, thus taking on the color most strongly reflected. A surface that has only a slight tendency to favor one wavelength in reflection will appear white or gray with a slight color cast. Another surface that reflects a much higher proportion of one wavelength and absorbs others will present a more vivid color to the eye — a higher *saturation* of color. A tweed fabric may serve as an example: if the fabric is predominantly made up of gray threads with a few blue threads, it will appear gray with only

Figure 2–6. *Reflected and transmitted color.*

(A) A surface may reflect some wavelengths more strongly than others, in which case it presents the visual color of those wavelengths most strongly reflected. Other wavelengths are absorbed by the surface in varying degrees.

(B) With a transparent colored surface, such as colored glass, the wavelengths transmitted most freely determine the color, and other wavelengths are absorbed. For both substances shown, we would perceive the color blue, since the other colors are absorbed.

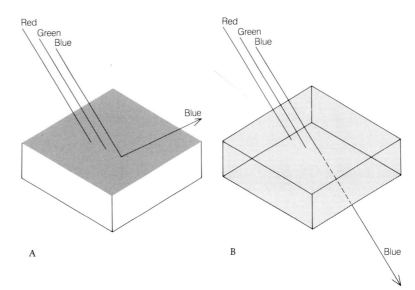

A B

a slight bluish cast. Increasing the proportion of blue threads will make the fabric a more highly saturated blue. Most colors that occur in nature are of relatively low saturation, but certain artificial pigments can represent nearly pure color.

See Chapter 5

Similar considerations occur with transmitted light and determine the characteristics of, for example, color filters. ◁ A yellow filter transmits primarily the red, yellow, and green wavelengths, and absorbs the blues. The #12 filter is often called a "minus blue" filter because it withholds practically all blue light. As with reflected light, transmitted color can be of high or low saturation. Color filters used with black-and-white film alter the exposure of different subject areas by transmitting more light of some colors and less of others, and thus change the relative values in the image.

COMPONENTS OF FILM

The basic components of modern photographic films were in use well before the start of this century, although a great number of refinements have occurred since. The fundamental interaction that

Figure 2–7 *Cross section of film.* The drawing suggests the various layers in a typical modern film. Note that they are not drawn to scale; the emulsion and other coatings are extremely thin in relation to the base.

Anti-scratch Layer
Emulsion
Adhesive Layer
Film Base
(acetate or polyester)
Adhesive Layer
Anti-curl and/or
Anti-halation Coatings

photography depends on is the chemical reduction of silver metal from silver halides that have been exposed to light. The term "silver halide" refers to the group of compounds of silver with bromine, chlorine, or iodine.

Crystals of silver halide that are exposed to light are "triggered" so that they will reduce to black particles of metallic silver during development. On exposure, the light produces an invisible *latent image* composed of crystals that will form image silver when developed, but have not yet undergone any detectable change. Portions of the film which have been exposed to great amounts of light yield a considerable deposit of reduced silver upon development, referred to as a higher *density;* ◁ areas of film exposed to less light yield less silver, or lower density. Thus the image on film is *negative,* dark areas of which correspond to bright areas of the subject. When printed, the dense areas of the negative give relatively little exposure to the paper and produce a light area on the print, and the low negative densities produce dark print areas. Thus a second reversal occurs that re-establishes the original relationships of lighter and darker values.

See page 85

The minute light-sensitive silver halide crystals are distributed in an emulsion of gelatin (or similar substance), which is bonded to a support or base. The emulsion is spread across the support material in one or more very thin layers of precise uniformity. One relatively recent advance in photographic technology is the use of "thin-emulsion" coating. (Many of my best-known photographs were made on what we now call thick-emulsion films, and these had a somewhat different response to exposure and to processing controls.)

The support material itself must be strong and transparent. Today it is often cellulose triacetate, a nonflammable substance (hence the term "safety film" — early films were made using cellulose nitrate, which proved to be unstable and highly flammable). A polyester base material is increasingly being used today, especially for sheet films. Where maximum dimensional stability is required (i.e., freedom from expansion or contraction), as in aerial survey and astronomical photography, polyester or even glass is used as the base.

Layers may be added to the back of the film base to prevent scratching and curl of the film, and to avoid *halation.* Halation occurs when light passes through the emulsion and base, and reflects off the rear surface of the base, back into the emulsion, causing exposure effects usually visible as a halo around any bright points. The antihalation dye on the back of the support prevents such reflection during exposure, and then usually washes out during processing. Other means of avoiding halation include a coating between the emulsion and the base or a slight dye density within the base itself. Both of these are permanent, but contribute only a slight overall density which does

not affect the image-density relationships in printing. An anti-scratch layer may be added over both the emulsion and base, and both sides are sometimes treated to permit retouching.

FILM SPEED

Each film has a characteristic sensitivity to light, determined during its manufacture. A particular film requires a specific amount of light to produce the first useful density, with greater amounts of light yielding greater densities up to a maximum. The control of exposure time and lens aperture allows us to ensure that the amount of light reaching the film from the subject falls within this range that produces visible density increments, and thus a usable image. We therefore must have a measure of the film's sensitivity, or *speed*. Various film speed systems have been used over the years, but the two predominant systems today are the ASA scale (named for the old American Standards Association, now American National Standards Institute) and the DIN (Deutsche Industrie Norm — German Industrial Standard). The two are being combined into a single international standard called ISO, but the numbers and values themselves remain the same.

The ASA speed of a film is represented by an arithmetic scale on which a doubling of the sensitivity is indicated by a doubling of the speed number. For each doubling of the ASA number the required exposure for a given scene is thus reduced by half (or one stop). The entire scale is divided into intervals equivalent to one-third stop exposure changes, so that every third index number represents a whole stop, thus:

See Book 1, pages 46–47

64 80 100 *125* 160 200 *250* 320 400 *500*, etc. ◁

This relationship allows us to predict, for example, that changing from an ASA 64 film to an ASA 250 film will permit a reduction of two stops in the exposure required for a particular scene, or 1/4 the exposure time.

Although most cameras and meters in the United States are calibrated in the ASA numbers, film manufacturers also usually give the DIN speeds. The DIN scale is logarithmic, rather than arithmetic, so that a doubling in sensitivity is indicated by an increase of 3 in the film's index number. A DIN 23 film is twice as fast as a DIN 20 film, again the equivalent of a one-stop exposure change. Thus the one-third stop intervals from one ASA number to the next correspond to an increase or decrease of *one* on the DIN scale.

The film speed *must* be set on the dial of the meter used, or on the camera itself if metering is built in. Beginning photographers will use the speed value given on the film package, but it should be understood that this number is only a guide, representing an average of conditions achieved in film-testing laboratory procedures. With experience the photographer learns to make informed departures from the manufacturer's speed recommendation, based on the film's characteristics, the performance of his own equipment, and his processing procedures. A series of tests ◁ should be conducted to determine whether the manufacturer's indicated film speed is appropriate to your requirements. Film speed is also affected by such conditions as age, heat, and the time between exposure and processing of the film. ◁ I can assure you that the variations are by no means inconsiderable.

See Appendix 1, page 239

See pages 25–27

One of the perplexing situations we confront is that the manufacturers may change the characteristics of films (and papers) without clear indication on the packaging. The experienced photographer may be forewarned if he observes a change in the film speed or development instructions on the enclosed "tip sheet" (if he *reads* the tip sheet). I have had some distressing experiences because of this tendency among manufacturers, and I regret that I must issue a warning to make frequent basic film tests, since we may not know when an "improvement" is being introduced!

GRAIN SIZE

Examination of a photographic negative with a magnifier reveals that it is not made up of a continuous range of white-to-black values, but that such values are simulated using a controlled deposit of individual black specks. These specks are the *grain* of the emulsion, the reduced metallic silver deposited when a halide crystal responded to light and "developed." It should be pointed out that the dark "grain" specks visible in the print are actually the spaces *between* the grains of the negative; since negative grains withhold light during printing, they appear white in the print.

See pages 20–21

Films manufactured with very fine grain will almost invariably have relatively high contrast, high resolution, ◁ and low speed. It is possible during manufacture to form crystals of larger size, producing an increase in speed accompanied by a reduction in the contrast and resolution. The photographer who needs a high-speed emulsion to cope with low light levels (or for other reasons ◁) thus may expect

See Book 1, pages 120, 133–134

Figure 2–8. *Acutance and grain comparison.* These are 80x enlargements from same-size original negatives.

(A) This negative was developed in Kodak Microdol-X. The image shows slight softness in the grain and a slightly reduced acutance.

(B) Develpment in Agfa Rodinal yields higher acutance and increases graininess.

A B

larger grain size along with some reduction in contrast and a sacrifice of resolution.

The appearance of graininess in the final print will depend also on the degree of enlargement in printing the negative. Since relatively high magnification enlargements are common for small-format negatives, the 35mm camera user in particular is frequently preoccupied with the issue of fine grain. In general it should be remembered that the grain itself is a property of the film, and therefore largely predetermined once the film has been selected. Development and the manner in which the negative is enlarged ◁ will have a secondary influence on the appearance of grain in the final print. Both extended development and high contrast in the print will increase the visual prominence of the grain.

See Book 3

Grain size and other factors govern the apparent sharpness of the final image. The terms *resolution* and *acutance* have a similar relationship to the emulsion definition as they do to the "sharpness" of a lens. ◁ Resolution refers to the ability of a film to render distinguishably very fine detail, measured by photographing a test chart made up of closely spaced lines. Acutance is the "edge sharpness"

See Book 1, page 73

visible in the image. Among the factors influencing image definition is the thickness of the emulsion layer. Excessive density, produced by overexposure or extended development, will also cause a reduction in definition. The choice of developer may have an additional influence on both resolution and acutance. ◁

See pages 182–185

SPECTRAL SENSITIVITY

Figure 2–9. *Mrs. Sigmund Stern, Atherton, California (c. 1927).* I used a 6½ × 8½ camera with an orthochromatic glass plate. The orthochromatic rendering favored foliage and shadow values, and rendered the sky quite light.

Different films can have quite different responses to the various colors of the spectrum. Early emulsions were sensitive only to blue light, and as a result, most nineteenth-century landscape photographs show a blank white sky. The blue of the sky was overexposed during the long exposure times required to record the landscape it-

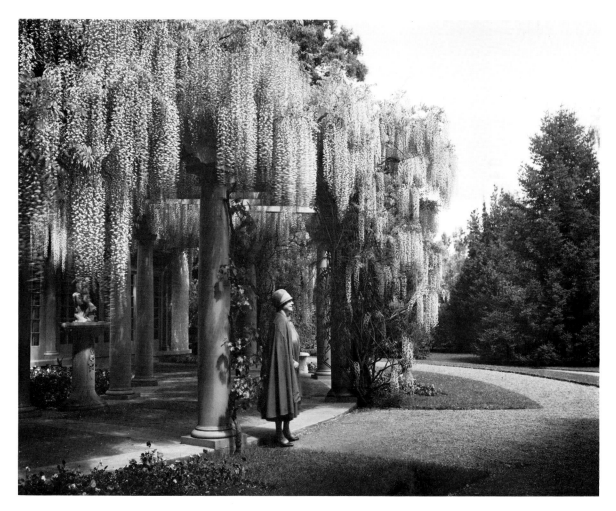

self, and therefore the sky printed as pure white. Some early photographers overcame the problem by maintaining a separate stock of cloud negatives, which they deftly printed in on the otherwise blank skies of their landscapes. It is always a surprise to see the same clouds appear in a number of different landscapes, with the clouds often lighted by the sun at a different angle from the landscape itself!

By adding dyes to the gelatin emulsions, scientists learned how to provide sensitivity first to all but the red end of the spectrum (*orthochromatic* sensitization), and finally, sensitivity to the entire visible spectrum (*panchromatic*). Panchromatic films used for most photography today are usually designated "Type B," indicating a generally uniform sensitivity over the entire spectrum under daylight conditions. Panchromatic Type A, most sensitive to blue light, and Type C, most sensitive to red (for higher effective speed under red-rich tungsten illumination) are relatively obsolete. Type B panchromatic films are not equally sensitive to all colors, however. With their films, Kodak recommends using a #8 filter with daylight and #11 filter with tungsten illumination for the best approximation of

Figure 2–10. *Spectral response of films.* The curves show the response of different film types to daylight. A blue-sensitive emulsion responds only to blue light, not to green or red. An orthochromatic emulsion is sensitive to the green and blue, but does not respond to red. Panchromatic film responds to all visible wavelengths although it often shows a slightly reduced sensitivity to green. The infrared emulsion is sensitive both to the invisible infrared radiation plus visible violet and blue light; hence a deep yellow or red filter is often used with infrared film to eliminate the blue light. (Some filters for use with infrared film are opaque to light and transmit only infrared wavelengths.)

See pages 111–112

visual perception of values. As discussed later ◁ the effects of filters must always be considered in relation to the spectral qualities of the emulsion used.

Orthochromatic and blue-sensitive films are still available, and are most widely used in line copy of black-on-white originals for graphic arts applications. The most common example of a blue-sensitive emulsion is ordinary photographic printing paper; because its response is limited to blue light only, it may be handled and processed under a relatively bright yellow safelight. Orthochromatic emulsions, which are sensitive to yellow light, must be processed under a red safelight or in darkness.

Because panchromatic films are sensitive to the entire spectrum, they are processed in total darkness. In earlier days, when their speed was lower, panchromatic materials were often developed "by inspection," using a very dim green safelight for brief examination late in the development process. Their spectral curve often still includes a slightly reduced sensitivity to green which may permit this procedure, but I do not recommend it except under unusual circumstances. One reason is that the negative is examined before fixing has removed the residual silver halides, so it has a dense, cloudy appearance that makes accurate density estimates extremely diffi-

See Appendix 1, page 239

cult. Once testing ◁ has been done to determine optimum time-and-temperature processing, there is little reason to consider development by inspection.

The nature of the film affects its recording of different-colored subjects. The lack of red sensitivity of an orthochromatic emulsion causes it to record red objects in darker-than-expected values. A blue-sensitive emulsion renders blues quite light, with much darker

See page 16

greens, yellows, and reds. As mentioned, ◁ however, very few natural colors are of high saturation. Both green and red objects reflect a small amount of blue light, and a blue-sensitive film will record some slight value in foliage, red rock, etc. A good reference example is Timothy O'Sullivan's photographs of the Grand Canyon from the

See Figure 2–11

1870s. ◁ The skies (blue) are white, and the reddish cliffs are very deep and rich in tone, but not *black* since they reflect some blue light. The shadows, illuminated by the blue light from the sky, often have a rewarding luminosity. The early blue-sensitive emulsions possessed certain beautiful qualities and conveyed a feeling of light that is sometimes missing with present-day panchromatic films.

Our visualization of image values must also include awareness of the color response of the material in relation to the color values of the light itself. At high altitudes, sky light is very strong in the blue and ultraviolet portion of the spectrum, and the absence of atmospheric haze may result in very high subject contrast. Surfaces that reflect blue strongly may thus be elevated in value compared to other

colors. In the red-rock country of the Southwest, on the other hand, the reflected light favors the red end of the spectrum. Early morning and late afternoon light is also strong in red, as countless color photographs of sunrises and sunsets demonstrate. Under such red-rich illumination, the effective speed of an orthochromatic or blue-sensitive emulsion drops off dramatically, as it will under tungsten lighting. Orthochromatic films usually have separate published speed ratings for daylight and tungsten light, while a blue-sensitive film intended for process work may have only a speed or exposure recommendation for use with a carbon arc lamp or the equivalent. Remember that, in general, a film loses effective speed if only part of the spectrum to which it is sensitized is utilized.

Although panchromatic films are used for nearly all general photography today, we should avoid prejudice against other emulsions since they may have practical and aesthetic application. Both orthochromatic and blue-sensitive films are usually capable of higher

Figure 2–11. *Black Canyon, Colorado River, 1871,* by Timothy H. O'Sullivan. (Courtesy of the Chicago Albumen Works and the National Archives.)

contrast than panchromatic film. An orthochromatic film can be quite luminous in rendering foliage in the landscape since the foliage green is rendered relatively light, comparable to our visual response; caution must be exercised if the subject contains red-reflecting surfaces such as certain rocks, tree bark, and flowers, since these will be rendered quite dark. It can also be used in portraiture, where it will emphasize skin features such as lips and freckles, and darken (sometimes excessively) a ruddy complexion. Kodak has continued to manufacture Tri-X Ortho film since some portrait photographers prefer it, particularly for photographs of men.

A blue-sensitive film will present a bleak sky in landscapes, perhaps desirable in some images where a strong impression of light is desired. To cite another example, there is a magnificent early photograph by Paul Strand showing a dark jug and a platter of fruit on a white garden table, seen from above against a dark lawn. The design is exciting, enhanced by the "color-blind" rendition of the lawn and fruit. The white table stands out vigorously against the dark background of the grass; the fruit, too, is very dark, defined mostly by its outline against the white table and by sensitive recording of the highlights. The values are not "realistic," but the general effect is spectacular.

It should be noted that a panchromatic film can be used to simulate orthochromatic or blue-sensitive rendering using filters. ◁ See page 112 Specialized films are also made that are sensitive to infrared radiation. Their response is primarily to the far-red and infrared regions of the spectrum, plus some sensitivity to blue light. ◁ See Figure 2–2 The red-yellow-green portions of the visible spectrum are not recorded. The film thus "sees" radiation that is invisible to the eye, and judging exposure and the visual effects of such films requires experience. Some striking images have been made with such materials, however, by Minor White among others. I have used infrared film for low-contrast and hazy-landscape photographs. ◁ See Figure 2–12 and pages 151–153

STORAGE OF FILM

Photographic films deteriorate over time, and the conditions of storage are thus of great importance. Unexposed film is supplied in foil or other vapor-tight packaging to protect it from excessive humidity. The temperature, however, is of great importance: under no circumstances should film be subjected to high temperatures. For storage of a month or two the temperature should be 70°F (22°C) or lower, and storage of up to a year is possible if the film is refrigerated at

Figure 2–12. *The Grand Canyon of the Colorado, Arizona.*

(A) This is a view east shortly after sunrise. I used 8 × 10 Agfa Isopan panchromatic film with a light yellow filter. The heavy haze was mostly from forest fires north of the Canyon.

(B) Kodak 8 × 10 infrared film penetrated the haze and smoke to a far greater extent. The usual high contrast of the infrared image has been lessened here because I reduced the development (about half the normal time in Kodak D-23). As infrared film is sensitive to blue light in addition to the infrared, I used a red (#25) filter to eliminate the blue. No filter factor is involved, as the "speed" of infrared film is based on its sensitivity to infrared only.

A

B

50°F (10°C) or lower. Whenever a film is refrigerated, it is essential that the seal on the film packaging not be broken; the humidity is usually quite high inside a refrigerator, and the film must not be exposed to such moisture. Refrigerated films must also be allowed to warm up to ambient temperature before the seal is broken, to avoid condensation of moisture in the air on the film surface. A warmup time of six hours is advisable for all films, although less time may be sufficient. If film is frozen, it requires a considerable time to thaw.

Exposed films should always be processed as soon as possible after exposure. Kodak recommends that exposed black-and-white films be processed within 72 hours, or sooner if the temperature is above 75°F (24°C) or humidity is above 50 percent. If it is not possible to process the film within 72 hours, it should be sealed in an airtight container and refrigerated.

Other factors that affect the deterioration of films include chemically active substances in the environment. Among the potentially damaging chemicals identified by Kodak are certain plastics, solvents, lacquers, paints, and gases. The hydrogen sulfide fumes given off by sulfide toners, for example, are capable of fogging a photographic emulsion. Ionizing radiation, such as X-rays, must be avoided in all circumstances unless the film is fully protected by lead foil or other means.

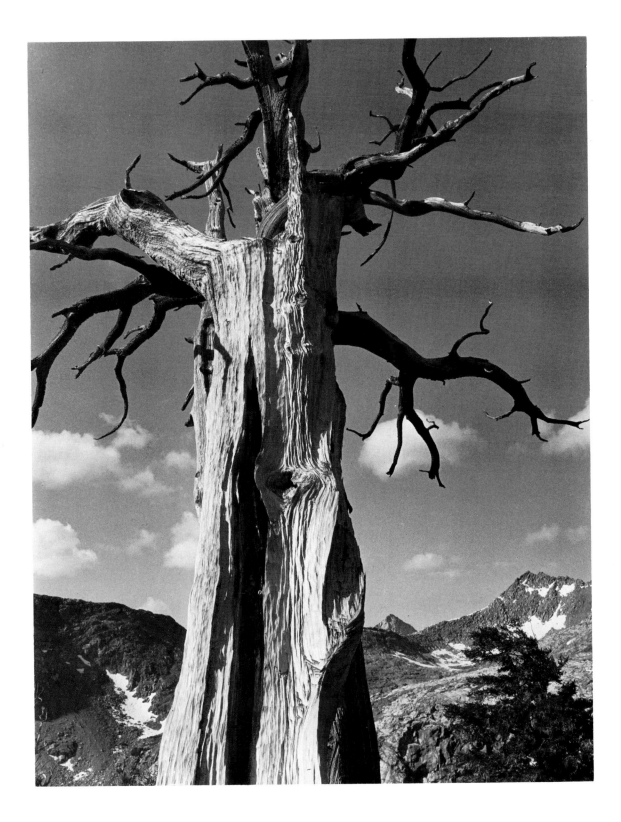

Chapter 3 **Exposure**

Figure 3–1. *Juniper Tree, Sierra Nevada.* This is an example of nearly perfect exposure determined by averaging with an early Weston meter. The sky, tree, clouds, and mountains averaged out in such a way that both shadow and high values retain texture. Had I worked closer to the tree, the light wood would have dominated the meter reading, and the shadows might have been seriously underexposed. Thus the same conditions that led to nearly ideal exposure could just as well have led to exposure error using the average-reading technique.

The concept of the "perfect negative" is both intriguing and exasperating to the student and photographer. If exposure and processing are both "normal," using recommended average techniques, it may seem that the negative should be "correct" even when it fails to yield the anticipated print. Such a negative may contain considerable information yet not be adequate for interpretation in terms of an expressive image. There is simply too much room for error in the use of "average" meter readings and processing; the ability to produce a fine print depends on greater precision.

If there is such a thing as a perfect negative, it is one exposed and developed in specific relation to the visualized values of the functional or expressive print. As our aesthetic and emotional reactions may not be ruled by simple numbers, we must learn how to evaluate each subject and understand it in relation to the materials used. Even so, it cannot be taken for granted that a properly executed negative will ensure that printing will be an easy process; the appropriate paper and developer combination, for example, may be elusive. But without careful control we are likely to have many negatives that defy satisfactory printing.

METERING EXPOSURE

The term *exposure* requires a definition. As our discussion of apertures and shutter speeds indicated, ◁ we can give equivalent total

See Book 1, pages 47, 80

exposure to the film using relatively high intensity of light for a short time, or less intense light for a longer duration. Stated as a formula, this relationship can be expressed:

$$\text{Exposure} = \text{Intensity} \times \text{time, or } E = I \times t.$$

Thus the same total exposure will occur if we increase the *intensity* of light reaching the film while reducing the exposure *time* proportionally. Opening the lens aperture one stop doubles the intensity of light at the film plane; if the shutter speed is then reduced by one-half, no net change of exposure occurs. Similarly we can reduce the intensity by closing down one stop, and compensate by doubling the exposure time.*

We use the term "exposure" to refer to the camera aperture and shutter speed used to record a given subject. We should remember, however, that each such exposure is really a range of different exposures on the film: a dark area of the subject gives less exposure to the negative area recording it than does a light subject area. Only by knowledgeable use of a good-quality exposure meter can we ensure that this entire range of "exposures" is evaluated and recorded successfully in a single negative in the manner determined by our visualization.

Although modern equipment is of remarkable accuracy, the process of determining the ideal camera exposure will always involve a considerable degree of judgment. I can recall seeing Edward Weston, who was not particularly of scientific persuasion, using his meter in rather unorthodox ways. He would point it in several directions, take a reading from each, and fiddle with the dial with a thoughtful expression. "It says one-quarter second at f/32, I'll give one second." His approach was empirical, based on long experience combined with very deep sensitivity and intuition, and his extraordinary results speak for themselves. My own approach relies on experience and intuition for the visualization of the image, but I prefer a more methodical system for executing the visualized photograph.

Exposure Meters

See Book 1, pages 163–167

See page 11

The mechanics of exposure meters is described in Book 1 ◁ and need not be repeated. We are concerned here with understanding their use, particularly the use of the reflected-light meter. I consider the incident meter◁ to be of limited usefulness since it reads only the light falling on the subject and omits consideration of the specific luminances that produce the image.

Luminance is measured in candles-per-square-foot, but most meters today use an arbitrary scale of numbers instead of these real units. One advantage of reading directly in candles-per-square-foot

*The exception, the "reciprocity effect," is discussed on pages 41–42.

is that a doubling of luminance is indicated by a doubling of the value on the meter. With the arithmetic scale numbers now used on most meters, however, a doubling of luminance is indicated by an increase of *one* unit on the scale. These scale units are arbitrary in the sense that the number 12 on such a meter invariably represents twice the luminance of the number 11, but does not necessarily have relationship to the number 12 on a different meter.

These index numbers are read from the meter and transferred to a rotating calculator dial which converts them into f-stop and shutter-speed settings, taking into account the film speed. Interpreting the meter readings and making the appropriate setting on the meter dial requires a considerable amount of judgment, however. For now it is sufficient to note that a one-unit change on an arithmetic meter scale represents a doubling or halving of the actual luminance, and thus corresponds also to a one-stop exposure change.

A general-purpose reflected-light meter reads about a 30° area of the subject. If pointed generally toward the subject it will give an average reading of *all* luminances within its field, but very often this reading does not yield the best exposure for securing a superior negative. It must be understood that such a reading is nothing more than the average of whatever luminances happen to fall within the area read by the meter. If the subject contains a roughly equal distribution of light and dark areas, such an average may produce an adequate exposure, at least for a "literal" recording; it will offer no opportunity for creative departure from the literal. With other subjects that are not average — a single figure in front of a large dark wall, for instance, or a backlighted portrait — a general average reading of the area will undoubtedly lead to erroneous exposure.

We must realize that the meter has no way of knowing what kind of subject it is directed at, or the proportion of light and dark areas

Figure 3–2. *Incident- and reflected-light exposure meters.* The Sekonic meter at left is an incident-reading type, which uses a white hemisphere to average all the light falling upon it. The Luna-Pro SBC is a broad-angle reflected-light meter (it can also be used for incident light measurement by sliding the white hemisphere over the cell). The two meters on the right are Pentax 1° spot meters, the smaller one being the new digital unit that I now use.

in the subject. It is calibrated on the assumption that the subject is "average." A subject in which the light and dark areas are not approximately equal will thus lead to uncertain exposure.

Consider as an example a large checkerboard pattern of black and white squares. If the checkerboard has the same number of light and dark squares, a general meter reading will give about the right exposure setting to record it as white and black areas. If, however, the surface is predominantly black with only a few white squares, we will get a different average reading from it, since it will appear to the meter as a "darker" subject; an average reading will thus indicate *more* exposure required. Conversely if the surface contains mostly white with only a few black squares, the meter will indicate a higher average luminance level and *less* exposure required. The problem that arises is that, in photographing each of the three checkerboard arrangements we would usually want the black areas to appear black in the final print and the white areas white. Only one of the three exposure readings — the one from the normal checkerboard — will provide an exposure setting that is appropriate to achieve that result. To repeat: the meter assumes it is reading an average subject, as it was in the case of the normal checkerboard. When the distribution of light and dark areas is not average, the meter has no way, in itself, to compensate.

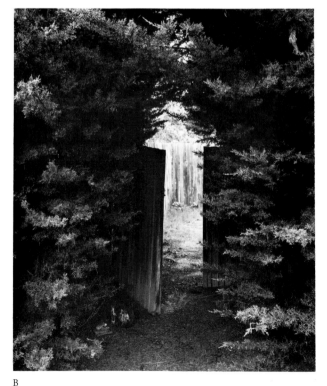

A

B

Reading Middle Gray

We can greatly improve the exposure accuracy by making a reading from a middle value within the scene — a surface of uniform luminance midway between the lightest and darkest values of the subject. In doing so, we must again understand that the meter assumes that whatever single surface we read in this way is an "average" value. Thus, *a reading made from any uniform luminance surface used directly to determine exposure will give exposure settings that will reproduce that surface as a middle gray in the final print.*

A calibrated middle gray value exists in the Kodak 18 percent reflectance neutral gray card, available at most camera stores or bound into several of Kodak's publications. The 18 percent reflectance value is mathematically a middle gray on a geometric scale from "black" to "white," and it is this value that the meter is calibrated to reproduce in the final print (with exceptions noted below ◁). This 18 percent reflectance is a fixed key reference point, and functions like the "A" of the musical scale as a universally recognized basic value.

See pages 42–43

Knowing that the meter is calibrated to reproduce this value, we must remember that making a reading from *any* single luminance surface in the subject and using that reading to determine exposure will cause that surface to be reproduced as a middle gray in the final print. If we make the reading from a "black" surface in the subject, we can expect it to reproduce not as a black, but as a middle gray in the print. Similarly a reading from a "white" subject area will yield an exposure setting that reproduces that area as middle gray. The meter, again, has no way of knowing what it is reading and "assumes" that it is an average middle value comparable to that of the 18 percent gray card.

If we place the gray card within a scene and take a meter reading from it, we are assured that the meter is measuring a middle reflectance value, and we can avoid the pitfalls of a single averaged reading of the entire subject. Thus, placing the gray card in front of the three checkerboard surfaces described above would yield the same exposure for each. This exposure reading would reproduce the gray card as a middle gray, and would also ensure that the black and white squares of the checkerboard will be rendered satisfactorily as blacks and whites. Because we are reading from the gray card instead of the checkerboard, the reading is not influenced by the proportion of white and black areas, and we obtain the same exposure for each of the three checkerboards.

This approach can often be a valuable one for determining exposure in the field. It amounts to providing a known middle-gray luminance where none may exist in the subject, for purposes only of

Figure 3–3. *Gate, Trees, Distant Fence.* The illumination was quite hazy sunlight. There obviously are three major planes of luminance: the near foliage, the middle-distance gate in shadow, and the far ground and fence.

(A) Using an incident-light meter I stood at the plane of the foliage (illuminated by open sky) and made an exposure reading. In this case both the high and low values are recorded within the exposure scale. Had I taken the incident-light reading from the gate, where the illumination was much lower, the meter would have indicated considerably greater exposure. The shadows would then have had much more detail, but the near foliage and the distant fence would have been seriously overexposed.

(B) Using a 30° meter for an average reading from the camera position indicated 2 stops more exposure was required. The reason is simple to grasp: the subject contained large areas of shadow, but the meter "assumed" it was reading an average middle value. Consequently the near foliage and distant fence were overexposed.

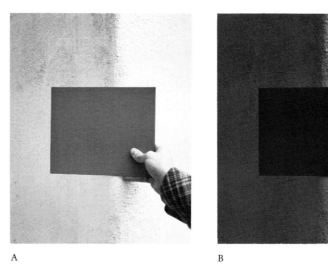

A B

Figure 3–4. *Gray Card and Adobe Wall.*

(A) An incident-light exposure meter was held at the gray card facing the camera for the exposure reading.

(B) A reflected-light meter was used to read the entire subject area from camera position.

This is an important, if extreme, example of the results given by the two types of exposure meters. The incident-light meter is calibrated to give optimum exposure for all reflective values of the subject *provided* they are equally illuminated; it cannot compensate for shadow values. The reflected light meter reads about a 30° area of the subject, and thus encompasses a considerable area of the sunlit and shaded adobe wall, as well as the card and the hand. All these luminances are averaged by the meter. Since this subject area is predominantly white adobe, the result is underexposure. Had the reflected-light meter been used to read only the gray card, its reading would have agreed with the incident-light meter. Proper use of a spot meter to evaluate small areas of subject luminance from the camera position is the most accurate of all exposure determination methods.

making the exposure reading (for test exposures the card may be left in the image area, but otherwise it should be removed prior to exposure!). If the card is under the same incident light as the subject, we are assured that it will have a middle-value luminance in relation to the subject's range of luminances. This method is similar in principle to using an incident-light meter, and in fact, an incident-light meter, properly calibrated, will give the same exposure as a reflected-light reading from a gray card. ◁ But both approaches also have the same limitation: they ignore the actual different luminances of the subject. There is little danger in using these methods if the lighting is uniform, since the luminances are then determined by the different reflectances of the subject, and the 18 percent gray is known to be the geometric midpoint of reflectances from black to white. If, however, the subject contains some areas in direct light and others in shadow, the incident light or gray card reading will provide no clue to the actual total range of luminances.

Averaging High and Low Values

We can take a further step toward refining our exposure readings by doing the averaging ourselves from separate subject luminances, instead of relying on a single average meter reading of the scene or a reading from the "average" value of the gray card. The procedure involves examining the subject to find the darkest area where you wish to record detail, and similarly the lightest. After making individual readings of each area, you set the meter dial midway between them, or on the average of the two readings. We thus begin to account for the principal luminances of the actual subject instead of assuming that the range is average.

Since we are now at the point of reading individual subject luminances, a few cautionary remarks are in order. First, be aware of what you are reading. Try to measure large areas of single luminance if they exist in the subject. Some areas that appear from a distance as a single luminance will be found at closer inspection to have a range of discrete values. Readings can be made from such areas, but they must be understood to be local averages of the textures and details within that surface. Second, and very important, be sure your meter reads only the area you intend it to. I strongly favor the use of a 1° spot meter, since it provides accurate readings of even quite small subject areas. If you use a general-purpose meter that reads roughly a 30° area, you must be especially careful that the surface you read is adequately large, and you must hold the meter quite close to it, but without allowing the shadow of your hand, body, or the meter itself to fall on the surface. Be sure to shield the meter's cell or lens from direct sunlight or other light sources that will create light scatter and reflections that cause false readings. Finally, make the meter reading from the direction of the camera (from the camera position itself if using a spot meter), pointing it toward the subject approximately along the lens axis. Since many surfaces reflect some glare at certain angles, you want to be certain you are reading only the diffuse luminances or specular components *as seen from the camera's position.*

Figure 3–5. *Stream, Oceano Dunes, California.* I made this photograph with Polaroid Type 55 positive/negative film. The shadows on the right were near the limit of the exposure scale and are almost empty, while the glare on the stream is above the upper limit of the negative scale (as it would be with any material). With a film of longer scale the visualized concept might have been quite different, particularly in the shadow and middle values. The exposure scale of the film *must* be taken into consideration when we visualize the image.

Carefully employed, the reading of high and low subject values to average the result will produce a higher proportion of acceptable exposures than the methods discussed earlier, since it takes into account the actual range of luminances within the subject. It too has several shortcomings, however: it gives no indication of specifically how the luminances within the subject will be rendered, or even if they can all be recorded successfully. Most important, it assumes that a relatively literal interpretation of the subject is desired, and gives little assistance in choosing to alter values deliberately according to one's personal visualization of the subject rendered in an expressive image.

These limitations can be overcome using more specific readings of subject luminances and relating them to our knowledge of materials to control the values in the final print. Such a method is the Zone System, to be discussed in the next chapter. I wish to encourage the reader not to be intimidated by the Zone System. It really is only a refinement of the concepts described above. Furthermore, the knowledge of exposure and development controls available through the Zone System can be usefully applied by all photographers, even those using automated 35mm cameras, in black-and-white and color photography. With an automatic camera, the Zone System at least provides a framework for understanding when a departure from "normal" exposure and processing will help achieve the desired image. Without the Zone System, only years of trial-and-error experience can develop a similar comprehensive understanding of the interaction of light, film and processing procedures.

Over- and Underexposure

It will help the student appreciate the importance of careful exposure if he knows the perils of over- and underexposure. A brief description will suffice for now; these situations will be better understood after reading the sections on the Zone System and sensitometry. ◁ I would like to point out that the terms "overexposure" and "underexposure" refer to exposure *errors*; when a departure from normal exposure is intentional, I prefer to use the terms increased or decreased exposure.

Of the two errors, underexposure is certainly the more dangerous. The reason is that if a scene is underexposed, dark areas within the subject may not record at all on the film, and no amount of development modification or printing virtuosity will provide detail where none exists on the negative. Overexposure, on the other hand, leads to other problems such as loss of resolution, increased graininess, and reduced separation within the high values. The loss of high-value detail with overexposure corresponds to the loss of shadow

See Chapter 4

detail with underexposure, except that the latter tends to be absolute: underexposed shadow areas soon lose *all* detail, while the high values of an overexposed negative usually will retain *some* detail and subtle variations that may (or may not) be successfully printed. The guideline that most photographers follow is that it is better to overexpose *slightly* than to underexpose. (I assume here the use of a black-and-white or color negative material; with positive materials such as transparency films the situation is reversed, and a slight underexposure is usually less harmful than overexposure. ◁)

See pages 95–97

Figure 3–6. *Itinerant, Merced, California.* The light was quite harsh. More exposure, together with less development, would have helped with the two problems that exist with this negative: it is difficult to print the shadowed face because of its generally low density, and the high sodium sulfite content of the developer (Kodak D-23) tended to "block" the high values. Merely printing with less contrast reduces the impact of the image. I used a 5×7 camera and 13-inch component of my Zeiss Protar lens set.

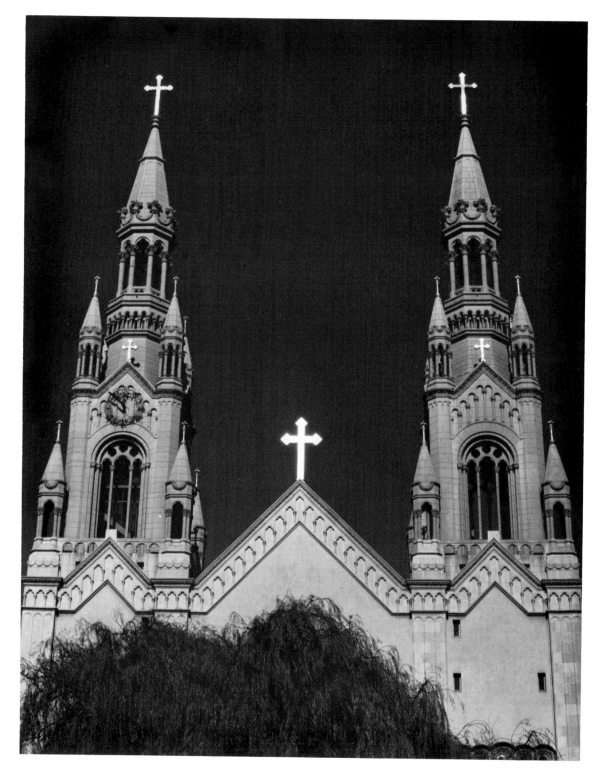

Figure 3–7. *Spires of St. Peter and Paul Church, San Francisco.* The gilt crosses were blazing with the glare of sunlight. The stone of the church was fairly light, but if rendered "literally" it would have competed with the crosses. Hence I exposed to keep the stone a middle value, and the foliage is thus quite dark. The sky was a deep blue and adequately separated in value from the stone. I made a second negative at one-half the exposure, but lost qualities in the shadows and in the foliage while gaining nothing with the values of the stone and cross. (The sky was deeper, but the effect was excessively theatrical.) With both negatives, the below-normal exposure had no effect on the glare from the crosses, since that was far beyond the normal exposure scale of the film.

See Figure 6–2
See pages 66–67

EV Numbers

Many meters, and some cameras, include calibration in the so-called EV numbers (Exposure Value). These numbers refer to specific combinations of f-stop and shutter speed, and thus allow these functions on a camera to be locked together in such a way that changing either one automatically also changes the other to compensate. If the camera is initially set for 1/60 second at f/11, for example, the interlock allows a single adjustment to be made to set all the equivalent exposures, in this case 1/30 at f/16, 1/15 at f/22, 1/125 at f/8, etc. These are all equivalent exposures, and they correspond to EV 13. EV 12 would thus be 1/30 second at f/11 and all equal settings. Although EV numbers bear the same relationship to each other that a meter's arithmetic index numbers do, the two are not interchangeable since EV numbers refer to *camera exposure settings*, and meter scale numbers refer to *luminance*. In order to translate luminance values to exposure settings, we must take into account the film speed. Thus a scene that reads 13 on the meter scale will always read 13 if the lighting remains constant, but the appropriate EV setting for exposure of that scene will vary depending on the film speed.

Estimating Exposure

Having emphasized the importance of careful exposure, I must also state that there are occasions when time pressure or equipment failure may require estimating exposure if any image is to be made at all. A case in point is my *Moonrise, Hernandez, N.M.,* ◁ where I had to make an educated guess using the Exposure Formula, ◁ since I could not find my exposure meter. Knowing that the moon is usually about 250 c/ft² at this distance from the horizon, I used this value to make a quick calculation, and then made the exposure. As I reversed the film holder to make a second negative, I saw that the light had faded from the crosses! I am reminded of Pasteur's comment that "chance favors the prepared mind."

In cases where an estimate of exposure is essential, two emergency methods are worth remembering. One is simply to refer to the "tip sheet" packaged with the film. It usually has exposure guidelines for various lighting conditions, and the results will generally be superior to wild guesses, although certainly not as accurate as a specific exposure placement.

A second emergency approach is to remember a few basic exposure conditions and apply the following rule: under bright sunlight conditions a "normal" exposure is about f/16 at a shutter speed equal to 1/ASA-number. Thus with ASA 64 film use 1/60 second at f/16 for a subject fully illuminated in sunlight. For side light or under bright

Figure 3–8. *Ranch at Julien, California.* My intention here was to convey an impression of a hot and glaring day. The sky was practically white, and all shadows were full of light. I exposed the shadows high on the scale, and gave reduced development. This reproduction is intended to convey the "information" in the negative; an exhibition print would be somewhat richer in values but would still preserve luminosity.

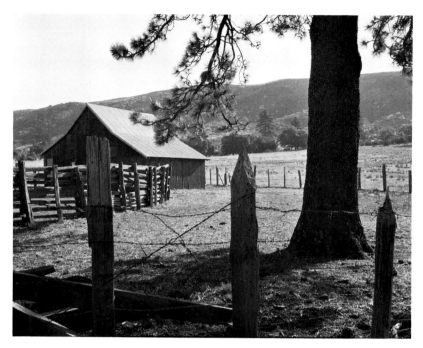

cloudy conditions, open one stop; under heavy overcast or in open shade, open two to three stops.

To repeat, these are emergency procedures to be stored in the back of the mind and used only when no better exposure information is available. The resulting negative may be printable, but can hardly be expected to yield fine-quality prints without a measure of good luck.

EXPOSURE CORRECTIONS

Exposure Factors

See pages 116–117

See Book 1, pages 67–69

A number of circumstances may alter the basic exposure, including the use of filters, ◁ or lens extension to focus on nearby subjects. ◁ In such cases the required correction is often expressed as a *factor.* Such a factor can be applied directly by multiplying it by the indicated exposure *time* to obtain a corrected time. To make the correction in f-stops, the factor must be converted into stops by remembering that each *one stop* is equal to a 2x exposure change, or a factor of 2. Thus a factor of 4 equals two stops, etc. (Mathematically, the exposure change in f-stops is given by the power to which 2 must be raised to obtain the factor: $2^1 = 2$, or *one* stop is equivalent to a factor of *two;* $2^2 = 4$, *two* stops equals a factor of *four;* $2^3 = 8$, *three*

Figure 3–9. *Detail, Dead Wood, Sierra Nevada.* This is a relatively simple "close-up" that required about 1.5 times the normal exposure because of the lens extension.

See pages 113–115

stops equals a factor of *eight* , etc. In practice, the intermediate values for a factor are usually estimated rather than calculated; the factor of 2.5 used with most polarizing filters ◁ can be considered 1⅓ stops in practical terms.) Remember *either* to multiply the factor by the exposure time, *or* to convert it to f-stops and open the aperture accordingly. Since changing apertures results in a loss of depth of field, I usually prefer to increase the exposure time if possible, unless doing so causes problems due to subject motion or the reciprocity effect.

In cases where two factors are required, as when using a filter while making a close-up photograph, the factors must be *multiplied*, not added. The same result is achieved by applying first one factor to correct for one condition, and then applying the second factor.

The Reciprocity Effect

See page 30

The formula $E = I \times T$ ◁ expresses a reciprocal relationship between the intensity of light reaching the film and the time it is allowed to

act on the film. If one increases and the other decreases proportionally, no net change in exposure occurs. However, very long or very short exposures do not follow this law, and special correction is required to compensate. This is commonly known as "failure of the reciprocity law," but I prefer the term *reciprocity effect* as it is not actually a "failure."

See Table 1, page 45

For example, if the meter indicates a 1-second exposure time, most black-and-white films would actually require about a 2-second exposure to secure the desired negative. As the exposure time increases beyond this point, so does the amount of correction; an indicated 10-second exposure should actually be given 50 seconds. Note that the corrections for the reciprocity effect are given in the chart ◁ separately in terms of f-stops or exposure time. If the instructions call for opening the lens by two stops, we are accustomed to considering this the equivalent of a 4x increase in exposure time. Since we are now in the region where the usual reciprocal relationship does not apply, however, these are not equivalent exposure changes. For an indicated exposure time of 10 seconds we should give either two stops more exposure (a 4x increase in *intensity*), or 50 seconds at the original stop (a 5x increase in *time*).

The reciprocity effect is not identical throughout the scale of negative densities. For a long exposure, the low values tend to be affected (i.e., underexposed) *more* than the high values, causing a decrease in their density, and there is thus an increase in contrast in the negative. It is therefore necessary to decrease development as suggested in the chart to avoid excessive contrast.

See Book 1, page 170

Short-exposure reciprocity has become an issue with the advent of electronic flash units, which can have a flash duration of 1/50,000 second or less. In particular most automatic flash units reduce the flash output for nearby subjects by reducing the duration of the flash pulse ◁ so that the effective exposure time may range from 1/1000 second to 1/50,000 second depending on the subject distance. You may need to test an electronic flash unit to determine if underexposure occurs, particularly at close subject distances. With these short exposures, the reciprocity departure affects first the *high* values of the image. It thus causes a reduction in contrast, which generally requires an *increase* in development time as shown in the chart.

With color films, corrective filtration is usually required, since the separate emulsions of a color film are not affected equally by either short- or long-exposure reciprocity effect and a color shift results.

The K Factor

If pressed, the manufacturers of some exposure meters will acknowledge that they depart from standard calibration of their meters by

incorporating a "K factor." This factor is supposed to give a higher percentage of acceptable images under average conditions than a meter calibrated exactly to an 18 percent reflectance. The practical effect of the K factor is that if we make a careful reading from a middle-gray surface and expose as indicated, the result will not be exactly a middle gray!

Some years ago I conducted a series of nearly a thousand trials, and found that when a meter is held at the lens and pointed along lens axis toward the subject, the resulting averaged exposure reading had to be increased in about 85 percent of the cases to meet my demands for shadow density. This effect does not directly relate to the functioning of the meter itself, but has to do with the natural disposition of light and shadow in most subject material. The manufacturers, apparently assuming that meters are most often used for average readings of the entire subject area, take this effect into account by using the K factor. With nearly all meters, this factor is equivalent to giving a one-third stop *increase* in exposure. Although the manufacturers may be acting with good intention, I find it far preferable to work with what I consider to be the true characteristics of the light and films. Intelligent use of the meter eliminates the need for such artificial aids as the K factor. In the tests described in Appendix 1, ◁ we offset the effect of the K factor by an adjustment in the film speed.

See page 239

PRECAUTIONS REGARDING METERING

Since the way the exposure meter is used is of great importance in affecting the accuracy of the readings, it is worthwhile to issue a few cautions and reminders:

1. Have your meter checked for accuracy over its entire scale. A small error can be tolerated provided it is uniform over the entire range and consistent, but a nonuniform error, or one that is erratic, may render the meter useless.

2. Spot meters include an optical system for viewing the subject, with the area read by the meter cell marked in the center of the field. You should check the accuracy of the spot indicator by reading a small bright area, such as a distant light bulb. As you move the spot toward the bright area, the reading should not rise sharply until the spot contacts the bright surface; try moving the meter toward the bright area from several directions. A small misalignment of the optical system is not uncommon, and can cause the meter to read a different area from the one you think you are measuring.

The optical system can also introduce error in the readings if it is
See Book 1, pages 69–73 not fully coated to reduce flare. ◁ You can check for the influence of

Figure 3–10. *John Marin in his Studio, Cliffside, N.J.* With only available light from the windows, the required exposure was 1/4 second at f/5.6 using Kodak Plus-X film (developed in Edwal FG-7). The scene was obviously of high contrast. Image study shows that the lack of sharpness in the head and hands is due more to subject motion than to movement of the hand-held camera. I used a 35mm Zeiss Professional Contarex with 35mm Zeiss Distagon f/4 lens.

flare on the meter by reading a small dark surface surrounded by light surfaces. First read the dark surface from a distance and then move in to make a reading with it filling the entire viewing area. If the reading from a close distance is significantly lower, flare should be suspected. More accurate reading should be possible by shielding the lens as much as possible without vignetting (cutting into the field of view). A cardboard tube, painted matte black on the inside, may be fitted over the meter lens to provide an effective shade. By

experimenting with different tube lengths, you can determine when the tube begins to vignette, indicated by a reduction in the luminance reading.

3. When reading a single-luminance area, be sure the meter cell is not influenced by adjacent areas. With a broad-angle meter this requires moving close to the surface, but you must be careful not to cast a shadow or reflect light onto the subject that will alter the reading. A spot meter can be used from greater distances, but it is wise to be sure the area being read more than covers the central spot in the viewer of the meter.

4. Be sure to make readings from as close as possible to the lens axis position. Avoid reading specular reflections unless you specifically wish to check on their luminance.

5. Maintenance is important — be sure to use the correct battery, and check that it is at full strength; keep the lens in front of the meter cell clean; avoid rough handling; protect the meter from heat; and have it calibrated at intervals by an expert, particularly if you notice a change in the overall density of your negatives, or if there is any obvious change in familiar luminance value readings.

Table 1. *Correction for the reciprocity effect.* For intermediate exposure times, between 1 and 10 or between 10 and 100 seconds, you may interpolate approximate adjustment values; when in doubt give slightly more, rather than less, exposure to preserve low-value densities in the negative. For greater accuracy tests should be conducted with the specific film you use. (Reproduced from "Kodak Professional Black-And-White Films" [publication number F-5] by permission of Eastman Kodak Co.)

If indicated exposure time is (seconds)	USE		AND in either case, use this development change
	EITHER this lens aperture adjustment	*OR* this exposure time adjustment (seconds)	
1/100,000	1 stop more	use aperture change	+ 20%
1/10,000	1/2 stop more	use aperture change	+ 15%
1/1000	none	none	+ 10% *
1/100	none	none	none
1	1 stop more	2	− 10%
10	2 stops more	50	− 20%
100	3 stops more	1200	− 30%

*Not required with Ektapan 4162 (Estar Thick Base)

Chapter 4

The Zone System

See Book 1

Figure 4–1. *Clearing Winter Storm, Yosemite National Park.* This was a generally gray situation, but the mood was impressive. I visualized the image as much more dramatic in values than I would have achieved with a straight "literal" representation. Accordingly, I used an exposure that was one-half that indicated by an average scene reading (this was done in the days before spot meters), and increased the development (N + 1) to raise the contrast, as discussed in this chapter. In retrospect, I could have given even more development since the negative requires at least a Grade 3 paper in printing.

The Zone System allows us to relate various luminances of a subject with the gray values from black to white that we visualize to represent each one in the final image. This is the basis for the visualization procedure, whether the representation is literal or a departure from reality as projected in our "mind's eye." After the creative visualization of the image, photography is a continuous chain of controls involving adjustment of camera position and other image management considerations, ◁ evaluation of the luminances of the subject and placement of these luminances on the exposure scale of the negative, appropriate development of the negative, and the making of the print.

You may well ask why anyone should go to such pains to produce consistent negatives when we have printing papers available in several contrast grades and other printing controls that allow us to compensate for negatives of differing scales. While every such control has its uses, it is best to strive for the optimum negative to minimize dependency on printing contrast control, since the tones of the print may be best achieved with the use of normal-contrast paper. In particular, papers of higher-than-normal contrast make it increasingly difficult to control the refinements of the higher and lower tonalities. It might be preferable to work for a negative of extensive density range and print only on the longest scale papers, but there is then little additional tolerance when we desire softer results.

Our discussion of the Zone System is based on the procedures of conventional photography, where we work first with a negative and attempt to secure therein all the information required to achieve the

desired final image through controlled printing of the negative on sensitized paper. It is convenient for learning, however, to think in terms of subject values related directly to final print values, since these are the ultimate objective.

See pages 3–6

I would like to remind you of the visualization practice methods suggested in Chapter 1, ◁ particularly the use of the #90 viewing filter and of Polaroid black-and-white films to aid in visualizing print values while viewing the subject. As photographers, we should study and reflect upon the details of the process; practice is essential, for when we are making photographs, we should be free to work creatively and intuitively, drawing upon our knowledge and experience to bring everything together as a performing musician must do — with no interference of technical issues with the "creative flow."

THE EXPOSURE SCALE

See pages 33–34

As discussed in Chapter 3, ◁ using an exposure meter (set for the appropriate film speed) to read the luminance of a single-value subject area will indicate an exposure that produces a middle-gray rendering. The middle gray print value is created directly if we are using a positive process such as transparency film or Polaroid print films; with conventional negative materials, the negative density produced by this exposure will be optimum for printing as a middle gray on normal-contrast paper. Since this relationship between the indicated exposure and the resulting print value is known and predictable, we use it to define the midpoint of the image-value scale: *a middle-gray print value that matches the 18 percent reflectance gray card is designated Value V.*

We further define the exposure reading taken from a single surface of the subject and used directly (i.e., without alteration) to produce this middle-gray print Value V as *Zone V exposure.* Thus, with a calibrated meter and the appropriate film speed, reading a single-luminance surface and using the indicated exposure is Zone V exposure for that surface; it produces a negative density we define as *negative density Value V* which in turn produces *print Value V.* Note that we use the term *zone* to refer only to the exposure scale, and *value* for the other concepts, specifically luminance values, negative density values, and print values. It is essential to remember the basic relationship: *if we take a reading from a single-luminance surface and use the indicated exposure settings, we are giving Zone V exposure for that surface, and anticipate a negative density Value V and a print Value V (middle gray) representing that surface.*

I want to point out that this print value is a specific gray that matches the 18 percent gray card, but the subject value represented by it in the final print is not fixed. The original surface we read with the meter can be white, black, or in between; making a meter reading from it and using that reading for exposure is defined as Zone V exposure, and will lead to a Value V middle gray that matches the gray card for the surface in the final print. As discussed earlier, ◁ this occurs because the meter must be calibrated on the assumption that it is reading an average-value surface. Thus we already have a procedure that will give us a known print value, and we can begin to visualize the result of Zone V exposure for any subject area.

See page 33

The Scale of Zones

At this point we have established the midpoint on a scale of exposures (Zone V), and negative values and print values (Value V). We also know from experience that reducing exposure will produce a darker print value, and increasing exposure will produce a lighter print value. To determine the remainder of the scale, then, *we define a one-stop exposure change as a change of one zone on the exposure scale, and the resulting gray in the print is considered one value higher or lower on the print scale.*

Thus, making a reading from a single-luminance surface and reducing the exposure by one stop gives *Zone IV exposure,* and yields print Value IV, which is darker than middle gray. Further reduction at one-stop intervals gives exposures of Zones III, II, I, and 0, with the corresponding darker tones in the print of Values III, II, I, and 0. (Each of these, of course, also has its corresponding negative-density

A B

Figure 4–2. *Peeling Paint.* The subject was light gray paint peeling from a medium-valued wood.

(A) An average exposure, used without compensation, produced a middle-gray value for the average luminance of wood and paint.

(B) By giving two stops more exposure, I achieved an image in which the paint and wood were rendered more nearly as seen. Zone System exposure procedures enable us to visualize the desired final values of the image and give exposure appropriate to achieve these values.

Figure 4–3. *Textured surface exposed on all zones.*

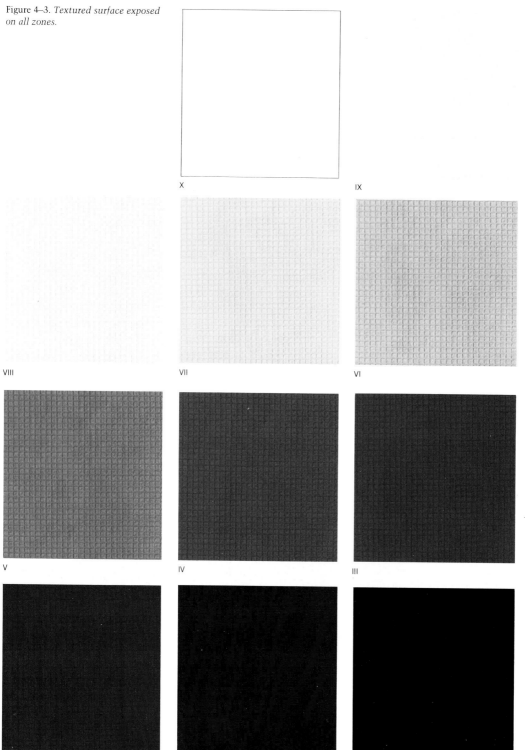

X

IX

VIII

VII

VI

V

IV

III

II

I

0

value as the intermediate step.) Similarly, if we increase the exposure one stop at a time from Zone V, we have Zones VI, VII, VIII, IX, and X.

If these concepts are new to you, I strongly urge you to make such a series of exposures, using either conventional film or Polaroid black-and-white print film (the scale will be somewhat different with Polaroid film, but will still give an indication of the relationship between exposure zones and print values). Take an evenly lighted, uniform surface and make a meter reading from it. A surface with slight texture, such as a concrete wall or a closely woven fabric, is ideal. Use whatever exposure is indicated to make one negative, thus giving Zone V exposure for that surface, and then reduce the exposure one stop at a time to make Zone IV, III, II, I, and 0 exposures on separate negatives. Then proceed with exposure increases at one-stop intervals to produce Zone VI, VII, VIII, IX, and X exposures. If the indicated "normal" exposure (Zone V exposure) is, for example, 1/30 at f/8, the sequence of other exposures could be as follows:

Zone IV	1/30 at f/11	Zone VI	1/30 at f/5.6
Zone III	1/30 at f/16	Zone VII	1/30 at f/4
Zone II	1/30 at f/22	Zone VIII	1/15 at f/4
Zone I	1/60 at f/22	Zone IX	1/8 at f/4
Zone 0	1/125 at f/22	Zone X	1/4 at f/4

(The actual sequence may have to be modified to fit the range of lens apertures and shutter speeds available, but always maintain the required one-stop intervals; be careful not to use long exposures which might be affected by the reciprocity effect, or high shutter speeds which may not be accurate.)

After developing the negatives, print the Zone V exposure to match the gray card precisely in value (the print must be dry before an accurate comparison can be made; I suggest viewing the print and card together with a #90 viewing filter). Then print all other negatives in exactly the same way, with the same exposure time and identical processing. The result will be a series of grays representing each value of the scale, and should extend from full black to pure white.

The actual values of the prints will depend on many factors, including the film and development, the paper and its development, the meter, etc., but they should approximate the full-scale progression. Do not be surprised if your first attempt does not produce the optimum scale, since testing is required to calibrate these procedures. ◁ You should refer to these prints in the discussion that follows.

See Appendix 1, page 239

DYNAMIC AND TEXTURAL RANGES

As discussed, the scale of print values is centered around Value V, which matches the 18 percent reflectance gray card. If you examine the darker print values below Value V, you should find that any texture and detail on the surface photographed is clearly visible in the Value IV and III prints. By Value II, a sense of "substance" and texture should remain. Value I is *nearly* full black, with almost no detail nor any real impression of substance, and Value 0 is the maximum black density possible with the paper used, showing no detail or texture. A similar progression occurs with the lighter values. Values VI and VII should show the texture and detail of the surface photographed. Value VIII is very light, with some slight texture and sense of substance, and Value IX is *nearly* pure white. Value X represents the pure white of the paper base, which like Value 0 shows no texture or substance whatever. Values 0 and X thus serve as key reference values, and are not truly "values" in the sense of conveying substance in the image.

It must be understood that these values are merely points on a continuous scale that ranges from full black to pure white. Each single value represents a range of grays slightly darker and slightly lighter, and the individual gray values produced in a sequence like this one are each the midpoint of their respective zones. If we wish to be very precise in our evaluations we can consider half zones and thirds of zones; one-third zone increments cannot always be set precisely on the aperture scale, but meter dials and film speed numbers use this interval, and it also relates to the logarithmic progressions of the exposure scale. ◁

See p 85–86

There are three important scales within the total range of exposures that can be printed. The full range from black to white is represented by Zones O to X. Within this lies the *dynamic range*, representing the first useful values above Zone 0 and below Zone X, or Zones I to IX. The range of zones which convey definite qualities of texture and the recognition of substance is the *textural range*, from Zones II to VIII. Thus:

On this scale I consider the negative density obtained from a Zone I exposure the lowest *useful* density; lower densities can be mea-

See page 85

sured with a densitometer, ◁ but have no significance in practical work. Similarly, the densities relating to exposures above Zone IX can be recorded, and in fact, considerable separation may exist *on the negative* for Zones X, XI, XII, and even higher. These extreme high values may require special negative processing and printing procedures to be brought into the scale of the print; with normal handling they will not be represented. The eye seems more responsive to subtle differences in the nearly white values than in the very dark ones. Depending on the film characteristics, however, the separation in values exposed above about Zone IX or X may be lost and processing control may not be effective; if printed lower than pure white, a degraded gray value without texture may result. For the moment we will limit our discussion to the normal dynamic range.

THE FULL-SCALE SUBJECT

In practical photography our subject is not a single-luminance surface photographed at different exposures, but is made up of a range of luminances within a single scene. A "light" area implies more exposure to the portion of the film recording it than a "dark" area. By measuring the individual luminances within a scene and comparing the readings with the scales of zones and print values, we can evaluate such a subject in terms of its projected rendering in the final print. I think it is appropriate to repeat that, while this process must be described in "step-by-step" fashion here, it resolves itself with practice into a swift, intuitive procedure that relates the considerations of exposure and processing at the time of visualization.

See pages 42–43

Before discussing luminance readings further, I must also say that I find that the exposure meter confuses many photographers of all levels of proficiency. Manufacturers have favored "fail-safe" policies in design and function, including biased calibration of the meter ◁ to compensate for our supposed tendency to misuse it, and automation of functions that can be performed as well or better manually with a certain measure of thought and understanding. Automation may have advantages for superficial work, but it creates difficulties when the serious student and photographer try to get at the heart of the process. At this point, however, we are concerned with the basic functions of the meter in terms of relative values, and most reflected-light meters (particularly spot meters) should be applicable to these

See Appendix 1, page 239

procedures without undue difficulty. In the course of testing, ◁ we can usually overcome any bias or mechanical "aid" that interferes with our use of the meter, although it seems regrettable that we should have to do so.

What is required of the meter is to be able to use it to read individual luminances within the subject and relate the differences in luminance to one-stop exposure intervals. If, for example, the meter indicates that one part of the subject has twice the luminance of another (whether indicated directly in candles-per-square-foot, in arbitrary arithmetic scale numbers, or by a one-stop difference in the indicated exposure), we know that this surface will be one *zone* higher on the exposure scale, and should appear one *value* lighter in the final print. This will be true whatever the actual exposure of the

Figure 4–4. *Silverton, Colorado.* The print values are shown on the scale. The photograph was taken into the sun, and the maximum luminance was the glare from the roofs on the left. These approach Value X in the print, and were above Zone X on the exposure scale. The lowest value on the shadowed fence (about 8 c/ft²) was on Zone II. (In addition, I used a #12 filter to lower the shadow values and help clear the atmospheric haze, as discussed in the next chapter. The filter also raised the value of the autumn foliage.) I used an 8 × 10 view camera and Kodak 10-inch Wide-Field Ektar lens.

negative is; if one part of the subject has twice the luminance of another, it *must* give one zone more exposure to the part of the negative recording it. A different part of the subject that has one-quarter the luminance of the first will similarly be two zones lower on the exposure scale, and will appear about two values darker on the print. We can thus relate the luminances within a single full-range subject to the exposure and print scales:

subject luminances (exposure units):	½	1	2	4	8	16	32	64	128	256	512
exposure zones:	(0)	I	II	III	IV	V	VI	VII	VIII	IX	(X)

this produces negative density values, which lead to

print values:	(0)	I	II	III	IV	V	VI	VII	VIII	IX	(X)

The subject luminances in this chart are given in terms of "units of exposure" that have no absolute value but express the 1:2 relationship from one exposure zone to the next. We start from the lowest zone we are considering (in this case, Zone I), and call that *one unit* of exposure. We can then double this for each higher zone, because of their one-stop intervals, to see the *relative* exposures of each zone. This provides a convenient way to compute the effective luminance ratio for any two subject areas: merely divide the greater number of units by the smaller. Thus the ratio from Zone II (2 units) to Zone VIII (128 units) is simply 1 to 64.

In practice we more often use the luminance values read from the exposure meter in establishing the relationship of subject values – exposure zones – print values. Consider a hypothetical subject that includes a gray card, where the gray card reads 12 on the meter scale. If we set this number on the meter calculator dial to determine exposure, we know that the gray card should reproduce as a negative density Value V and a middle gray Value V in the normal print.

Since the meter is calibrated in one-stop increments, we then also know that a subject area that reads 10, for example, will give two stops *less* exposure to that part of the film recording it than the area reading 12; we thus know that this area, and any others we may find that read 10, will be exposed on Zone III, and we can anticipate that they will appear as a Value III in the print. Similarly, an area reading 15, or three stops above the luminance value of middle gray, is exposed on Zone VIII, and will normally yield a Value VIII on the print.

A

B

C

D

Figure 4–5. *House, Pescadero, California.* These four images show the overall effect of successive one-zone exposure increases.

(A) The shadowed area near the door on the left was placed on Zone II. The white painted surfaces in sunlight then fell on Zone VII. Note the gray card at the lower left; at this exposure the gray card luminance fell on Zone V, and is reproduced in the print as a middle gray. Part of the white wall in shadow also fell on Zone V.

(B) Increasing the exposure by one stop, or one zone, produces a one-value increase for each subject area. The shadow near the door is now a Value III, and the white wood in sun is Value VIII.

(C) A further one-zone exposure increase raises the shadow area near the door to Value IV, and the white painted wood in sun to Value IX. It is nearly pure white in the print, with just a trace of tonality showing.

(D) After another one-zone exposure increase, the shadow area near the door is a Value V; note that it matches the gray card in example A. The white wood is now Value X, pure white.

To relate these numbers from the arithmetic meter scale to the scale of zones:

exposure zones:	(0)	I	II	III	IV	V	VI	VII	VIII	IX	(X)
meter scale numbers:			**10**		**12**				**15**		

And, because we know that each meter scale number relates to a one-zone interval, we can fill in the other numbers as they relate to the zones:

exposure zones:	(0)	I	II	III	IV	V	VI	VII	VIII	IX	(X)	
meter scale numbers:		7	8	9	**10**	11	**12**	13	14	**15**	16	17

The advantage of being able to relate subject luminances to print values should be obvious: if we know what Value III, Value V, and Value VIII look like or "feel like" in a print, we can view this subject and anticipate the appearance of these three important areas in the final rendering. We can then also scan the subject with our meter and check the exposure of other important areas. Any area we find that reads 13, for example, will be exposed on Zone VI, 14 on Zone VII, 8 on Zone I, etc.

Place and Fall

What we have actually done in the foregoing example is to make an initial decision regarding one subject luminance, and then determine the other subject luminances and their corresponding exposure zones. In Zone System terms, we say that we first *placed* the luminance of the middle-gray subject area on Zone V of the exposure scale, and the other luminances then *fell* on other zones. In nearly all cases using the Zone System, we follow this procedure; we place one luminance on a specific exposure zone and then observe where other subject luminances fall.

By placing one luminance on a particular zone we determine the exposure settings of the camera, and we have no control over the exposure of other luminances of the subject; they fall elsewhere on the exposure scale according to the one-stop (1:2) luminance ratio described. In our example, we first read the luminance of the gray card (12) and placed that value on Zone V. Having done this, the dark area which read 10 *must* fall on Zone III, since its luminance is two

A B C

A B C

stops, or two *zones*, lower on the scale. Similarly, the area reading 15 also *must* fall on Zone VIII. The results are shown below:

zones:	I	II	III	IV	V	VI	VII	VIII	IX
meter scale numbers:	8	9	**10**	11	**12**	13	14	**15**	16

gray card
reading *placed*
on Zone V

dark area
must *fall*
on Zone III

light area
must *fall*
on Zone VIII

◄ Figure 4–6. *Adobe House with Chimney, Monterey, California.* This was a fairly long-scale subject, photographed at three exposures as follows:

 (A) The chimney was placed on Zone V, and the trees in the upper left fell on Zone II.

 (B) With the chimney placed on Zone VI, the trees fell on Zone III.

 (C) With the chimney on Zone VII, the trees fell on Zone IV. The illumination was slightly hazy sunlight. The shadows of the adobe wall are about Values III, IV, and V.

The result is exactly as described earlier, but note that it is the placement of a single luminance (12) on a specific zone (V) that determines how all the subject luminances are exposed.

In the subject cited it is logical to assume that we will want the gray card to reproduce as a middle gray in the print. But it must be understood that we are under no restriction regarding this placement. If we chose for some reason to render it darker than middle gray, we might place its luminance on Zone IV. It and all other subject areas would then be one zone lower in exposure, and one value darker in the print, as follows:

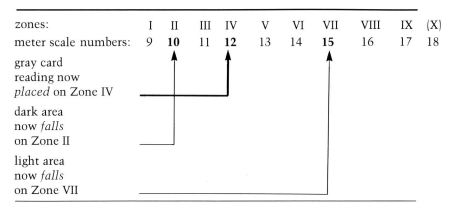

◄ Figure 4–7. *Gravestone Detail, San Juan Bautista, California.* The subject was in direct sun at about 45° and showed considerable contrast as the lichens, especially in shadow, were very dark in relation to the white marble.

 (A) With the average luminance placed on Zone V, the marble itself was about Zone VI.

 (B) With the average on Zone VI, the marble in sun fell about on Zone VII, but there is still little value or texture in the dark shadowed lichen.

 (C) The average placed on Zone VII shows more texture in the shadowed lichen.

Rather than use an average reading, my normal procedure would be to use a spot meter to expose for the shadowed lichen. If the lichen were placed on Zone III the marble would have fallen about on Zone VII½, and would then have approximated the desired value. Placing the lichen on Zone II would have meant the marble would fall on Zone VI½. With such subjects it is sometimes helpful to use a white card to reflect additional light into the shadow areas to reduce the subject contrast, although that was not done here. The gravestone itself is an interesting piece of early California carving; the proportions of the child figure, and the disparate scale of the hand in relation to it, have almost surrealistic overtones.

Thus the essential rule: *we can place any one luminance value on any zone of the exposure scale, and doing so will determine the camera exposure.* We can then read other luminances of the subject, and *these will fall elsewhere on the scale of zones, with each one-stop or 1:2 luminance change representing a one-zone difference.*

It should be clear by now that establishing these relationships between subject luminances and print values enables us to anticipate (visualize) from the luminance readings the way each area will be rendered in terms of the image values. If you have made the exposure series I recommended earlier, you will have a good first impression of the appearance of each of the print values. Table 2 gives the approximate values for various types of subjects rendered "realistically." I would like to emphasize again, however, that one of the great advantages of the Zone System is that it does not require a literal rendering, and we are entirely free to depart from the descriptions in the chart as our visualization demands.

Table 2. *Description of Zones.*

Value Range	Zone	Description
Low Values	Zone 0	Total black in print. No useful density in the negative other than filmbase-plus-fog.
	Zone I	Effective threshold. First step above complete black in print, with slight tonality but no texture.
	Zone II	First suggestion of texture. Deep tonalities, representing the darkest part of the image in which some slight detail is required.
	Zone III	Average dark materials and low values showing adequate texture.
Middle Values	Zone IV	Average dark foliage, dark stone, or landscape shadow. Normal shadow value for Caucasian skin portraits in sunlight.
	Zone V	Middle gray (18% reflectance). Clear north sky as rendered by panchromatic film, dark skin, gray stone, average weathered wood.
	Zone VI	Average Caucasian skin value in sunlight, diffuse skylight or artificial light. Light stone, shadows on snow in sunlit landscapes, clear north sky on panchromatic film with light blue filter.
High Values	Zone VII	Very light skin, light gray objects; average snow with acute side lighting.
	Zone VIII	Whites with texture and delicate values; textured snow; highlights on Caucasian skin.
	Zone IX	White without texture approaching pure white, thus comparable to Zone I in its slight tonality without true texture. Snow in flat sunlight. With small-format negatives printed with condenser enlarger, Zone IX may print as pure white not distinguishable from Zone X.
	Zone X	Pure white of the printing paper base; specular glare or light sources in the picture area.

ZONE SYSTEM EXPOSURE

The Initial Placement

See pages 36-37

Since the camera exposure settings are determined by the decision to place one luminance on a certain zone, this choice must be made with care. As mentioned in Chapter 3, ◁ the most serious error in exposure is giving too little exposure, because detail is thereby lost in shadow areas that cannot be recovered through any processing or subsequent manipulation. For most photographs, therefore, we make the initial placement based on *the darkest area of the subject where we want to preserve detail in the image.* From Table 2 you will note that the darkest exposure zone that preserves some subject texture is Zone II, and full detail is visible in Zone III. Therefore, it is usually best to *place the luminance of an important dark area where minimum effective texture is desired on Zone II, or an area where full detail is required on Zone III* (using the procedure described below). In this way we are able to examine the subject for the darkest area where texture or detail is required, and ensure that we give these areas sufficient exposure.

If we are to make the critical placement decision appropriately, we must visualize its effect. With a dark area of the subject where only minimum texture is required, Zone II placement may be the logical choice. We may find on consideration, however, that we really want the additional detail of Zone III placement. As we learn to recognize these values in our mind we can make such choices almost automatically, thus becoming quite fluent in our application of the Zone System procedures.

These placements should be considered guidelines. Cases will arise where we do not make our initial placement on these low zones, but we will then almost always at least check to see what luminance falls on these low zones, since any luminance that is allowed to fall lower than Zone II will be recorded without useful detail in the negative. In other cases the subject may require Zone IV placement of an important shadow area to yield much fuller and more luminous detail; I have even placed shadow values as high as Zone V to obtain certain effects of great luminosity, and then re-

See Chapter 10

sorted to development control ◁ to hold the rest of the subject luminance scale within the range of printable densities. Experience is required to make such judgments effectively.

Once the decision has been made regarding the low-value placement, we must measure the other important luminances of the subject and see where they *fall* on the exposure scale. If there are darker areas of the subject that fall below Zone II, they will be full black,

or nearly so, in the print, and we must decide if this is appropriate. Most photographs benefit from having a few very deep values (Values 0 and I), but such areas must usually be small, since a large mass of deep black without detail can be visually distracting. We should remember that we can "print down" a low textured value on the negative (Value III, for example) to make it appear darker than usual, or even full black; but we cannot "print up" a textureless area (Value 0 or I) and make it appear anything more than a blank dark gray value in the print.

Similarly, light areas that require convincing rendition of texture should not, if possible, fall above Zone VII to VIII, although this is somewhat less critical than the loss of detail that begins to occur with exposure below Zone III. Most films today can maintain separation and detail through Zones IX, X, or even higher, and this detail See Chapter 10 can be printed if we modify the development of the negative ◁ or See Book 3 through manipulation during printing. ◁ We can thus be somewhat less concerned about high values that fall above Zone VIII than with dark areas below Zone II where no processing steps will restore detail. For purposes of learning the Zone System, however, it is best to assume that full detail is present only through Zone VII, and some texture through Zone VIII, based on "normal" paper grade and de- See Appendix 1, page 239 velopment (which are established through testing). ◁

Reading the Meter in Zones

The specific procedure for placing one luminance on an exposure zone can be understood by recalling our discussion of middle gray. ◁ See page 48 If a luminance is read by the meter and that reading used to determine camera exposure without alteration, we have placed the luminance on Zone V. If, instead, we give one stop less exposure, we are placing the luminance on Zone IV, and if we give two stops less exposure, we are placing the luminance on Zone III. Similarly, giving one stop more than Zone V exposure is Zone VI exposure, and two stops more is Zone VII exposure. The specific procedure can be most easily applied if we consider the scale of values on an exposure meter dial.

See pages 30–31 As discussed earlier, ◁ most meters today use an arbitrary scale of numbers to represent luminance values, with each interval of *one* on the scale equal to a doubling or halving of luminance, or a one-stop exposure change. The number read from the meter is transferred to a rotating calculator dial on the meter which, taking into account the film speed, relates the scale numbers to exposure settings in

Figure 4–8. *Exposure Zones on the meter dial.*

(A) The dial of the Pentax 1° digital spot meter permits addition of a scale of zones for determining exposure. The setting shown corresponds to a Zone V placement of a subject area that reads 9 on the meter scale. It is also correct for placing 7 on Zone III, as described in the text.

(B) With a "null" meter like the Luna-Pro SBC, the "0" position shown represents Zone V placement of the luminance read by the meter. The marks to the *left* of the 0 represent successively lower zones (less exposure), and marks to the *right* of 0 represent higher zones (more exposure).

A B

f-stops and shutter speeds. Meters which function in this manner include the Pentax 1° spot meters (both conventional and digital), the Soligor Spot Meter, the Gossen Luna-Pro (though not the Luna-Pro SBC), and many others. The important point to understand is that the arrow or index mark on the rotating dial corresponds to Zone V exposure; *any luminance read from the meter scale and set opposite this index mark is given Zone V exposure.*

Thus if a subject area reads 7 on the meter and you align this value opposite the index mark, you have placed it on Zone V. If, instead, you want the area reading 7 placed on Zone III, then you know that 8 must fall on Zone IV and 9 falls on Zone V; aligning 9 opposite the index point has the effect of placing 7 on Zone III. You can then determine the zones on which all other luminances fall, as follows:

zones:	(0)	I	II	III	IV	V	VI	VII	VIII	IX	(X)
meter scale numbers:	4	5	6	7	8	9	10	11	12	13	14

The mental process of placing the reading 7 on Zone III would be something like this: First align 7 opposite the index mark and think, "That's Zone V placement." Then turn the dial so 8 is opposite the index mark; "That's Zone IV placement (for 7)." Then again turn the dial so that 9 is opposite the mark; "That's Zone III placement (for

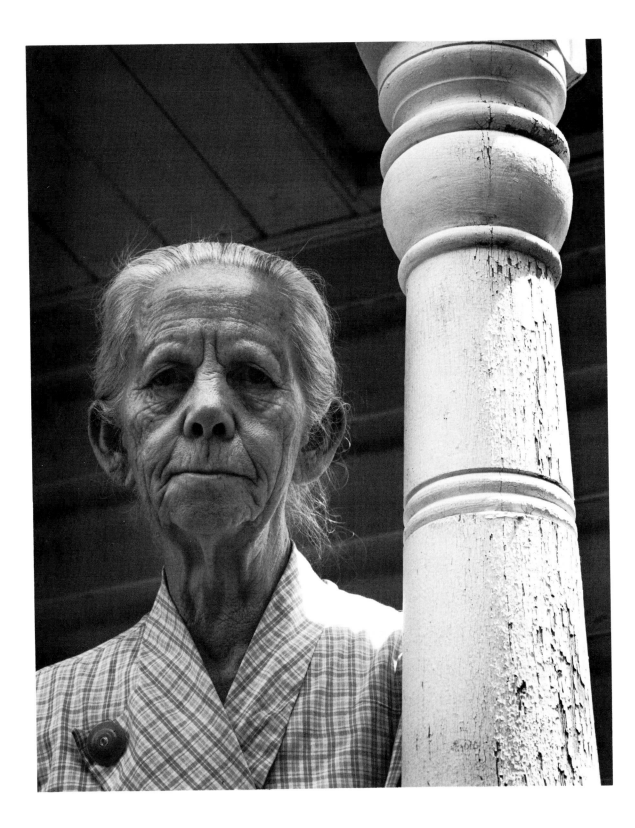

Figure 4–9. *Martha Porter, Pioneer Woman, Orderville, Utah.* The average of the face was placed on Zone V and the luminance of the white post fell on Zones VII, VIII, and IX. I placed the face on Zone V rather than VI because I did not want to overexpose the white pillar and achieve blank areas which I could not control in printing. The shaft of direct sun on her shoulder was on or above Zone IX. This 1960 film had a rather abrupt shoulder, and this sunlit area is thoroughly blocked and lacking in detail. All efforts to print it down result in a gray textureless area. While disturbing to me, I would rather see it blank white than empty dismal gray! The camera was a Hasselblad 500C with a 120mm lens and Kodak Tri-X roll film.

See Figure 4–8(A)

See Figure 4–8(B)

7)." The exposure settings now indicated on the dial are correct for Zone III placement of the reading 7.

It is often possible to attach a printed zone scale to the dial to make it possible to see graphically the place-fall relationships (although some meter designs, such as the Luna-Pro, do not readily permit attaching a separate scale.) With a zone scale on the meter we can read a subject area and simply align its numerical value opposite the desired zone, thus placing that luminance on the indicated zone. Once this initial placement has been made, other luminances can be read and the exposure zone on which they fall will be clearly visible on the scale. ◁ This clear visual representation is probably the most easily grasped for someone learning the Zone System and I recommend using such a scale where possible if these concepts are not fully understood. If you attach a zone scale to your meter, remember that Zone V of the scale must be carefully aligned with the meter's index mark or arrow. Zone scales may be constructed, or purchased from suppliers like Zone VI Studios in Vermont.

A few meters, such as the Luna-Pro SBC and the S.E.I. photometer, operate on the "null" principle instead of using a numerical scale. ◁ With such a meter, you make a reading by pointing it at a subject area and turning the dial until the meter pointer aligns with a zero mark at the middle of a scale, and then read f-stops and shutter speeds directly. The null point here is equivalent to Zone V exposure, so that other zone placements can be easily worked out. With the

Figure 4–10. *Exposure Record Form.* The form shown is for recording a single exposure, with separate lines for up to four notations of subject values. It also clearly shows the relationship of ASA speed, subject luminance (in c/ft^2), lens stop, and shutter speed, conforming with the Exposure Formula. A larger form, which appears on page 265, contains 12 lines for recording the exposures of one 120 roll of film, or 12 sheets. You may photocopy these for your own use. (designed by Ted Orland)

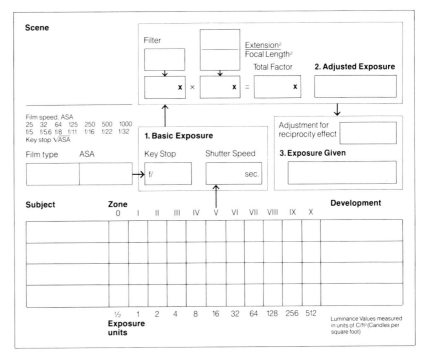

Luna-Pro SBC, for example, there are three marks at one-stop intervals on either side of the null point (marked "0"), and these each represent one-zone exposure changes. Thus once we have made a reading with this meter, rotating the dial until the pointer is one mark to the *left* of the zero places the luminance on Zone IV; one mark to the *right* of zero is Zone VI, and so forth, and the appropriate exposure appears on the dial.

The Exposure Formula

A formula exists which, once learned, facilitates rapid exposure calculation mentally, without the need for setting dials on meters. It requires knowing luminance values in candles-per-square-foot, and unfortunately few, if any, meters today are calibrated in these units. Since the early Weston Master meters read directly in c/ft^2, very rapid exposure determination was possible. Current meters can usually be calibrated in these units to facilitate the use of the exposure formula, as described below.

To use the Exposure Formula, take the film speed number (on the ASA scale) and determine its approximate square root. This number is remembered as the *key stop* for that film. For example, a film rated as ASA 125 has a key stop of f/11.

At the key stop, the correct shutter speed in seconds to expose a given luminance on Zone V is the reciprocal of the luminance expressed in c/ft^2. Thus for a surface that measures 60 c/ft^2, we would use a shutter speed of 1/60 second at the key stop.

In a typical situation, I might visualize a certain area as a Value III in the print and find that its luminance is 30 c/ft^2. If this is placed on Zone III, then 60 c/ft^2 falls on Zone IV and 120 c/ft^2 falls on Zone V. My exposure then is 1/125 second at the key stop, or any equivalent combination. The Exposure Formula thus permits very rapid calculation of exposure without reference to the meter's rotating dial.

Note that this formula also permits us to calibrate meters with arithmetic scales in units of candles-per-square-foot. For example, if we set 10 on the meter dial and the resulting indicated exposure at the key stop for the film speed is 1/10 second, then we know that any surface that reads 10 is reflecting 10 c/ft^2 (this is the calibration of the Pentax spot meter and some others). We can then establish the equivalent values in candles-per-square-foot for the other index numbers: 11 would be 20 c/ft^2, 12 would be 40 c/ft^2, 9 would be 5 c/ft^2, etc. One caution: if your meter includes a K factor you must eliminate its effect by using an adjusted film speed, determined by

See Appendix 1, page 239

appropriate testing. ◁ If the K factor requires us to change the film speed setting on the meter from ASA 64 to 80, for example, we should still *think* ASA 64 when using the Exposure Formula. Once we have determined the luminance in candles-per-square-foot for the index numbers of our meter, these can be written out and taped to the meter body for reference.

See Figure 4–10 and page 265

Exposure Record. I would like to recommend the use of the Exposure Record form, or any similar system for recording the luminances, place-fall relationships, processing instructions and other data. Two versions of the Exposure Record are shown, ◁ and you may photocopy them for your own use. This form is a most helpful "diagnostic" reference. If you find yourself in the field without exposure record forms, at least try to note down the luminances and zone relationships, or make a rough sketch of the subject with luminances marked on it. Much can be learned by referring to such records after making a print, to see how the subject luminances translate to print values and as a diagnostic check of the meter performance and exposure method, etc.

SUBJECT CONTRAST

Let us consider three basic conditions of subject contrast in Zone System terms, to be sure the concepts are understood and to briefly explore the implications:

1. Figure 4–11 shows a "normal" range subject. When a reading from the important shadow area (7) is placed on Zone III, the middle-gray value (9) falls on Zone V, and the light surface (11) on Zone VII. The very deep shadow areas and bright highlights that fall outside this range from Zone III through Zone VII are small and do not require detail, but lend a sense of richness to the image. (Specular highlights and glare are many times brighter than diffuse surfaces under the same illumination; they are consequently full white in the image and approach the maximum density possible in the negative.) Thus the exposure indicated for this placement will yield a full-range negative, and detail will be preserved in all important areas since they fall in the range of Zones III through VII.

2. A short-scale subject is shown in Figure 4–12. Reading the important shadow area (4) and placing it on Zone III means that the lightest important luminance (7) falls only on Zone VI. This is a flat, low-contrast subject that uses less than the full scale of zones. We

Figure 4–11. *Normal range subject.* The luminances and meter settings are described in the text. This print and the two that follow are unmanipulated "literal" recordings of the subject values.

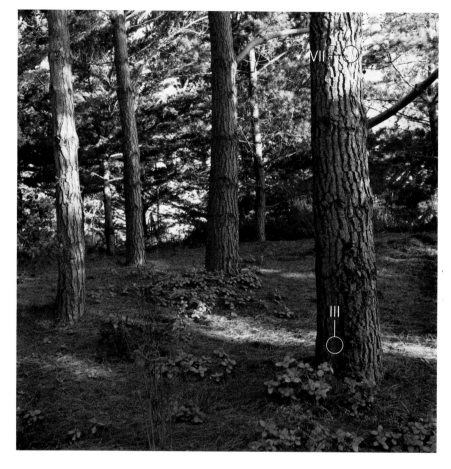

See Appendix 1, page 239

might wonder in this case whether to proceed with the exposure indicated by the Zone III placement for the shadow area, or to give more exposure to raise the high value. The latter approach might involve giving one stop more exposure overall, making the shadow area fall on Zone IV and the high value on Zone VII. The *range* of values would remain the same. A different visualization is called for in each situation, and we may make our choice based on our preferred concept of the final image. It should be noted, however, that in terms of information on the negative there is nothing gained by giving the additional exposure. Even with the lower exposure that results from placing the important shadow on Zone III and letting the high value fall on Zone VI, we will be sure of recording full detail for all important areas of the subject (assuming our exposure-development system has been tested ◁), and we will be able to adjust values if necessary in processing. Therefore, in the absence of compelling reason to give the additional one stop of exposure, use the Zone III placement of the shadow area; the resulting negative will

Figure 4–12. *Short-scale subject.* (See text.)

See Chapter 10, and Book 3

have less grain and higher acutance since there is no "wasted" density, and will still have full detail in the important areas. We probably will not want the light area of the subject to print as low as Value VI, however, and we may apply development and printing procedures described later ◁ to raise this value and achieve optimum contrast.

The short-scale subject is obviously the least critical exposure condition. We can conceivably expose the shadow area on Zone III, IV, or even V, and the other values still fall within the range where detail or substance is recorded. This is actually what is meant by the often-misunderstood term "exposure latitude." The film has a long enough scale to tolerate several different exposures of such a flat scene without sacrificing detail and separation of values, and therefore has some "latitude" for exposure variation or error. Note, however, that as the subject contrast range increases, more of the scale is used, and the latitude diminishes. With the full-range subject cited in Example 1, a one-stop exposure change from the one used would have caused a loss of information in either the high or low values. Latitude, there-

Figure 4–13. *High-contrast subject.* (See text.)

fore, is a function of subject luminance range in combination with a film's characteristic scale, and must not be taken for granted as a margin for error built into every film. Let me repeat that the optimum image quality will be obtained for all values using the *minimum exposure consistent with securing desired shadow detail.*

3. Figure 4–13 shows a long-scale or contrasty subject. If we make an initial placement of the important shadow area (which reads 8⅓ in this case) on Zone III, the light areas (14⅓) fall on Zone IX, and will normally print with no detail. Subjects of even longer range may occasionally be encountered, extending to Zone XII or even higher. In such cases the photographer should first reconsider the visualization: can the shadow area be exposed lower than Zone III without spoiling the image? If so, the high values will fall lower on the scale and will be easier to control. However, if the shadow area is truly important to the image, placing it below Zone III will sacrifice some detail and may not be acceptable. In the example shown, the full detail was considered essential and Zone III placement main-

tained. The high values must then be controlled using reduced development of the negative, as discussed in the section that follows, or through other means. There is really no "latitude" in such situations, since an error on the side of underexposure will jeopardize the shadow detail, and any overexposure will make the high values more difficult to control.

EXPANSION AND CONTRACTION

Our discussion of the Zone System so far has related the different subject luminance ranges to a scale of image values that we have considered fixed, based on *normal* development of the negative. By departing from standard development, however, we can adjust the negative scale, within limits, to achieve a range of densities that compensates for long or short subject luminance scales. It must be noted that the current films have somewhat more limited capacity for contrast control through extended or reduced development than the films in use when I first formulated the Zone System over forty years ago. Modification of development remains a valuable means of controlling contrast, however, even if it is now often necessary to combine it with other methods applied both to the negative and in printing to achieve visualized results.

The general rule of controlled development is that *increasing the amount of development increases the contrast of the negative, and reducing development reduces contrast.* This occurs because all areas of the negative are not equally affected by a change in development time: the higher negative densities (representing high subject and print values) are affected *more* than the low-density areas (around Zone III and lower). ◁ Thus the density *difference* between the high and low zones can be increased or decreased by altering the amount of development. ◁

See Figure 4–14

See pages 90–93

In practice, we usually keep the developer strength, temperature, and agitation constant, and then control the amount of development by an increase or decrease in development *time.* The objective is to achieve a negative of optimum density range, which will print with the desired scale of values on a normal paper, even though the subject may have had a shorter or longer than normal range of luminances.

Increasing contrast through extended development is referred to as *expansion,* and lowering contrast by reduced development is called *contraction.* It is most useful to visualize and express the amount of expansion or contraction in zones: a negative that was exposed to a five-zone range of subject luminances can be made to

print with a range of six values by expanded development. Such a negative is said to have been expanded by one zone, designated Normal-Plus, or N + 1 development. If the meter indicates a subject range of Zones III to VII, for example, N + 1 development will produce a negative-density range that will print as Values III to VIII. Given even more development, it might print as Values III to IX, a two-zone expansion, or N + 2 (although not all current films permit N + 2 development). With a long-scale subject, on the other hand, a negative exposed to Zones II to IX will yield print Values II to VIII if given N − 1 development, or II to VII with N − 2. There are certain practical limitations to both expansion and contraction, discussed below. ◁

See pages 80–83

It is important to understand that the primary effect of expansion or contraction is in the higher values, with much less alteration of low values. This fact leads to an important principle underlying exposure and development control: *the low values (shadow areas) are controlled primarily by exposure, while the high values (light areas) are controlled by both exposure and development.* Hence the im-

Figure 4–14. *Effect of expansion and contraction.* The arrows suggest the effect at each value of expansion and contraction. For example, a subject area exposed on Zone IX and given N–1 development results in a Value VIII in the final print. Changes in development have the most pronounced effect on high values, and relatively little effect on low values, as shown.

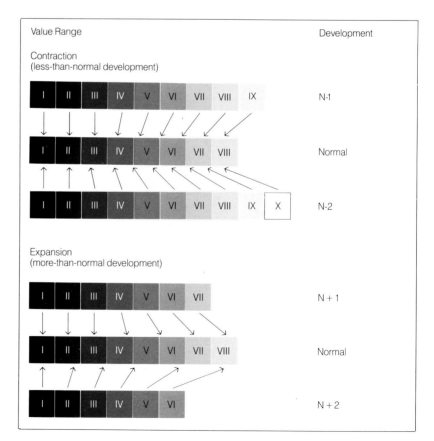

Figure 4–15. *Leaf, Glacier Bay National Monument, Alaska.* This was a low-contrast subject in soft light. The leaf was a pale gray-green, one of a complex mass of foliage which was difficult to isolate and compose. The deep shadows in the foliage were placed on Zones I and II, and the leaf value fell on Zone V. N + 2 development was given, which served not only to separate the leaf from the background but also to accentuate the detail of the leaf structure. The background shadows are printed down a bit for aesthetic effect. A normal "realistic" interpretation of this subject would be quite drab.

Figure 4–16. *Fence Detail, Monterey, California.* This is a good example of the effects of severely reduced development (N-3).

(A) The luminance of the shadowed fence posts was placed on Zone II, and the high values on the hinged storage bin fell on Zone VIII. The values are acceptable at the "informative" level, but better representation of texture was required. The exposure range from Zone II to VIII is 1:64. The negative received normal development, and the print was made on a normal grade paper.

(B) With the shadowed fence posts placed two zones higher (on Zone IV), development given was N − 3. The values are considerably compressed, and texture is clearly apparent in the sunlit wood. The shadow values are substantial, and the entire scale is much more informative than in Example A.

In most such cases, I prefer the two-solution development method (see pages 229–232) to N − 3 development, with increased exposure as given in B. The use of highly dilute developers can also give favorable compensating results.

A

B

portance of careful placement of important low subject values on the appropriate exposure zones: the high values can be further controlled through expansion and contraction while the low values, in practical terms, cannot. This is really only a re-statement of the old maxim in photography, "expose for the shadows and develop for the high values." By applying Zone System methods, it becomes possible to use this principle in a controlled way with predictable results.

For example, consider a high-contrast subject. With the important shadow area (reading, say, 6 in this case) placed on Zone III, the

◄ Figure 4–17. *Glacier Polish, Yosemite National Park.* The negative was given N – 1 development, since subject luminances extended from Zones I to X and higher. The circled areas indicate the print values of various areas. The high values were affected by the reduced development, so that the area shown as a Value VII, for example, was exposed on Zone VIII and lowered by one value in development. The luminance readings were made with a Weston Master III meter with a tube over the cell, this tube reduced its angle of view to about 10°, and reduced the sensitivity to about one-fourth its original level, which was adequate in normal daylight.

textured high value (12) falls on Zone IX, too high to retain important texture in a normal print. We could reduce exposure to bring down the high value, but would lose detail in the shadow area by so doing. Instead, we keep the original exposure and give N – 1 development. The low value then retains its detail while the shorter scale of the negative means the high value will now print as about Value VIII instead of IX, with more convincing texture and subtle high-value differences. Depending on our visualization and the limits of the film-developer combination, we might attempt to give N – 2 development to bring the high value down to Value VII for even greater detail.

With a subject of low contrast, the situation is reversed. We might

Figure 4–18. *Maynard Dixon, Artist, Tucson, Arizona.* I used bright sunlight to make this outdoor portrait. I placed the left side of his face on Zone VI½, and the right side fell on Zone V. The high values of the skull fell on Zone VIII, and those of the jacket on Zone VIII½. The recessed background in deep shade fell on Zones I, II, and III. The shadowed side of his face was illuminated by bright diffused light reflected from the environment of wall and ground. Development was N – 1.

One zone less exposure would have been quite satisfactory as far as the higher values were concerned (and normal development would be indicated), but the shadow values would have been "empty." The reader should visualize for himself how more or less exposure would have altered the tonal relationships of the image.

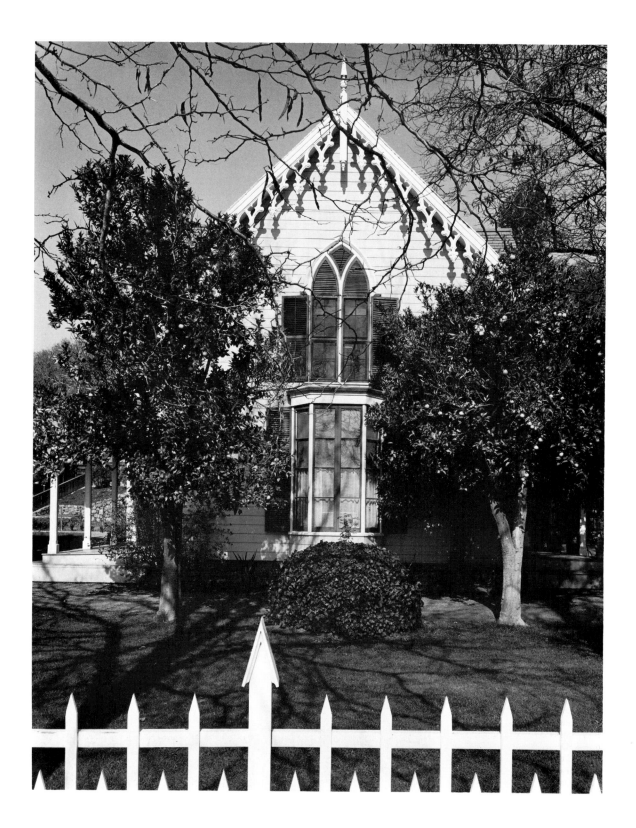

Figure 4–19. *General Vallejo's Home, Vallejo, California.* The camera was obviously quite accurately adjusted: the back was precisely vertical and the focus adjusted by a slight tilt of the lens. The focus point was about one-third the distance from the fence to the building facade, and a small lens stop was used. The shadows on the house under the tree at right were placed on Zone II and the sunlit house fell on Zone IX; development was N – 1. As we will see in Book 3, images of this kind, with deep shadows and strong high values, are often difficult to print even with controlled negative development. Such values can be almost impossible to reproduce with the usual engraving methods.

find, for example, that optimum shadow placement provides high values that fall only on Zone VI. N + 1 development would raise those areas to Zone VII density, and N + 2, if feasible, would provide about Zone VIII density.

These and other possibilities can be visualized at the time the initial exposure measurements are made. The result is that the essential decisions regarding exposure and development can all be made before the negative is exposed, with specific reference to the personally conceived final image. We plan a certain exposure placement of the low values, adequate to ensure that detail is recorded where desired, and anticipate processing that will adjust the high values as needed to obtain the visualized print.

Figure 4–20. *Stone and Wood, Old Barn, Santa Cruz, California.* This is an exercise in textural control. The darkest textured shadow (not the apertures between boards, but the obviously illuminated surfaces) was placed on Zone II. The stone, actually lower in value than the photograph suggests, measured 250 c/ft^2 and fell on Zone VI. Development was N + 1; this elevated the value of the sunlit wood and raised the stone to a Value VII. Texture is maintained and emphasized in all areas.

Figure 4–21. *Dogwood Blossoms, Yosemite National Park.* Lighting was from the open sky only. The "flowers" are a waxy white, and it is difficult to hold subtle values. They were placed on Zone VI½, and N + 1 development was given the negative. The dark background rock and leaves fell mostly on Zones II and III, with some of the rock and foliage approaching Zone V. As we will discuss in Book 3, this negative is printed in somewhat lower values for reproduction than for visual appreciation to hold subtle values in the whites. I used a 5 × 7 camera and a 7-inch Zeiss-Goerz Dagor lens.

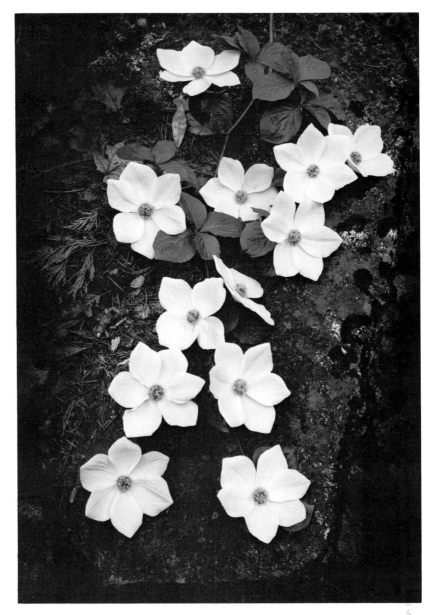

In practice it will be found that while development modification has its primary effect in the high values, it does also cause some slight density change in the shadow areas. With contractions, the decreased development time causes a slight loss of density (and contrast) in the low values, and a small additional exposure should be given to compensate. For most films and developers, a 1/3 to 1/2 stop increase should be sufficient, unless testing indicates otherwise. Similarly, with expanded development, it is possible to reduce the

exposure slightly since the low densities are somewhat strengthened by the increased developing time.*

We have not yet specified the meaning of "normal" development, or N + 1, N − 1, etc. Testing is required to establish, first, the optimum film speed rating to record the low-zone densities, and then the development time which provides the anticipated densities for the high values. We are then assured that a negative exposed to an eight-zone subject, for example, will yield a print of eight discrete values with normal-contrast paper. Having established this norm, we use further tests to determine the development time which yields a one-zone expansion, and label this N + 1 development, and so on for other expansions and contractions. This system is thus entirely practical, since it is based on your own methods and procedures rather than standards (precise but inflexible) established at a manufacturer's laboratory. Procedures for film testing are given in Appendix 1. ◁

See Appendix 1, page 239

*Some texts refer to this phenomenon as a change in effective film speed. I think it is less confusing to the student to consider the film speed fixed, once determined by testing, and to apply these exposure adjustments separately, just as one does when applying a filter factor. The effect is the same in either case.

Figure 4–22. *Rock Pavement near Tenaya Lake, Yosemite National Park.* This is a very flat subject, illuminated in sunlight at about 45°. Excepting the small shadows on the far left, the contrast range was only about 1:3. I placed the average luminance on Zone IV and gave N + 3 development to the negative, but it still demands a high-contrast paper (such as Oriental Seagull Grade 4) to achieve a print relating to the original visualization. A film of extreme contrast, such as Kodalith or Polaroid Type 51 Land film, could have been used to good effect. Since the subject was of almost neutral grays, however, filters would have been of no use. In relation to the original subject, the image as reproduced here is a considerable "departure from reality," and a good example of imaginative visualization.

Figure 4–23. *Edward Weston, Carmel (c. 1940).* This is an excellent example of the use of reduced development for local contrast effect. I placed the skin values on Zone VII, and used N – 1 development to minimize skin textures. In addition, the hazy sunlight and environmental reflections contributed to the luminous quality.

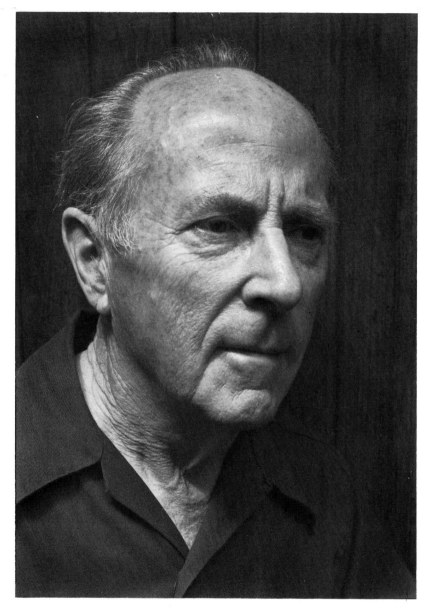

Local Contrast

Changes of development are applied to control the total contrast range of the negative, but a side effect is that the "local contrast" within low and middle values is affected. Most surfaces include lighter and darker components that we perceive as texture, and while these textural variations may all lie within a range of one or two zones, they will be reinforced or weakened by modified development.

Figure 4–24. *Julian Camacho, Carmel, California.* The subject was standing near a tall window with his head turned slightly away from it. The skin value was placed on Zone V and development of N + 1 was given to emphasize texture. The exposure, using Kodak Plus-X film at ASA 64, was 1/4 second at f/22; thus, from the Exposure Formula, the luminance of the face was about 30 c/ft² (see page 66). I used a 250mm Sonnar lens with the Hasselblad 500C (on a tripod), and the relatively long focus of the lens gave excellent "drawing" to the features. I usually focus on the eyes as they are the most critical elements of the face. If we do not have much depth of field, we may lose precise focus on the nose; loss of sharp focus toward the back of the head is less disturbing.

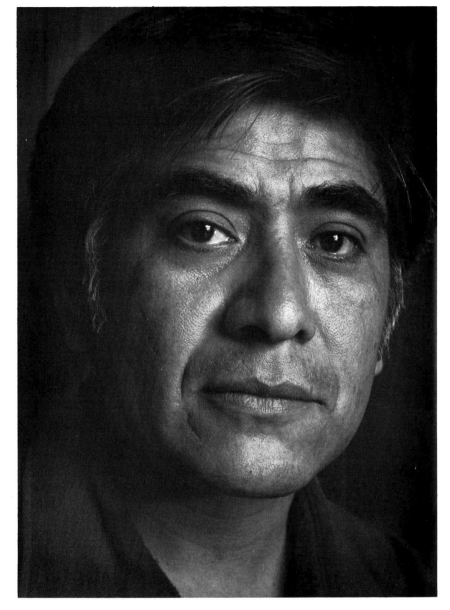

For example, if we reduce the development time to control the range of a very long-scale subject, we may find that the image lacks vitality below Value V. The reduced development causes a compression of local contrast within these values, which may lead to a dull and lifeless progression. This effect usually limits the extent to which contraction can be applied. N − 1 is usually quite acceptable, but more severely reduced development may not be satisfactory unless we add about ½ stop of exposure to support shadow values.

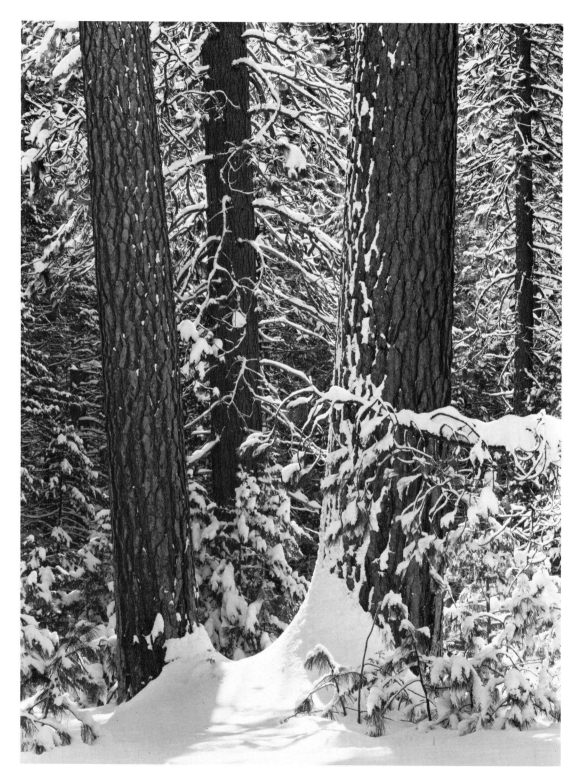

See Figure 4–23

See Figure 4–24

Figure 4–25. *Winter Forest, Yosemite Valley.* This is a good example of the effect of N – 1 development. The shadowed tree trunks were placed on Zone V (there was considerable reflection from the surrounding snow-covered trees), and the sunlit snow between the two trees fell about on Zone IX–X.

There are times when we can take advantage of the local contrast effect. We may find it appropriate in portraiture to decrease the contrast within the skin values, particularly with an elderly subject or one with facial blemishes. If the other subject values permit, we can then plan exposure for Caucasian flesh tones on Zone VII instead of Zone VI, and give N – 1 development so the skin values print as Value VI (assuming that is the appropriate value for the subject). The result is a softening of the local contrast within the skin tones, and a more considerate and pleasing portrayal. ◁

Conversely, we may desire for interpretive reasons to emphasize texture. We might then control exposure so that the average skin value falls on Zone V, and give expanded development to exaggerate its texture. Here again we must take into account both the local contrast and the overall scale of values in determining the appropriate exposure and development procedures. ◁

The Limits of Expansion

Although the local contrast effects just discussed often limit the practical extent of reduced development, expansion is usually limited by other factors. In particular, extended development tends to increase the graininess of the negative, and this often becomes objectionable. N + 1 development is practical with most films and N + 2 with some (the size of the negative and the degree of enlargement planned are also important considerations here). In addition, contemporary thin-emulsion films have less capacity for increasing their maximum density than earlier materials, setting a further limit on the degree of expansion that is practical. Other means of contrast control that can be used in combination with both expansion and contraction are discussed in Chapters 5 and 10. Remember that the primary function of the Zone System is to support *visualization*, and the means available are numerous and flexible.

Other Development Variations

In addition to expansion and contraction, other modifications of development procedure can sometimes be helpful in controlling image contrast and tonal values. A compensating developer is one that allows full exposure for shadow detail while maintaining separation and moderate density in the high values. It thus allows full exposure of a contrasty subject, while preserving separation in high values. Among the more successful procedures for compensating development with current films are the use of a highly dilute developer and

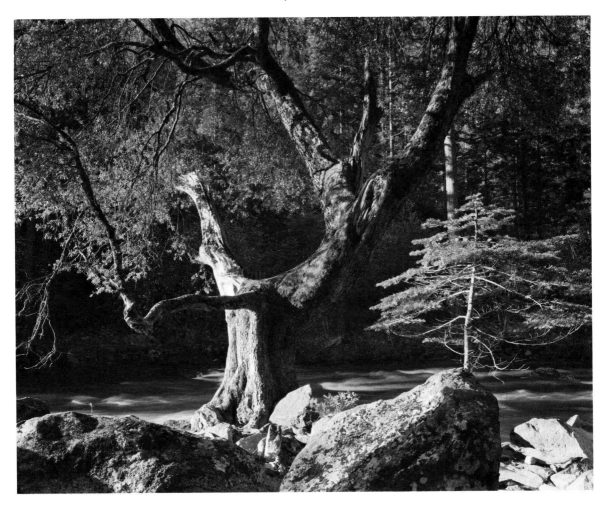

the two-solution process. It must be remembered when using these procedures that extra exposure is *required* in the shadow areas; the major benefit of compensating development is that this additional exposure can be given without sacrificing high-value detail. In general, low values should be placed one zone higher on the exposure scale than normal. These procedures, and other contrast control methods, are described more fully in Chapter 10.

SENSITOMETRY

The Zone System is a practical expression of sensitometry, the science that relates exposure and density in photography. If the Zone System is understood, the underlying sensitometric principles

Figure 4–26. *Merced River, Trees, Morning Light, Yosemite Valley.* This is an excellent example of the water-bath development effect. The darkest shadow in the shaded foliage across the river was about 5 c/ft², and I placed that value on Zone II. The sun-lit tree and light rock were about 500 c/ft², and fell on Zone VIII½. I used f/45 for maximum depth of field, and the exposure was about one-half second.

should not be difficult to grasp and can provide much information useful to the photographer.

Density

To understand the meaning of the term *density,* consider what happens when light is directed through a developed negative. A small amount of the light is reflected or absorbed, and the remainder is transmitted. The amount of light that passes through the negative depends on the amount of silver deposited at that location during development. The transmitted light can be measured as a percentage of the incident light: if 1/4 the light falling on the negative is transmitted, we can say that that part of the negative has a *transmission* of 25 percent, or 0.25.

We are actually concerned more with how much light is absorbed than with how much is transmitted (we want to know how "dense" the negative is, not how "clear"). We therefore convert the transmission to *opacity* by taking its reciprocal (that is, 1 divided by the transmission). In this example the opacity would be 1/0.25, or 4. *Density* is defined as the logarithm (base 10) of opacity, in this case 0.60.

I would like to quell anxiety that common logarithms cannot be grasped by the average person. They are, in effect, nothing more than a mathematical shorthand, and their use in practical sensitometry is really very simple. A short review of logarithms is included in Appendix 5. ◁ In practice, however, density is read directly in \log_{10} units, and no conversion is required.

See Appendix 5, page 263

The densitometer is an instrument calibrated to measure densities, either on a negative (transmission densitometer) or on a print (reflection densitometer ◁). The transmission densitometer consists of a light source that can be directed at a very small area of the negative and a light probe in contact with the emulsion surface that measures how much light is transmitted.

See Book 3

The Characteristic Curve

To describe the behavior of film we plot a graph of the relationship between the logarithm of exposure and the density (which is already a logarithmic unit). The major divisions of the log exposure scale as used in technical laboratories are usually in units of 1. Because it is a logarithmic scale, each major division of 1.0 represents ten times the exposure of the previous division. The scale is then usually further divided into units of 0.2.

These divisions are unfortunate, because it is far more useful in applied photography to divide the scale into log exposure units of 0.3. The advantage is that a scale in log exposure units of 0.3 represents arithmetic change *by a factor of 2* (since 0.3 is the log of 2); each interval of 0.3 log exposure units therefore represents a one-stop exposure change, and 0.1 represents one-third stop. Keep this fact in mind when examining a manufacturer's characteristic curve; whatever units may be attached to the exposure scale (usually it is meter-candle-seconds, abbreviated mcs, not a useful unit outside the laboratory), *an increment of 0.3 on the log exposure scale represents a one-stop or one-zone exposure difference.*

The characteristic curve, or H&D curve as it is sometimes called (it was created by Hurter and Driffield in the 1890s), is a graph of the density that results from each exposure level. The log exposure units are thus measured on the horizontal axis, and density on the vertical axis. We can find an exposure value on the log E axis and go upward until we reach the curve, then move across to the density scale at the left and read what density results from that exposure. As you would expect, a low exposure relates to a low density value, and higher exposures to higher densities. It is important also to understand that each such curve represents a certain film developed in a

Figure 4–27. *The characteristic curve.* This is a graph representing the relationship between exposure and density. Exposure is in \log_{10} units, and the relationship to "exposure units" is also shown. The position of the scale of zones is determined by locating the Zone I point where the density value is 0.10 units above the filmbase-plus-fog level; each higher zone is then 0.3 log exposure units to the right, since an interval of 0.3 on the log scale represents a doubling or halving of exposure. The vertical scales are opacity and the log of opacity, which is density.

Note that a one-zone exposure increase in the toe or shoulder region produces a smaller density increase than it does in the straight-line section. This fact explains the reduced texture and "substance" within the low zones, and the "blocking" of high values that are overexposed. Since most current thin-emulsion films have little, if any, shoulder in the range of normal exposures (see Figure 4–28), there is much less tendency for high values to become blocked. This curve represents Ilford Pan-F developed in HC-110 (for other data, see Appendix 2).

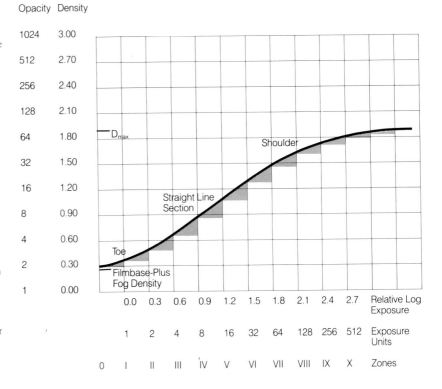

Opacity	Density
1024	3.00
512	2.70
256	2.40
128	2.10
64	1.80
32	1.50
16	1.20
8	0.90
4	0.60
2	0.30
1	0.00

D_{max} Shoulder Straight Line Section Toe Filmbase-Plus Fog Density

0.0	0.3	0.6	0.9	1.2	1.5	1.8	2.1	2.4	2.7	Relative Log Exposure	
	1	2	4	8	16	32	64	128	256	512	Exposure Units
0	I	II	III	IV	V	VI	VII	VIII	IX	X	Zones

See pages 90–93

See Figure 4–27

See Figure 4–31

specified way; as we will see, a change in development alters the curve shape. ◁

Note from the example ◁ the sequence that occurs as we proceed from low exposure to high exposure. The far left end of the log E scale represents very low exposures. At the minimum level of exposure (Zone 0 and below) the film receives insufficient light energy to respond at all. There is nevertheless a certain minimum density in this area just because of the presence of the film base itself and an unavoidable small silver deposit called fog. This minimum density is termed *filmbase-plus-fog* density (I abbreviate this as fb-f), and will exist in the border areas of any negative where no exposure has occurred, or with an unexposed film that is processed. Age, heat, and humidity will increase the fog level (as will increasing the development time) and thus the fb-f density. The fb-f density is subtracted from a given density value to leave *net density,* the useful densities above fb-f that contain image information. We "print through" the fb-f density and it has very little or no effect on the image values.

As we move to the right along the exposure scale from this minimum density level, the first significant response to light occurs. The exposure required to produce the first measurable net density is called the *threshold exposure.* The region of the curve that represents the threshold point and the adjacent area is called the *toe* of the curve. In this region the film's response (in terms of density and contrast) gradually increases with an increase in exposure. It is here that the densities around Zone I, II, and III occur.

As we proceed to higher exposures, the film's response usually forms a nearly straight line on the characteristic curve. In this *straight line section* a given increase in exposure will produce the maximum density increase possible *for the film and development given,* and thus shows the maximum separation of values and detail. Here the middle and upper zones (about IV to VIII) are recorded.

Ultimately the straight-line response tapers off at the *shoulder* of the curve (Zone IX and above with modern films). This occurs at high exposure levels and shows graphically the compression of detail in subject areas that are overexposed, frequently called "blocking" of highlights. A given exposure increase no longer yields much density increase, and value separation is diminished or lost entirely. Where the curve levels off at the top of the shoulder is the maximum density possible for the film and development combination, called D_{max}. Once D_{max} is reached, further increases in exposure produce no additional density. (Actually, very great increases in exposure beyond this point will cause a *reduction* in densities, a reversal effect called solarization. ◁)

Contemporary emulsions have a much longer straight-line section than earlier films, and frequently they do not shoulder off until a

very high level of exposure is reached. The result is a greatly reduced tendency for highlights to "block up," making development contraction somewhat less critical than in the past. However, light scatter within the emulsion and other effects produce a loss of acutance in high-density areas; ◁ thus it is always advisable to keep exposure at the appropriate minimum.

See pages 36–37

Exposure in Zones

If we consider the log exposure scale in intervals of 0.3, each such interval represents a doubling or halving of exposure, and therefore corresponds to a one-zone exposure change. If we can locate one specific zone on the scale, the others must fall into place at intervals of 0.3 log exposure units. We will thus have a link between camera exposure and the exposure units of sensitometry.

The key point is at the threshold; we consider a density of 0.10 above filmbase-plus-fog density as the useful threshold. *The exposure that yields this first significant net density of 0.10 is established as the Zone I exposure point.* Zone II exposure is then 0.3 units to the right of it, Zone III is 0.6 units to the right, etc. We can then inspect the curve and see what densities correspond to each exposure zone for this film and development.

This procedure is applied as practical exposure information in the test ◁ that determines the film speed rating that gives 0.10 net density for Zone I exposure. If, for example, using the manufacturer's recommended ASA number, we find that a Zone I exposure produces a density higher than 0.1, we can reduce this exposure by assigning a higher ASA film speed number. If the Zone I density is consistently below 0.1 we use a lower ASA number to increase the exposure until the optimum value is achieved.

See Appendix 1, page 239

Gamma and Contrast

The film's contrast can be measured by determining the *slope* of the straight-line portion of the curve. The slope is the ratio of the density change to the exposure change in the straight-line region, and is given the name *gamma*. Gamma, then, equals change in density divided by change in log E in the straight-line region. A film with a higher value for gamma will have more contrast than a film with lower gamma; it should be clear, for example, that a one-zone exposure change produces a greater density interval with a higher gamma film than with a lower gamma film.

There are some limits to the usefulness of gamma as a measure of negative contrast, however. For one thing, not all films have a long region that closely approximates a straight line. Even when a true straight-line region is present, gamma gives no measure of the nature or extent of the toe region of the film, which is of great importance in photography. Several different contrast measures have been developed over the years with the intention of supplanting gamma as a contrast indicator. One such index is called mean gradient (written \bar{G}), and another is the Contrast Index (CI) system used by Eastman Kodak. Both approaches define limits on the film curve to be connected by a straight line, and the slope of this line is then measured. I find such systems confusing and uncertain in applied photography, and I still consider gamma the most useful figure. No index, including gamma, is nearly as informative as comparing the entire curves of two films, or of one film under different processing conditions. In addition, many contemporary films have exceptionally long straight-line sections which, in my opinion, definitely change the concepts of contrast measurement.

Comparing Curves

A single characteristic curve tells much about a film, but is probably of greatest use when compared with another curve. If you are familiar with the characteristics of one film and development in practical terms, you can learn a great deal by comparing a curve representing this system with another curve that represents a new film you wish to try, or a modification in development time. With practice one learns to "read" curves and their comparative values with ease. Some important points of comparison are the following:

Speed point. Locate the point on the two curves where the film reaches a density of 0.1 above filmbase-plus-fog level. Then compare the two values on the log E scale where this point occurs. The curve with the lower exposure value required to reach the speed point is the "faster" film. This information is particularly valuable if we are comparing the curves of one film under different development conditions. ◁ If, for example, we find that a certain change in development moves the speed point 0.1 log E units to the right, we know that one-third stop more exposure is required to reach the effective threshold, or Zone I density.

See Figures 4–28, 4–29, 4–30

Curve shape. Obviously, a difference in the slope of the straight-line sections of two curves indicates different contrast and separation for

Figure 4–28. *Comparison of two film curves.* Some of the differences between two films can be anticipated by comparing their characteristic curves. The upper curve represents Ilford FP-4 and the lower curve is Ilford Pan-F, according to our recent tests. Each curve has its own Zone I density point (indicated on graph) where the density is 0.1 above filmbase-plus-fog. These two points are separated by 0.4 units on the log exposure scale, indicating a 1⅓ stop difference in speed; the actual tested speeds are 64 for FP-4 and 25 for Pan-F. The relative positions of Zones V and VIII are noted on each curve. Note also that the FP-4 curve has a short toe section and very long straight line, with only the beginning of a shoulder. Pan-F, on the other hand, has a longer toe and a much more definite shoulder that is quite pronounced by about Zones VIII and IX. The long toe of Pan-F might be useful under low-flare conditions. FP-4 obviously can be expected to do well maintaining separation of high values. (More data on the films is found in Appendix 2). Comparative curves can be superimposed to show Zone I of each film on the same exposure position, but these curves indicate the difference in film speed as well as response to exposure and development.

See Book 1, pages 69–73

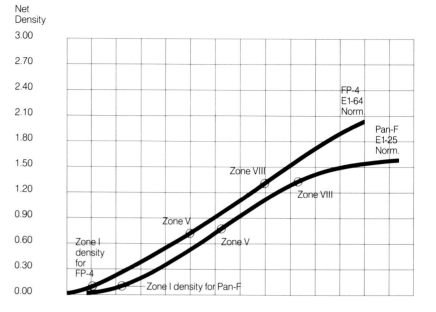

those exposure zones that produce densities in this region. If you mark off the log E scale in zones, working from Zone I at the threshold point and moving to the right by 0.3 units for each zone, you can determine just which zones fall within this region. You may then be able to draw conclusions about the density range that results from a given range of zones. You may find, for example, that a new film exposed to Zones III to VII will yield a density range you expect for Zones III to VIII with your standard film, etc.

Then compare the toe regions, noting which zones produce these lower densities. Some films have a longer toe than others, and this will affect the rendering of the low values. Kodak's films intended for studio use often have a longer toe than films intended for general-purpose and outdoor photography. The reason is that flare ◁ tends to be less a factor in the studio than outdoors, and higher flare has the effect of "lengthening" the toe. Some Kodak films for studio use are described as "all toe," meaning they never really reach a straight-line configuration.

Most films today have very long straight-line regions, but if a shoulder is present, you should observe at what zone the separation of values begins to diminish. This may be especially important with curves representing development modifications.

Effect of Development

Changes in development alter the shape of the characteristic curve, as might be expected from the fact that they are used to expand or

Figure 4–29. *Effect of increasing development.* Extended development produces more contrast in the negative, indicated by the greater slope of the N + 1 curve. The extended development curve represents a one-zone expansion because its density range for exposure to Zones I to VII equals the density range for Zone I to VIII exposure on the normal curve. Thus a Zone I to VII subject given this increased development would print as if it had been exposed to Zones I to VIII and normally developed. In addition, the contrast "locally" within each zone (especially the higher ones) would be expanded. (The film is Kodak Tri-X Professional 4 × 5 sheet film.)

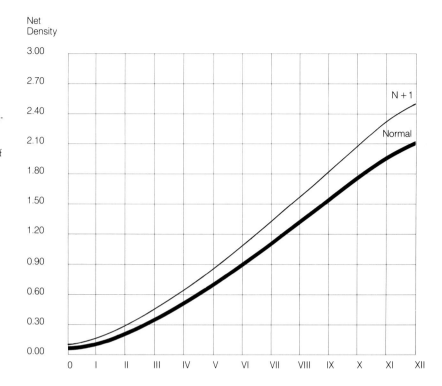

Figure 4–30. *Effect of reduced development.* The lower slope of the reduced-development curve indicates that a negative given this development will have less contrast than one normally developed, if both have been exposed to the same subject-value range. The density range corresponding to exposures of Zone I to IX on the N – 1 curve is nearly the same as the density range for Zones I to VIII normally developed. Reduced development affects all zones to some degree, and the densities of the low values may be reduced to the extent that it becomes difficult to give them "life" in the print. Therefore, as we apply N – 1 and N – 2 development, we usually must increase the exposure by 1.5x to 2x. Such additional exposure modifies only to a small degree the actual development times defined as N – 1 and N – 2 without the additional exposure. As we will see in Book 3, adjustments of such small density differences can be made with slight changes in the printing process. (Tri-X Professional 4 × 5 Sheet film.)

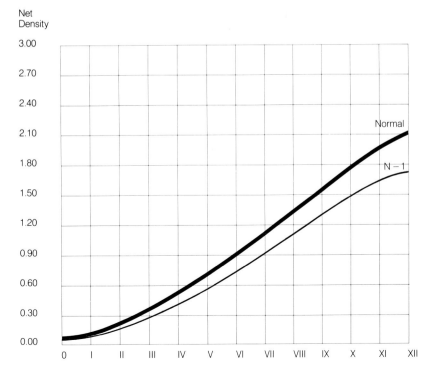

Figure 4–31. *The "Black Sun," Owens Valley, California.*

With the shadow values placed on Zone V, the sun was so bright as to pass beyond the shoulder of the film curve to the area of reversal (see page 87), where an exposure increase produces a *reduction* in density. This is true solarization (as distinct from a darkroom technique often called solarization), and caused the sun to appear as a dark circle. The "corona" effect around the sun and the sun's reflections in the stream are still in the area of the curve shoulder, and are rendered white. This negative was developed in the highly compensating pyrocatechin formula (see page 255), and the surface development action of this formula apparently contributed to the reversal effect.

contract the negative density scale. (It should be clear by now that exposure changes alone, as when changing film speed or zone placement, do not alter the curve shape, but merely correspond to a change of position along the log E scale.)

As shown in Figure 4–29, increasing development has the effect of raising the contrast of the negative, indicated by the higher slope of the straight-line region of the negative given more development. Thus a given range on the exposure scale (corresponding to a certain range of luminances in the subject) translates to a greater range of negative densities with increased development.

The toe region of the curve is affected *less* by the development increase than the middle and especially the upper regions. On the curve the densities corresponding to low zones are not greatly affected by the development change (and are thus controlled primarily by exposure alone). With earlier films, the toe remained virtually unchanged, but contemporary films show a somewhat greater ten-

dency for the low densities to shift as development is modified, although certainly still less than the middle and high values.

See Figure 4–30

The effect of reduced development is also shown. ◁ The two curves show that the entire scale of the negative has been reduced; the low values drop slightly, but the high values are reduced by a greater amount, causing a reduction in overall contrast. It should also be apparent that a compression of local contrast occurs due to the lower slope of the curve.

Note also that the effective threshold and toe region also tend to move as the development is changed. Increased development moves the threshold to the left, indicating that less exposure is necessary to reach the threshold, and reducing development moves the threshold to the right, indicating that an increase of exposure is required. The amount of exposure increase needed to compensate can be determined by comparing the threshold points of the two curves, as described above. If you have not made such careful calibrations, it is usually wise to give an extra half-stop of exposure to a negative if you plan to develop it at $N-2$.

35MM AND ROLL FILMS

Full control using the Zone System requires individual processing of each negative, obviously not practical with roll films. It is a mistake, however, to assume that the Zone System therefore "does not work" with roll-film cameras; since it is a practical expression of sensitometric principles, the Zone System remains valid, even though its use is somewhat different. At the minimum, it can provide a framework for understanding the exposure-development considerations, and making informed decisions that relate the circumstances of subject luminance and contrast with the capabilities of the photographic process. While the Zone System allows considerable freedom to control the process to achieve our visualized objectives, we also learn to visualize images within the limits *imposed by the process*, regardless of format. With roll films we usually must accept the requirement for uniform development of the entire roll, and we can adjust our procedure to accommodate this fact.

The absence of development control will mean a greater reliance on contrast control through the use of paper grades in printing. We can usually achieve satisfactory prints this way provided we have taken care in exposure of the negative to be certain that detail is present throughout all important subject values. As with sheet films,

there is little margin for error on the side of underexposure. At the same time, a greater penalty is paid for overexposure with roll films than with sheet films, since the relatively high magnifications common in enlarging small negatives make graininess an important consideration. If a single roll must be exposed to varying subject contrast conditions, I recommend very careful exposure to ensure adequate shadow detail, and then giving the equivalent of N − 1 development. Those negatives that represent high-contrast subjects will thus be of manageable scale, and lower-contrast subjects can be printed on papers of higher than normal grade. This procedure will minimize the build-up of grain (although the higher contrast papers will emphasize the grain that is present), and will ensure that most subjects are recorded with good detail and separation of values throughout.

Whenever possible it is best to expose an entire roll under similar contrast conditions. There are many occasions when one subject is photographed under consistent lighting, and an entire roll so exposed can be given modified development as the conditions require. There

Figure 4–32. *Family Group.* This is one of my early 35mm photographs, made in the late 1930s with a Zeiss Contax II camera and a Zeiss Biogon 40mm lens on Agfa Superpan film. In spite of the extraordinary quality of contemporary lenses and films, the earlier materials produced images of a certain character that is not easy to duplicate today; the problems were different, but control was possible and rewarding.

are also many photographers who carry separate camera bodies (or separate backs for medium-format cameras with interchangeable backs), marked for normal, normal-plus, and normal-minus development, and so forth. Film thus exposed to relatively uniform conditions can be given modified development, within limits:

—A slight increase of developing time is usually acceptable, especially if the negatives do not have to be enlarged greatly and do not contain large areas of smooth middle-tone value (such as the sky), which are especially revealing of grain structure. Because of the increase of grain size, however, true expansion in development is not usually practical beyond about N + 1, although we can later apply See pages 235–237 other controls, such as negative intensification, ◁ for individual processed frames. We can also use papers of higher than normal contrast in printing.

—With high subject contrast, the developing time can be reduced to about 2/3 of normal without losing "body" in the shadows. However, reducing development beyond about N − 1 may cause the middle tones and shadows to be weakened in separation, and the resulting prints may be flat and "muddy." Variations in development See pages 226–232 procedure, such as the two-solution or high-dilution formulas, ◁ may be helpful when considerable contrast reduction is necessary.

Image quality with 35mm cameras can be significantly improved by taking a few other precautions: except with moving subjects which require mobility of the camera, use a tripod if possible, both to avoid camera motion and to permit small apertures, which increase depth of field. Fill the frame: move close to the subject or use a lens of as long a focal length as appropriate to eliminate the need to enlarge only a section of the frame. You should also use lenses and gelatin or optical glass filters of the highest quality.

REVERSAL FILMS

The Zone System procedures described apply to the use of conventional black-and-white negative films, and with modification of scale, to color negative films. Reversal films (that is, those which produce a positive image directly rather than a negative) call for a somewhat different approach. Such films include transparency materials and Polaroid Land prints.

The procedure discussed with negative films was to expose for the shadows and develop for the high values, based on the use of exposure alone to control the low-density areas, and exposure combined with development to control higher densities. The same require-

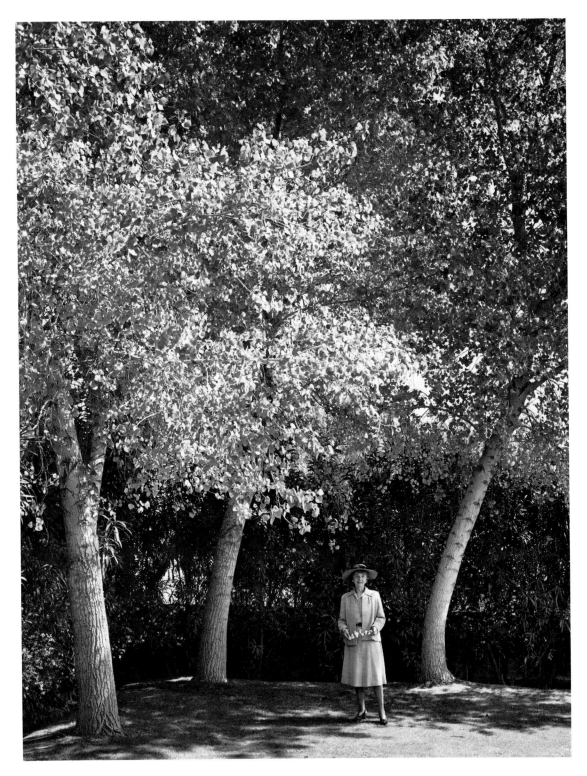

Figure 4–33. *Margaret Sanger in Her Garden, Tucson, Arizona.* The exposure was quite "full" to preserve the feeling of light: the shadow on the background fence was placed on Zone III, and the skin fell on Zone VII½. Development was normal-minus. The spring leaves were a light green, and quite brilliant, and I used a light green filter to enhance them, as described in the next chapter. In all probability an average meter reading of this scene would have indicated about one-half the exposure given, and the shadows would have been too far down on the scale; the image then would have been harsh and lacking in luminosity. I used an 8 × 10 view camera and 10-inch Ektar lens, with the rising front employed to the full extent allowed by lens and camera design (see Book 1).

See pages 119–123

ments apply with reversal films, except that the low-density areas are now the high values of the subject, and the high densities represent the shadows. This will be apparent if you examine a positive transparency or Polaroid Land print: the lowest deposit of silver (or dye if a color film) is in the high-value areas, and minimum density represents clear film or pure white paper base. The high densities occur in areas corresponding to low-luminance subject values.

Thus the procedure for exposure placement and development control (if any) is the reverse of that with a negative film. The most critical values for exposure are Values VI through VIII, and this is the area where the initial exposure placement should be made. Just which zone we use for the placement decision will depend on the scale of the specific material, and the subject at hand. Both Polaroid films and transparencies have a considerably shorter scale than conventional negative films, however. Few reversal materials will record detail above Zone VII, and even this may be beyond the scale of some. A series of tests should be conducted to determine the practical scale of the film used before deciding where to place important high values which must retain texture and detail.

Once you have placed the important high values on the appropriate zones, you must consider where the low values fall. With the relatively short scale of positive materials, Zone II is usually the "threshold" of useful exposure, and Zone III should reveal some substance and texture. With an average-contrast subject the low values may in some cases be underexposed. Pre-exposure ◁ may be useful in enabling us to increase the exposure scale of positive materials by at least one zone; the pre-exposure must usually be about on Zone II to III to be effective.

If development modifications are possible, they will have their primary effect on the low values (higher densities). In the case of Polaroid Land black-and-white films, there is sometimes a significant amount of development control possible through extending or decreasing the "imbibition time" of the print (see my volume *Polaroid Land Photography*).

Positive transparencies offer little or no opportunity for development modification to control the low values. It is nonetheless true that the high values are the most critical for exposure placement. High values that lose detail through too-high placement will be empty and distracting; the low values may continue to suggest substance after the full detail has begun to be lost. For this reason, exposure with transparency film should favor underexposure slightly rather than overexposure (the reverse of the situation with negative films). The actual limits of acceptable texture rendering will also vary depending on whether the transparency is viewed on a light box, projected on a screen in a darkened room, or planned for reproduction.

Chapter 5 **Filters and Pre-exposure**

Figure 5–1. *Grass and Burned Stump, Sierra Nevada.* I used 4 × 5 panchromatic film. Since I wished to give a bright effect to the young grass, I used a light green filter (#13). The burned wood was not as "black" as one might guess; charcoal contains much crystalline material. It obviously shows specular reflections in direct sun and broad reflections in diffused light. I gave less than normal exposure and about 20 percent more development (about N + 1). A 12-inch lens was used and, as the wind was blowing the grass, a short exposure was necessary with a large lens aperture.

Although quite different from each other, filters and pre-exposure represent additional means of controlling negative values at the time of exposure, and thus both will be considered in this chapter. Filters are used in black-and-white photography to alter the value relationships of subject areas of different color, thus providing a kind of localized contrast control. Pre-exposure, on the other hand, is a useful means of extending the film's capability of recording shadow detail, and can be very helpful in handling long-scale subjects. Experience is required before the effects of these procedures can be visualized reliably, but once mastered, both can become an integral part of the visualization-value control process.

FILTERS

A filter is an optically flat material, usually gelatin or high-quality glass, that contains dyes or compounds to limit specifically its transmission of different colors (wavelengths) of light. A red filter has its characteristic color, for example, because it transmits a high percentage of red wavelengths and absorbs most others. When used to control contrast with black-and-white films, *a filter lightens its own color and darkens complementary colors in the values of the final print,* when compared with a neutral gray in the subject.

A good basic rule for learning the use of filters is to apply them

A

B

conservatively, starting with the minimum filtration needed to achieve the anticipated effect. While learning the use of filters I recommend making several extra exposures of the same subject with different filters and/or exposure factors to enable you to see the effects. Considerable practice and experimentation are required to become familiar with filter effects. A few general guidelines specifically related to filters are given below; other considerations involving various types of subjects are given in Chapter 6.

Keep in mind when using filters that their effects are partly determined by the color of the incident light. Combined sun and blue-sky light is considered about neutral in color, but the shadows of a subject, illuminated by the sky alone, contain much more blue than parts of the same subject in full sunlight. As a result a blue filter will lighten the shadows, and a blue-absorbing filter (yellow, orange, or red) will darken them. Other conditions to remember:

1. The sun gives warmer (redder) light early and late in the day. Clear blue sky is very strong in blue, violet, and ultraviolet, especially at high altitudes.

2. A clear blue sky gives colder (bluer) light than a hazy or partially cloudy sky in which the haze or clouds scatter sunlight.

3. The light on an overcast day is about the same color temperature as the light from sun and clear sky.

4. Shadows illuminated by open sky alone are colder (bluer) when the sky is clear than when it is misty, partly cloudy, or overcast.

Figure 5–2. *Golden Gate Bridge, San Francisco.* The bridge was orange-red, the hills mainly brown, the near foliage was a variety of greens, and the water bluish-gray (reflecting a mostly clouded sky). As the day was clear, with minimum haze, the atmospheric effects are minor.

(A) With no filter the rendering is satisfactory, with fairly "literal" values.

(B) A red filter (#29) separated sky and clouds, darkened the water only slightly (because it is reflecting mostly clouds and not blue sky), and strongly enhanced the reddish values of the bridge in sunlight. The effect on the near foliage varies in relation to its different levels of color saturation. A lighter red filter (#23 or #25) would have given almost the same result.

(C) The blue filter (#47) gave a generally drab effect. The bridge is not lowered significantly in value, indicating there is more blue reflected than was apparent to the eye. The foliage also does not change as much as one might expect.

C

Figure 5–3. *Color filter circle.* This is a useful reference for filter selection. The colors on the outer ring refer to the color of filter in the adjacent block, and to the visual effect of the filter with panchromatic film. The "deep yellow" #15 filter, for example, lightens the rendering of yellows and darkens blues, the color that appears on the opposite side of the circle. (Reproduced from Kodak Publication No. F-5, by kind permission of Eastman Kodak Co.)

A

B

C

D

Figure 5–4. *Forest, Early Morning, Sierra Nevada.* The colors were of green conifers, distant gray rock, and horizon sky of low blue saturation. I used a 250mm lens on the Hasselblad 2000FC with Ilford FP-4 film. The distances were considerable, and the atmospheric effect is obvious in A and B.

(A) With no filter, the near shadows were averaged and exposed on Zone III.

(B) With a #47 (blue) filter, the foreground shadow changes only slightly, although the green trees are reduced in value. The atmospheric effect becomes obvious in the middle distance: sunlit tree values are lower, and shadow values higher. The effect is further emphasized in the far distance, where the haze almost eliminates the forest details.

(C) With the #12 (minus-blue) filter, the shadows are "crisper" and the foliage lighter. The general atmospheric haze is penetrated, and the far distant hills show much detail.

(D) With the #25 (red) filter, the shadows are slightly darker and the far distance a little richer in value. The sunlight was very strong at 6500 feet elevation, and the light from the deep blue sky suggested a higher factor than I gave for the #25 filter (8x). A 10x or 12x factor and N-1 development would have given a more balanced negative without reducing the haze-clearing effect.

I have found that the #12 filter is the strongest required for most landscape situations. With this filter a factor of 2.5x is normal for average low-altitude situations, but at high elevations the factor can be increased to 3x or 4x to ensure detail in the sky-illuminated shadows. The high values, illuminated by sunlight as well as blue sky, have greater proportional exposure and can be controlled by giving N-1 development.

Table 3. *Frequently Used Filters*

Filter	Effect
#6, #8	Yellow filters that moderately darken blue sky and shadows illuminated by blue skylight, and lighten foliage. The #8 filter (formerly designated K2) is frequently considered a correction filter which gives approximately "normal" visual rendering of daylight-illuminated colors with panchromatic films.
#12, #15	Deeper yellow filters with correspondingly greater effect than the #6 and #8. The #12 filter is "minus blue," meaning it absorbs virtually all light of blue wavelengths. The #15 filter absorbs some green light as well as all blue.
#11, #13, #58	The #11 is a light yellow-green, #13 is similar but stronger, and the #58 is a strong tricolor green filter (see page 116). These darken blue sky values and shadows, as well as red subjects, and lighten foliage somewhat (green filters in general may have less effect on foliage than expected, partly because of the reduced sensitivity of panchromatic films to green.) The #11 filter is considered to provide "correction" when using panchromatic film under tungsten illumination, and the #13 is somewhat stronger in effect.
#23A, #25, #29	These red filters tend to darken blue sky and sky-illuminated shadows considerably and produce strong contrast effects; they also darken diffuse reflection from foliage. The #23A is red-orange, but has about the same effect on landscape subjects as the #25. The #29 (deep, sharp-cutting tricolor red; see page 116) gives maximum contrast with landscape and other situations.
#47	A blue filter (tricolor) that lightens the sky and darkens green foliage and reds. The use of a blue filter exaggerates atmospheric effects. (See page 109.)
#44A	Minus-red. This filter, used with a panchromatic emulsion, simulates the effect of an orthochromatic film, emphasizing blue and green.

Use of Contrast Filters

The most frequently used filters outdoors are the yellows, particularly the #8 (formerly known as K2), and the #12 (minus-blue). Without such a filter, the sky tends to be too light, merging in value with white clouds. Using a #8 filter deepens the sky moderately and brings out separation between it and the very light cloud values, as well as light rock or snow. Proceeding to stronger yellow filters and then to the reds produces a progressive increase in this effect. With a red filter a strongly saturated blue sky becomes extremely deep in value, and this exaggeration can be distracting unless judiciously

Figure 5–5. *The Great White Throne, Zion National Park, Utah.* I used a yellow filter to brighten the autumnal foliage and darken the sky; it also darkened the shadows (which were illuminated by skylight). The exposure could have been one zone higher with N − 1 development, and there would have been a better sense of luminosity throughout. I used 5 × 7 Isopan film and a 7-inch Zeiss-Goerz Dagor lens.

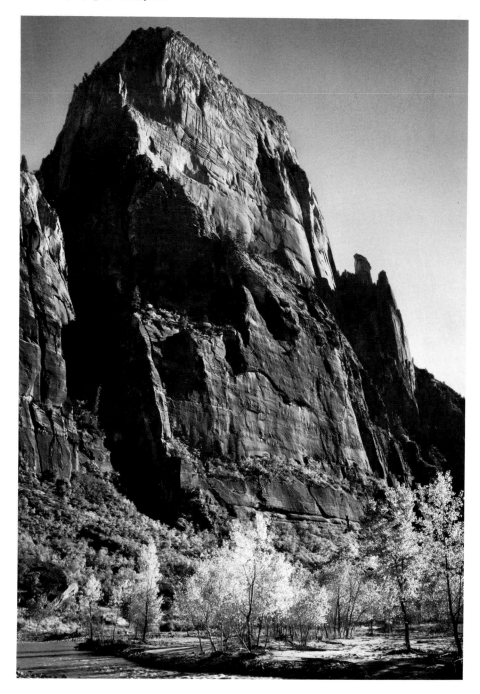

Figure 5–6. *Goosenecks of the San Juan River near Mexican Hat, Utah.* For the sake of a strong composition I placed the shadowed areas on Zone III. The use of an orange-red filter (#23) increased the brilliancy of the sunlit slopes but deepened the values of the shadowed cliffs. The horizon sky was very bright and of low blue saturation, and hence appears quite light. Development was normal.

In retrospect it might have been better to place the shadows on Zone IV and use a #23 or #25 (red) filter with N – 1 development. I would then take advantage of the additional shadow-area densities and could print them down slightly if required.

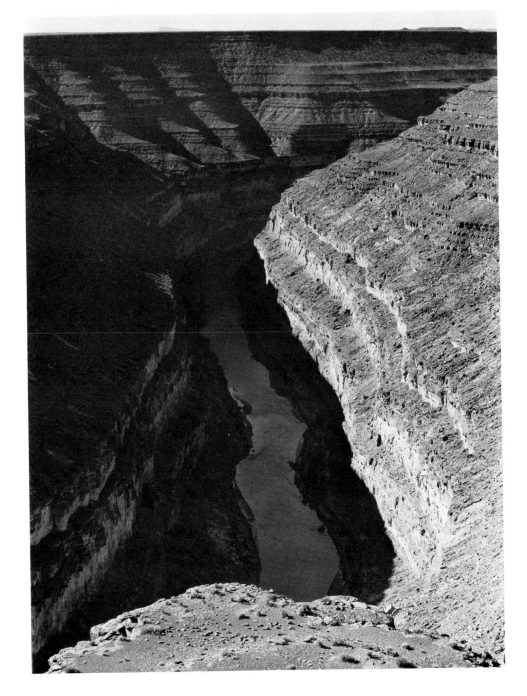

Figure 5–7. *South Rim of Yosemite Valley and Moon.* This was made in the late afternoon, when the shadows were fairly intense and the southern sky was slightly veiled. I used a strong red filter (#29) to "separate" the moon and sky value. This was an error, however, as the filter rendered the shadows as practically empty and did not give the expected value to the sky. Conifers, dark as they may appear to the eye, reflect some red light, and this plus the sun glare on the pine needles gave a higher value than I expected with the red filter. A better approach here would have been to use a moderate filter (such as a #12 or #15). These would have had less effect on the deep shadows.

applied. A sky that is clear but of lower blue saturation will be affected less by the yellow, green, and red filters. It should be understood that a filter that darkens blue sky will also produce deeper shadow values if the shadows are illuminated by the sky. In some cases the effect in the shadows is more pronounced than in the sky itself, and the overall result can be an excessive increase in contrast. It may be necessary in such cases to increase exposure to retain detail in the shadow areas. The orange and red filters also absorb green, further increasing the overall contrast in landscapes. The use of overstrong filters becomes a questionable habit.

Atmospheric conditions often produce a visual haze that is reduced or eliminated by even a light yellow filter, such as #6 and #8. If smog is present, it can lend a yellowish tint to the appearance of the sky at the horizon, and a yellow or red filter may render it excessively light. Normal haze is usually composed of scattered blue

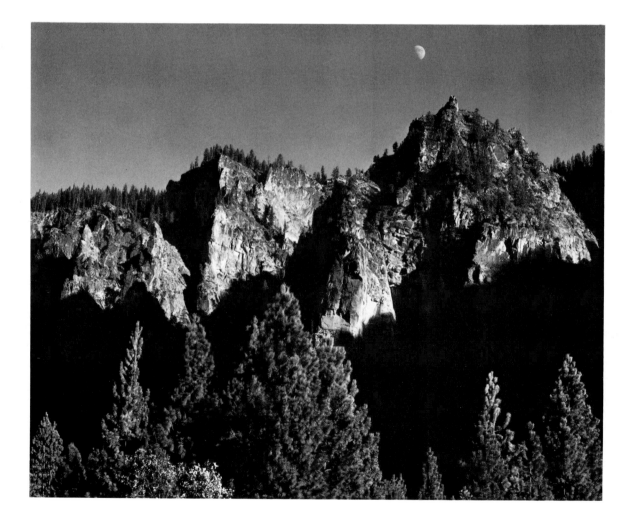

light, and is therefore reduced by blue-absorbing filters. In some instances the haze is more apparent in the photograph than to the eye because of the presence of scattered radiation of the "extreme-violet" wavelengths along with the blue; the eye sees only the scattered blue light, but the film records both it and the extreme-violet (true ultraviolet, with wavelengths shorter than about 350nm, does not pass through the optical glass of most photographic lenses, and thus is not a factor). A #8 yellow filter or stronger, or any of the red-orange filters, will eliminate this effect, as will the skylight or ultraviolet filters discussed below. This atmospheric haze is largely a function of the distance to the subject and thus is most prevalent in distant landscapes (where "more atmosphere" intervenes between camera and subject); filtration is thus especially important when using a long focal length lens to photograph a distant landscape, since the accumulated haze may obscure desired detail. There are

Figure 5–8. *Sierra Nevada Foothills, Afternoon.* Use of the Wratten #15 (deep yellow) filter served to lower the values of the shadow areas on the near hills, but could not penetrate the distant haze. A strong red filter would have been slightly more effective, but the far distant hills and sky would not have been changed to any major extent. Infrared film would, of course, give more brilliant results (see pages 151–153), but the strong haze (chiefly smoke from agricultural burning) would still be apparent. The haze is effective in lending a sense of depth and distance to the photograph.

Figure 5–9. *Artichoke Farm.*

(A) With no filter the haze is quite apparent and the details at the horizon are practically invisible.

(B) With a Wratten #12 (minus-blue) filter the haze is greatly reduced, and the buildings and distant hill become visible. A stronger filter (such as a #25 red) would have made little difference in this case.

A

B

Figure 5–10. *Forest, Near Point Lobos, California.*

(A) With no filter, the foliage was on Zone VI with the deepest shadow placed on Zone I, and the grassy slope on the left (a rather bright yellow-brown) fell on Zone VII. The values of

the forest are lower than the visual impression.

(B) A minus-red filter (#44A) was used to simulate the orthochromatic effect (see page 112). The foliage is therefore rendered higher in value, very close to the visual impression. The brownish slope on the left is

slightly lower in value because of the small amount of red it reflected. As expected, the deep shadow values are slightly higher since they are illuminated by the blue sky and the reflections from the green environment, which are both enhanced by the filter.

A

B

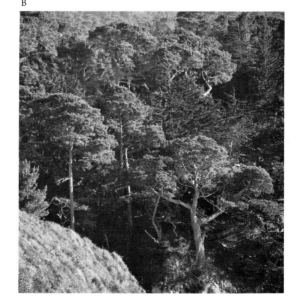

occasional instances where it is desired to emphasize the atmospheric effect to lend a sense of depth and distance to a photograph, in which case a blue filter, such as #47, may be used. "Particulate" haze (composed of smoke or dust) is not very manageable with visual-light filters; infrared film will be more helpful. ◁

See pages 151–153

The yellow filters also raise the value of green foliage to some extent, usually with satisfying effect. Orange and red filters absorb green and thus will darken foliage, and trees in shade, for example, may become excessively dark. Foliage may appear quite brilliant to the eye because of *specular* reflections. A meadow of green grass or rushes may sparkle with scintillations, and these can be emphasized if desired by using an orange or red filter; the filter lowers the values

Figure 5–11. *Church, Jackson, California.* My intention was to capture a sense of brilliant sunlight. I used a #8 filter, placed the central white wood values on Zone VI, and gave N + 1 development. The values of the door and windows fell on Zone I, and the shadows in the belfry and on the white wood fell on Zone IV. The white wood of the belfry measured Zone IX or higher because of its glare angle to the sun. The flare of light from the central pillar near the door is reflected sunlight at a sharp angle to the wall. The eye is not always aware of such effects but the image may accentuate them, especially with more-than-normal development; the eye compensates for value differences that the film enhances. I intentionally allowed the verticals of the building to converge.

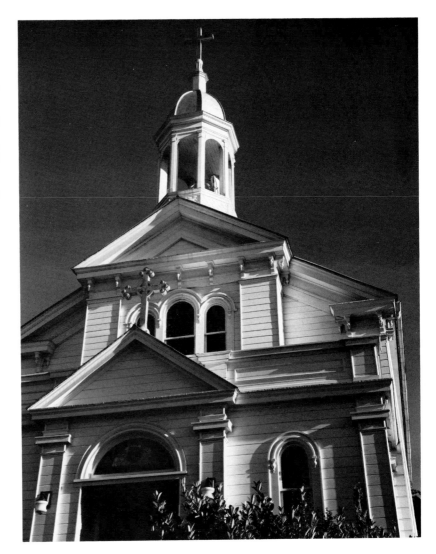

of the diffuse areas of green while the specular reflections, which are direct reflections of sunlight, are not affected.

Of the red filters, the #25 is widely used for contrast effect in landscape work. I find the #23A almost identical in effect, but with a basic exposure factor of 6X compared with 8X for the #25. Both filters absorb blue light and nearly all green light.

Green filters (such as #11, #13, and #58) can render foliage more nearly at a level the eye perceives it to be than when no filter is used with panchromatic film. ◁ The classic example is a red apple photographed against a green leaf; the eye usually perceives the leaf as a lighter value than the apple, but panchromatic film may record them as nearly indistinguishable in value. The moderate and broad-

See pages 137–139

Figure 5–12. *White Cross and Church, Coyote, New Mexico.* An orange-red filter helped to raise the value of the reddish-gray adobe. I placed the shadow in the door on Zone II, but it was lowered to an effective Zone I by the minus-blue effect of the filter used. The white cross and steeple were freshly painted and fell on Zone VIII, but note that the brighter edge of the cross approaches Zone X. The smooth side of the cross retains some texture, as expected for a Zone VIII rendering. The camera was tilted upward but horizontally level so that the cross is vertical (see Book I).

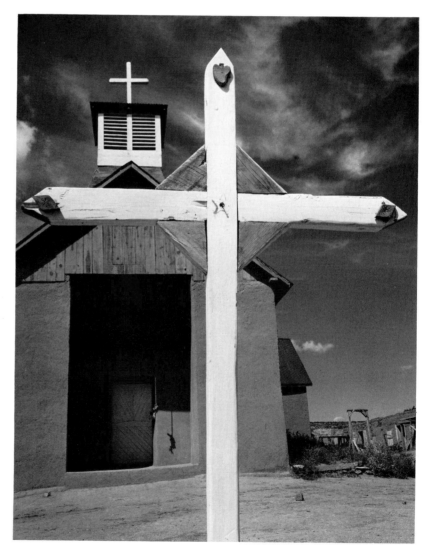

cutting green filters mentioned will reduce the red of the apple and raise the green somewhat, resulting in a more natural rendering. The #58 green is more sharp-cutting (meaning it passes a narrower green spectrum band that terminates more abruptly ◁) than the #11 and #13. Since a green filter reduces the value of both red and blue, I have found that it can give excellent balance of values in the natural scene.

Film Response and Filters

When a filter is used with a film other than panchromatic, consideration must be given to the specific response of the emulsion in relation to the transmission of the filter. With an orthochromatic film, which is not sensitive to red light, a red filter is obviously

See Appendix 4, page 259

Figure 5–13. *MacDonald Lake, Glacier National Park, Montana.* This was a difficult subject. The distant clouds were very pale, and what blue sky could be seen was of very weak blue value (the air was hazy due to smoke from a forest fire). I used a red filter (#25) and gave N − 1 development. I found that the dark areas needed some expansion, so the print was made on Grade 3 paper. Printing the distant clouds and sky darker merely produces a lifeless gray.

useless, since it transmits only light the film does not respond to. Orange filters are similarly not useful with orthochromatic films, but yellow, green, and blue filters can be used for contrast effect. With a blue-sensitive film a blue filter will have little effect, since it absorbs wavelengths the film does not respond to anyway. Green, yellow, and red filters all absorb blue, and thus cannot be used with blue-sensitive films.

See Appendix 4, page 259

Type B panchromatic film is approximately uniform in its response to light, but for critical applications the spectral response curve should be referred to. ◁ Panchromatic films can be made to simulate orthochromatic response by using a #44A (minus-red) filter, which passes only blue and green light. Blue-only sensitivity can be approximated with panchromatic films by using a #47 or #47B filter.

Black-and-white infrared film is sensitized to the very long wavelengths of infrared, beyond the visual range, but it also retains some sensitivity to blue. It is therefore necessary to use a blue-absorbing filter. The recommended Wratten #89B absorbs all visible wavelengths and thus appears opaque; the image must be composed without the filter, or a camera with separate viewfinder used. It is usually more practical to use a #25 (red) or #12 (minus-blue) filter, which gives about the same effect.

Other Filters

Skylight and UV-Absorbing Filters. As mentioned, extreme violet radiation invisible to the eye can affect photographic emulsions, frequently contributing to haze in distant landscapes. The skylight (1A) and ultraviolet-absorbing (2A, 2B) filters eliminate this effect without modifying the other values of the image. The skylight filter is particularly intended for color films to reduce the bluish cast in open shade which is caused by both blue and extreme-violet wavelengths. The UV filters are effective below about 400nm, roughly the limit of visible radiation. Some photographers keep one of these filters on their lenses at all times, both for their UV absorption and to protect the lens (these filters have no exposure factor of consequence). Since filters may cause some loss of optical image quality, I suggest limiting this use to adverse conditions such as blowing sand or salt spray from the ocean.

Figure 5–14. *Polarization of Light.* Unpolarized light can be thought of as "vibrating" in all directions around the path it travels. A polarizer transmits the light that is vibrating in a single direction, so that the emerging beam is "polarized." By rotating the polarizer we can change the plane of polarization of the emerging light. Glare reflected from some surfaces, or light coming from some portions of the sky, is already polarized; it can thus be reduced or eliminated by using a polarizer over the lens which is rotated to the position that absorbs the polarized light.

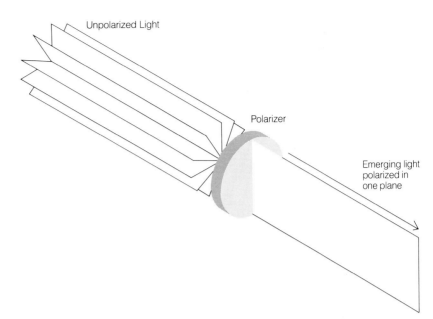

Unpolarized Light

Polarizer

Emerging light polarized in one plane

See page 167

The Polarizer. Although not strictly a filter, the polarizer is appropriately considered here because it has definite effect on the tonal values of a photograph. The theory of light polarization is quite complex, but in simple terms, light may be thought of as vibrating in all directions in its unpolarized state. Polarized light, on the other hand, vibrates in only a single plane, the others having been reduced or eliminated by the polarizing material or surface. Polarization can occur when light is reflected from certain surfaces or when it passes through crystalline structures like the synthetic polarizer material.

The effect of polarization can be clearly seen using two sheets of polarizer, or two lenses from polarizing sunglasses. By looking through both sheets and rotating one in relation to the other, it will be seen that the amount of light transmitted varies. It is at its peak when the two polarizers are aligned in their direction of polarization, and almost no light is transmitted when the two are at 90° to each other. This effect is called cross-polarization. ◁

A single polarizer is frequently used in general photography to eliminate the polarized component of glare and reflection in subjects like water, glass, ice, wet pavement, polished wood, and shiny leaves. The polarizer is rotated while viewing the subject through it to determine the orientation that gives the desired effect; it is then placed over the lens at the same orientation. If a view camera or single-lens reflex is used, the viewing can be done through the camera with the polarizer in place over the lens.

Figure 5–15. *Pool, Merced River, Yosemite National Park.* The polarizer was used at about maximum polarizing angle. The light rocks were placed on Zone VI½. I indicated N + 1 development but inadvertently gave only normal development, so the negative is difficult to print. Careful notations should always be made and referred to before developing; with sheet film be certain the film is properly segregated when unloaded and marked for appropriate development.

Maximum polarization of the sky occurs at about 90° from the sun, and with light reflected from a surface, maximum polarization occurs at about 56° from the normal (Brewster's angle), or 34° from the surface. Because of the change in values as the polarizer is rotated, photographers frequently assume the exposure factor must be increased as the degree of polarization increases. This is not the case! When used at the non-polarizing angle, the polarizer acts as a neutral density filter with a factor of about 2.5; at maximum polarization the same factor applies. If we increased the factor as the degree of polarization increased, *the non-polarized areas would be overexposed.* The same factor applies regardless of the film or the light source.

In addition, when the polarizer is used to remove reflection from a large surface such as a body of water, the details of the underwater surface are revealed. These values may be quite low, and we may then wish to recalculate exposure to ensure adequate detail therein. The polarizing effect may be evaluated through a spot meter (provided the meter's own optical system does not contribute to the polarization effect). Polarization of intense sun glare on water will reveal more texture in the very bright areas, but such extremely strong reflections can be only partially removed.

We must also realize that, aesthetically, removing the glare and scintillations may alter the character of the subject. Brilliant specular highlights are often of great aesthetic importance, and reducing or eliminating them may leave the subject relatively dull and lifeless.

Water and wet surfaces, or sunlit clouds, can become quite "dead" in appearance, and skin may look flat and "waxy." Fortunately the degree of polarization can be judged visually, and we can use only partial polarization if appropriate.

When the polarizer is used with a wide-angle lens, the increase in polarization near maximum region (90° from the sun) may exaggerate the contrast of different sky areas. Broad expanses of sky frequently show a difference in value even without the polarizer applied, and it may or may not be desirable to emphasize this difference of value.

When used with color films, the polarizer offers the only way of darkening a blue sky. In addition, the polarizer may have a slight warming effect with color films, but not usually to an objectionable degree.

The polarizer can reduce reflections and glare that you may not even be aware of, such as those from shiny leaves, wood surfaces, and rock; and with color films this frequently causes a rewarding increase in overall color saturation. I experienced an example of this effect in Hawaii. Viewing a red-earth cliff in Kauai, I observed that applying the polarizer at the maximum angle caused a marked deepening of the color, although the angle at which I was viewing the cliff was not even close to 56°. The effect was caused by the fact that the many minute crystals in the soil were randomly oriented at the optimum polarizing angle, and the polarization of these small crystals served to lower the total reflection from the soil.

Neutral Density Filters. The neutral density filters are designed to reduce the exposure uniformly across the visible spectrum, and they can be useful, for example, when a relatively fast film must be used under bright conditions. Since the ND filter's opacity is given in density units, an ND 0.30 is equal to a one-stop exposure reduction, 0.60 equals two stops, 0.9 equals three stops, and so on. Since these are logarithmic values, ND 1.0 has a factor of 10, 2.0 has a factor of 100, 3.0 a factor of 1,000, and 4.0 a factor of 10,000 (or 13⅓ stops!). ND filters are usually available in units of 0.1, equal to a one-third stop reduction, up to a density of 1.0, and then 2.0, 3.0, and 4.0. They are manufactured in gelatin and glass.

See pages 116–119

Neutral density filters can be combined to achieve the desired exposure, and the density values of each filter are *added;* if you use the arithmetic exposure factors, however, they must be *multiplied.* ◁ As with all combined filters, surface reflections may cause some additional loss of light (requiring an increase of exposure) as well as an increase in flare.

A

B

One common use of ND filters is when exposing one subject with two films of different speeds. For example, a studio photographer may make a test photograph with Polaroid film prior to exposing color transparency material. By using a high-speed Polaroid film and adjusting the exposure with ND filters as required, he avoids the need to change the aperture, and can therefore view depth of field as it will appear in the final image.

Tricolor filters are basic color separation filters that have a fairly sharp discrimination of the primary colors — blue (#47B), green (#61), and red (#29). We should be somewhat cautious in using them, as they are truly sharp cutting. ◁ Practically speaking, these filters do add contrast to the photograph, but they have a high exposure factor and very often a less severe filter will suffice. I find the #29 useful under extreme haze situations. Do not confuse the tricolor filters, which pass only one of the primary colors, with the contrast filters, which *absorb* a primary color: minus-blue (#12), minus-red (#44), and minus-green (#32).

See Appendix 4, page 259

Filter Factor

Because a filter withholds some of the light from the subject, the exposure must be adjusted to compensate by applying the filter factor. ◁ The factor is a property of the filter (in reference to the color of the light and color sensitivity of the film), and is listed by the manufacturer. In some cases separate factors are given for daylight and tungsten light, and the factors may have to be adjusted if the

See page 40

Figure 5–16. *Fall Foliage from Conway Summit Overview.* (Photographs by John Sexton.)

(A) *No Filter.* Despite its brilliant color, the fall foliage almost merges in value with the ground when no filter is used.

(B) *#47 Filter.* The blue #47 filter darkens the yellows and oranges of the foliage. Note also the increased atmospheric haze in the distance.

(C) *#25 Filter and Polarizer.* The red #25 filter brightens the foliage and separates it from the ground cover, and also darkens the blue sky considerably. The polarizer provided further darkening of the sky. Note, however, the problem of the uneven effect of the polarizer in different regions of the sky. This would ordinarily be corrected in printing.

C

filter is used with any film other than the normal panchromatic Type B or daylight color film.

The filter factor is based on maintaining a middle-gray density value for a *neutral* gray subject (such as the gray card) under the lighting conditions specified. A departure from normal daylight may alter the effective factor, depending on the film and filters used. Thus a blue filter has a lower factor under strong blue lighting, such as the very intense blue sky conditions at high altitude. It will have a higher factor under warm light, such as early or late in the day, or with tungsten. With a red filter the situation is reversed: the factor is higher under very blue lighting and lower under red-rich light. Environmental conditions, for example light reflected from a nearby colored building or from green foliage, must also be considered, and the effect estimated in applying the factor.

Combining Filters

It is sometimes thought that using two or more filters together intensifies their effect. In general, though, adding filters of the same *group* (yellow, green, red, or blue) tends in visual terms to give only the results of the strongest filter of that group. For example, using a #8 and #15 filter together gives the same visual effect as the #15 filter alone. The factor would be increased slightly because of the extra base density of the two filters and light loss due to reflections. Adding filters of different groups is seldom helpful, since there is invariably a single filter that will give the effect sought in practical work.

There are cases where combining filters is useful, however, such as with precise color correction or when using the polarizer or neu-

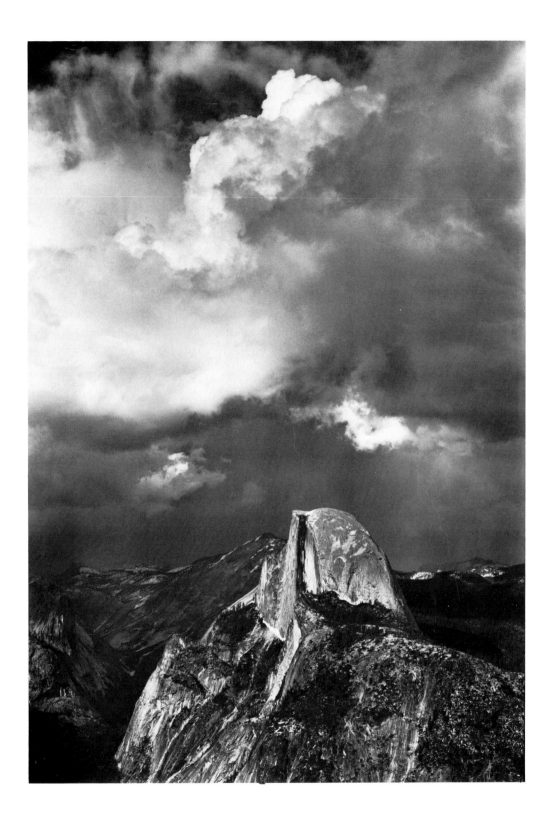

Figure 5–17. *Half Dome, Thunderstorm, from Glacier Point.* I used a #12 filter with Agfa Isopan 5 × 7 film. The negative received N + 1 development.

tral density filters together with a contrast filter. Remember in these cases that the factors of each filter must be *multiplied* or applied successively to the basic exposure. For example, the polarizer (2.5 exposure factor) used with a #25 red filter (factor 8) would require a total exposure adjustment of 2.5 x 8, or 20x.

PRE-EXPOSURE

When photographing a subject of high contrast, the normal procedure is to use contracted development to help control the negative scale, but in some cases the reduced contrast, especially in the lower values, is not acceptable. It is helpful in such cases to raise the exposure of the dark (low luminance) subject values. This effect can be achieved using pre-exposure of the negative, a simple method of reinforcing low values.

Pre-exposure involves giving the negative a first exposure to a uniform illumination placed on a chosen low zone, after which the normal exposure of the subject is given. The pre-exposure serves to bring the entire negative up to the threshold, or moderately above, so that it is sensitized to very small additional levels of exposure. It will then retain detail in deep shadow values that would otherwise fall on or below the threshold and therefore not record.

Figure 5–18. *Pre-exposure device.* There are various means of producing a dependable pre-exposure device. The one shown has given excellent results, and can be easily put together from two squares of diffusing plastic, cardboard, and black photographic tape. The two diffusing sheets are separated at the edges by cardboard strips 1/16 or 3/32 inch thick, to permit gel filters to be inserted between them. For black-and-white work, neutral density filters are usually helpful to secure the desired pre-exposure, and for color work gel CC filters can be added. The plastic squares and filters are 3- or 4-inch squares. The cardboard shield was made to fit over the diffuser to prevent unwanted light from falling on either the front or the back surface. The successful use of this device depends on holding it in the same plane for the meter reading as when making the exposure.

A

B

A

B

Figure 5–19. *Two Trees, Yosemite Valley.* The effect of pre-exposure can be seen in these examples, which were made with Polaroid Type 55 Land film exposed for the negative (the equivalent speed was ASA 20).

(A) The tree trunks were placed on Zone III and the earth foreground fell about on Zone V.

(B) Pre-exposure was given on Zone III. The low values of the tree trunks are definitely improved. The middle values with complex textures appear somewhat lighter, mostly because the small dark areas within them are affected by the pre-exposure. This type of subject is more favorable to pre-exposure than are subjects with broad, untextured, low-value areas, where the general elevation in value may suggest a "veiling." With conventional film I would have given a Zone II pre-exposure if the shadowed tree trunks were on Zone I, or used a higher placement with contracted development or the two-solution process (see page 229).

Figure 5–20. *Rocks, Pebble Beach, California.*

(A) The exposure was based on Zone II for the shadow areas, with the textured sunlit rock falling on Zone VIII. The rock in open shade fell about on Zone IV.

(B) With the same basic exposure, a pre-exposure on Zone II was used. The effect is most obvious in the lower right section of the image. The areas in open shade are considerably improved in value, while the sunlit rocks are virtually unchanged.

Suppose, for example, we have a subject with a luminance scale from Zone II to Zone VIII, and we wish to record full detail in the low values. We might first consider an overall increase of exposure; if the deep shadows are placed on Zone III instead of Zone II we will certainly maintain full detail there, but the high values originally on Zone VIII will fall on Zone IX. Reduced development $(N-1)$ would lower the high values, but this procedure is sometimes not satisfactory, either because of the specific film-developer combination in use, or because of the loss of separation in lower and middle values that results.

Using pre-exposure at the original exposure placement, we can raise the shadow values without affecting the middle and higher values. The effect can be understood by considering the units of exposure in the following example, where the pre-exposure was on Zone II:

Zones:	I	II	III	IV	V	VI	VII	VIII	IX
Basic Exposure (Units):	1	2	4	8	16	32	64	128	256
Added Units of Pre-exposure:	2	2	2	2	2	2	2	2	2
Total Units of Exposure:	3	4	6	10	18	34	66	130	258

Note that the pre-exposure has the effect of adding 2 units of exposure throughout the scale; this value of 2 units is determined by the fact that the pre-exposure was on Zone II, and the basic exposure gave 2 units for a Zone II exposure. Thus the Zone II area receives a total of 4 units, the equivalent of a one-zone increase (Zone III received 4 units without pre-exposure). Zone I is raised by the pre-exposure from 1 to 3 units, or higher than the original Zone II. By Zone V, however, the proportional increase is much smaller, only from 16 to 18 units, and Zones VII, VIII, and IX can be seen to have a negligible increase from the pre-exposure. The effect of the pre-exposure is thus visible only in the low values, with no apparent change in higher values.

Note that the low values of the negative in this example have all received at least a Zone II exposure, while the high values have received about normal exposure. The negative scale is thus compressed and should print quite readily with good separation throughout. The overall Value II density in deep-shadow areas will hold detail, and can be "printed through" as desired to achieve depth and richness.

Pre-exposure is entirely satisfactory for supporting small areas of deep shadow, but it should be used carefully if the deep-shadow areas are large. Under these conditions it can appear as a false tonality, and large shadow areas of uniform value can take on the appearance of fog. Lower placement of the pre-exposure luminance will reduce this effect, and careful printing is called for.

The procedure for pre-exposure is very simple with a stationary subject and a camera capable of double exposure. We set up the camera on a tripod, compose, and perform the normal exposure calculation. We then give the separate pre-exposure to a uniform luminance, which for black-and-white films can be placed about on Zone I to II½ (usually about Zone III with positive color and Polaroid films — see my *Polaroid Land Photography*).

See Figure 5–18

I have made a diffusing device of translucent Plexiglas ◁ which I simply hold against the lens for the pre-exposure. To determine the pre-exposure setting, I place the diffuser over the lens of the spot meter (a wider-angle meter can be used), and aim in the same direction the camera is pointing, being sure to stay as close as possible to the lens axis. The device must be shielded from extraneous light, such as direct sunlight falling on it, when reading its luminance. Remember that since the diffuser will be placed over the camera lens, the diffused light used for this reading must be the same as that entering the camera lens; it would be quite inaccurate to take readings from another direction. Once the luminance reading has been made, it is placed on the desired zone for pre-exposure — usually Zone II. The indicated exposure is then set on the camera, and with the device over the camera lens (again carefully shielded from extraneous light) the pre-exposure can be given. *This is followed by the normal exposure of the subject.*

Without such a diffusing device, the pre-exposure can be made using any smooth uniform-luminance surface. This can be a gray card, but any smooth wall, flat painted board, or other single-value surface is also ideal. We simply read its luminance and place this value on Zone II, or as desired. Focus the lens at infinity; be sure not to focus on the surface, since any texture it may have should not be recorded, and a close focus distance would require compensation for

See Book 1, pages 67–69

the lens extension. ◁ You must also be careful that the surface occupies the entire field of view of the lens. Note also that, if a card is used, a slight change in its tilt in relation to the direction of the light will seriously affect its luminance and can introduce glare; thus ideally it should be held in place on a stand (or by a reliable assistant).

Sheet films in separate holders and Polaroid 4 × 5 films can be pre-exposed in the studio under carefully controlled conditions, and then carried along with unexposed film for use when circumstances require it. The holders or Polaroid film envelopes should be *clearly*

marked with "PX" and the pre-exposure zone, and they should be carefully segregated from normal film.

Pre-exposure with roll film is quite simple with a camera capable of making double exposures, including those like the Hasselblad which permit making a pre-exposure and then removing the film magazine to reset the shutter without advancing the film. You may also pre-expose an entire roll in the darkroom by using a weak tungsten light to expose the entire roll and then carefully rewinding the roll and sealing it. I suggest that the exposure be adjusted by changing the light intensity, distance, or time to achieve a pre-exposure density of 0.20 to 0.25 above filmbase-plus-fog. If you cover a small area at the end of the roll during the pre-exposure you will have a clear film area to compare with the pre-exposure density. Be sure the pre-exposure illumination is uniform and consistent, and do not fail to mark each pre-exposed roll clearly.

Pre-exposure to a color can be used with color films to alter the hue in the shadow areas with little or no effect elsewhere. It is thus possible, for example, to reduce the bluish cast of shadows illuminated by the sky. Either color-compensating filters or a colored surface can be used for the pre-exposure, provided only that the color employed is complementary to the one you wish to reduce in the image (yellow is appropriate for reducing blue in shadows). Testing and experimentation are required, but this method does give rewarding results. The use of stronger colors in pre-exposure may produce interesting non-realistic images.

See Book 1, pages 69–73

The general effect of pre-exposure is not unlike that from the use of an uncoated lens. ◁ Such a lens contributes an overall flare exposure that elevates the total effective exposure in the shadow areas of the negative. I frequently found this helpful in earlier years (before coated lenses were developed) for working with a high-contrast subject. The effect is far less controllable than pre-exposure, however, and can contribute unwanted side effects, such as the "halo" appearing around light sources. With color films, an uncoated lens can also add an undesirable color cast if the subject has strong colors, such as a large expanse of green foliage, red brick wall, or blue sky. A subject with a predominance of high-luminance areas will produce high flare levels.

| *Chapter 6* | # Natural Light Photography |

Figure 6–1. *Thunder Cloud, Unicorn Peak, Yosemite National Park.* Placing the snow on Zone VI½ (to ensure texture) meant the conifers fell about on Zone I, and the light yellow filter further lowered their value. The film used, Agfa 25 (the actual working speed for me was ASA 16), had a rather short scale; hence the excellent snow values when placed on Zone VI½ with N + 1 development.

The impression of light is well sustained. Using a stronger filter would have lowered the sky values as well as the shadows within the clouds. The effect might have been more dramatic, but the quality of light could have been lost. Since the camera was pointed at a close angle to the sun, and since the area of sky covered was at a rather low angle, the sky value was much higher than it would be at zenith; it registered about 500 c/ft², and the filter lowered it less than one zone.

By now the reader should have an adequate understanding of many of the technical issues involved in recording a visualized image. In the preceding chapters, together with Book 1, we have discussed separately the considerations of image management and value control. These are not separate issues, however, and the photographer must integrate them as he visualizes and executes a photograph. In this chapter I would like to offer some practical information on various subjects and lighting conditions. Considering photographic situations by subject type should help make it clear how the elements combine and interact.

I will also be discussing some of the aesthetic issues of photography. Since aesthetic matters are essentially subjective, some of my observations in this area are personal and may not fully apply for each individual. It is not my intention to impose my "vision" on others, but to assist in the development of creative expression, whatever form that may take, by offering some suggestions on ways one may think about light and subject matter. I would like to repeat here that *the making of photographs is the prime function of the photographer.* Once the craft is under intuitive control, the creative objective is more positive and assured. Proficiency of craft should by no means be considered the goal in itself. The emphasis today on technique, equipment, materials, and gadgetry can be overpowering.

THE QUALITIES OF DAYLIGHT

The dominant direction of daylight is from *above,* or occasionally from the side, as at sunrise and sunset or when light is reflected from low clouds, mountains, or buildings. Our basic impression of the sky as being above the earth, and of most light as coming in a downward direction, is too strongly fixed in our consciousness to be overcome readily. Think of the appearance of practically everything in the out-of-doors: shapes, volumes and planes are revealed and are recognizable partly because of our understanding that light comes principally at various angles from above. When confronted with evidence of another direction of illumination we must make some mental ad-

justment. It may be a simple one or it may require definite effort, and it may produce pleasant or unpleasant reactions. The mood of thunderstorm light, for example, may be dramatic and emotional; the light reflected horizontally through a long passageway may have bleak and disturbing qualities. Figures illuminated by a campfire appear quite logical when the campfire shows or is definitely suggested in the image; when the fire does not appear, however, the lighting of the figures may be felt to lack a visual "explanation." A person viewing the photograph may be confused, although the photographer accepts it without question, as he remembers the original situation.

We may similarly have a strong negative reaction to the typical passport or driver's license photograph, which often requires that we make a considerable mental adjustment just to recognize the subject! This response occurs largely because the illumination is flat, usually coming from near the camera position; the negative is also often overexposed so that the planes and angles of the face are not well delineated. The projected personality of the subject in a photograph depends as much on the complex relationship of these elements in the face as on the evidences of a mobile expression.

In landscape photography we must not overlook the subjective importance of the luminance range. On an overcast day, or with a subject entirely in shade (sunlight), this range is much shorter than with sun-and-skylight. In addition, we may have areas of the subject that are shielded from both the sun and the sky, and illuminated by light reflected by other parts of the subject. The luminance of such areas is usually very low. Lest the foregoing seem unnecessarily obvious, it should be pointed out that too few photographers are fully aware of what light value can mean in both practical and emotionally expressive terms. Awareness of the subject luminance range is essential to adequate visualization of the final photograph. The impression of light is important in nearly all photographs; it is very subtle and sometimes difficult to achieve.

The clearer the air, the more intense the light from the sun and the less intense the light from the sky, and therefore the greater the difference between sunlit and shadowed areas. When photographing in high mountains, the exposure of an average scene must usually be increased if the shadow values are to be rendered adequately, and the contrast may then be very high unless development is reduced (or contrast may be reduced by using a blue filter or pre-exposure). On the other hand, in regions where the air is laden with smoke and haze from industry, the intensity of the sun's rays is reduced while reflection from the sky is increased. When the sky contains light clouds or haze, the shadows are more strongly illuminated and the ratio of sunlight to skylight decreased further. Less contrast results,

Figure 6–2. Moonrise, Hernandez, New Mexico. I came across this extraordinary scene when returning to Santa Fe from an excursion to the Chama Valley. The sun was edging a fast-moving bank of clouds in the west. I set up the 8×10 camera as fast as I could while visualizing the image. I had to exchange the front and back elements of my Cooke lens, attaching the 23-inch element in front, with a glass G filter (#15) behind the shutter. I focused and composed the image rapidly at full aperture, but I knew that because of the focus-shift of the single lens component, I had to advance the focus about 3/32 inch when I used f/32. These mechanical processes and the visualization were intuitively accomplished. Then, to my dismay, I could not find my exposure meter! I remembered that the luminance of the moon at that position was about 250 c/ft^2; placing this luminance on Zone VII, I could calculate that 60 c/ft^2 would fall on Zone V. With a film of ASA 64, the exposure would be 1/60 second at f/8. Allowing a 3x exposure factor for the filter, the basic exposure was 1/20 second at f/8, or about one second at f/32, the exposure given.

I had no idea what the foreground values were, but knowing they were quite low, I indicated water-bath development. The distant clouds were at least twice as luminous as the moon itself. The foreground density of the developed negative was about a Value II, and was locally strengthened by intensification in the Kodak IN-5 formula (quite permanent and colorless — see page 235). It was of utmost importance to preserve texture in the moon itself. We all have seen the blank white circle that represents the moon in many photographs, primarily caused by gross overexposure.

and you can compensate with slightly reduced exposure and more development.

The revelation of shape, volume, texture, and color possible with any subject in sunlight should be fully appreciated. These qualities are determined not only by the differences between sunlight and shadow brightness in the subject, but by the angle of the sun to the planes of the subject and by the nature of the shadow edge. The shadow edge is related to the effective width of the light source (that is, its angle *as it appears from the subject*), and to the distance from the subject to its shadow. The sun is about ½° of arc in apparent size; were this angle larger, the shadow edge at a given distance from the shadowing object would be broader and more indefinite. A smaller angle would cause the shadow edge to appear sharper. Some point-source artificial lights, such as arc lamps and spotlights, produce sharp shadows even when the shadow falls at a great distance

from the subject. To reproduce artificially a shadow edge like that formed by the sun would require a light source whose diameter and distance from the subject were such that it subtended ½° of arc (with a bright area of diffused light surrounding it). Sunlight shining through a small opening in foliage will have a reduced effective width, and the shadows may become sharper.

The quality of sunlight is also recognized by the acuteness of highlights. A broad light source produces broad highlights, and a point source produces small, sharp highlights. Thus a variation in the apparent size of the light source modifies the highlights of a subject. As the direct rays of the sun are progressively veiled by light clouds or haze, the shadow edge and the acute highlights both become more diffuse; under an overcast sky or in open shade the shadow edge and highlights attain maximum diffusion. To use a comparison from the terminology of artificial light, ◁ we can think of sunlight as the "main" light and skylight as the "fill" or "enveloping" light.

See Chapter 7

Consideration of design — in the photographic sense — is of extreme importance in visualization of the image. Great enthusiasm for the subject sometimes veils a clear concept of the image of it! An exciting subject may exist in an environment of field and sky, but in the print this "space" may appear as dull, neutral areas of distressingly low interest. Space in nature is one thing; space confined and restricted by the picture edges is quite another thing. Space, scale, and form must be made eloquent, not in imitation of painting arrangements, but in terms of the living camera image.

◀ Figure 6–3. *Noon, Tumacacori Cemetery and Ruin of Mission.* This is an attempt to capture the blazing light and heat of a southern Arizona day. The crosses were placed on Zone I, and the glaring earth and sky fell on Zone VI. A #47 (blue) filter was used, and development was N + 2.

Figure 6–4. *Adobe Houses, New Mexico.* The lighting conditions were very brilliant, and the exposure was made to balance the extremes — the shadow on the nearby door and the distant sunlit white door on the left. Note that the shadow of the near building on the ground is completely black and without detail. It was illuminated only by light from the clear open blue sky, and the #12 filter used reduced its value to a considerable degree. The shadow on the near door is illuminated by sunlight reflected from the door frame. I might have given twice the exposure and reduced development, but I feared that the separation of adobe texture and value would be weakened and the visual impact of the distant white door lost.

Figure 6–5. *Bronze Plaque (B. Bufano).* This subject, being of slight relief, required a slanting light to reveal the design. Sunlight was an ideal source of illumination. However, the angle of the light in relation to the position of the lens creates a slight glare effect in the upper right section (it is easily balanced in printing). The use of a lens of as long a focal length as possible will help avoid such problems.

Figure 6–6. *B. Bufano and Large Sculpture, San Francisco.* This photograph was taken in his studio, which had a very large skylight, with additional light from an open door. Note the modeling of features of both the artist and his sculpture caused by the directional quality of the light. I placed the shadow on his face on Zone IV and gave N−1 development. The material of the sculpture fell about on Zone VII.

Sunlight and Shade

In mixed sunlight and shade the reflective values of the subject are modified by the extremes of light intensity. Direct sunlight is usually about eight times as bright as open shade, although this ratio can be higher in very clear air or lower if mist or haze is present. An extreme example would be a figure standing in a shaft of sunlight in a dense grove of trees. In this case the ratio between sunlit skin and deep forest shadow might reach 1:800 or higher. Errors of judgment on such a full range of values are inevitable, because the eye has a far greater adaptability to extremes of brightness than does the photographic film.

The main problem is to preserve the *impression of light* falling on the subject. A print intended to convey an emotional sense may differ from a "literal" record. You must visualize the final expressive print, exposed for the desired values of the shadows and with high values controlled by development and printing procedures. A single average meter reading of the usual sun-and-shadow scene is seldom

See pages 70–71

See Figures 6–5, 6–7

See Figure 6–8

Figure 6–7. *Textured Wood.* The example on the left represents a wood surface in full shadow (diffuse light). On the right the wood is in slanting sunlight to emphasize texture. In both cases the exposures were based on *average* meter readings, and N + 1 development was given for further textural effect.

adequate for the best placement of values on the scale since, as discussed earlier, ◁ there is little or no margin for error with a subject of high contrast.

Analyzing the effect of sunlight on various objects demonstrates the importance of the angle of illumination in revealing shapes, planes, and textures. It should be obvious that maximum texture is revealed when the light "grazes" the surface at a low angle. The patterns of minute light and shadow areas thus created convey a tactile sense of the material and can greatly enhance its "presence." ◁

When the direction of the sunlight coincides with the optical axis of the lens, the subject appears without shadow, but the camera's shadow is in the center of the field. A practical "axis" light is achieved by moving the camera until its shadow falls just outside the image area. A plane surface under such axis light reflects about equally from its entire area, but a curved surface reflects the maximum light from the areas perpendicular to the light rays, with the intensity diminishing as the surface curves away from this plane. Under axis light the shapes are revealed not by strong contrasts of light and shade, but by subtle variations within fully illuminated areas. As we approach the edge of the curve, most of the light is reflected away from the camera, and if the background is light, the edges of the subject appear quite dark. ◁ This is known as the *limb effect.* If the light object so illuminated is against a dark background, it presents a somewhat indefinite outline, as the dark edge caused by the limb effect merges into the dark background. Axis light minimizes textural effects, which require more oblique lighting as described above.

Almost the opposite of axis lighting is *back lighting.* Most subjects illuminated from behind are outlined by diffuse and specular reflec-

Figure 6–8. *Egg (The Limb Effect).* The limb effect occurs when a curved white object like the egg is placed against a light background and photographed with axis light (light directed at the subject along the lens axis). The dark edges are due to the reflectance angle; as the surface bends away from the camera, progressively less light is reflected back to the lens despite the high reflectance of the egg surface itself. Were the background dark, the edges of the subject would tend to merge with the background, producing an indistinct border.

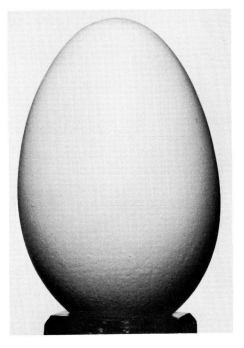

tions of a relatively high brightness value. We see increasing glare from the subject planes as we turn the camera "into the light"; the ratio of sunlit to shadowed areas becomes larger and the contrast increases. The parts of the subject toward the camera are mostly in shadow; even if these shadowed areas are of relatively high luminance, the exceptional brightness of the directly illuminated edges will make them appear dark, and they are frequently underexposed.

Assume we are making a portrait with the sun behind our subject. If we want to show separation and texture in the highlights of the hair, cheek and shoulder, they should fall about on Zone VII or VIII, but the face itself is in shadow and might then fall on Zone III. The resulting image would probably be disappointing and would fail to convey the mood of enveloping light that usually occurs with backlighting. Visually we do not perceive the face as a dark mass surrounded by a halo of light, but rather the eye adjusts to elevate the value of the face to "normal" value. Thus the shadowed face should usually be placed about on Zone V (sometimes as high as Zone VI), and the high values should then be controlled by adequate development and printing procedures. Since they are at least partly specular in nature, these high values can be allowed to fall quite high on the scale, particularly if they are not too large. This situation also suggests adding "fill" light to the shadowed features, either by using a diffuse white reflector near the camera or through the use of diffused flash. ◁

See pages 172–174

As a practical matter, movement of clouds before the sun can cause rapid shifting of light values, and meter readings that are valid at one moment may not be at the next. I advise setting up a gray card (or any smooth, diffuse surface) and taking a luminance reading from it at the time you make your evaluation of the subject luminances. Just before making the exposure, take another reading of the card; this will indicate how much you need to adjust exposure. Of course, the *contrast* of the scene may also change, and you may have to make some quick mental compensation in both exposure and planned development time.

Shade (Diffused Light)

In shade or on an overcast day, as with axis sunlight, the luminance scale of a subject is usually quite short, and expansion of values in processing is usually needed. One important difference between axis

sunlight and diffuse skylight is that the latter casts broad and diffuse but appreciable shadows, whereas in axis sunlight practically all parts of the subject are bathed in light and any shadows are very small and acute.

It is very important that the lowest values of a subject in shade be evaluated and placed on the exposure scale properly. The mood of the diffuse light is usually one of enveloping rather than directional light; all parts of the subject are almost uniformly revealed to the eye. If the lowest values are rendered black in the photograph, this illusion of enveloping light is lost, and a harsh, dead quality results. Of course, there are always small shadows that can be rendered black in the print, but larger areas in which substance and texture are important should usually be fully revealed.

The actual luminances of a scene in shade may be of fairly short contrast range, and expansion of the negative may help convey the impression of both light and substance. The contrast should not,

Figure 6–9. *Sunrise, Laguna Pueblo, New Mexico.* This is a moderately strong subject. The deep shadows were placed on Zone III and N-1 development was given. The flare on the walls on the right is due to sun reflection from a wall surface projecting at right angles thereto. The sky was quite bright and demands some "burning in" on the print. Less exposure to hold the sky values would have made the shadows rather harsh, destroying the feeling of morning light. A #8 filter was used; a stronger filter would have given more separation between sky and clouds, but would have produced deeper and harsher shadows in the foreground and building.

Figure 6–10. *Detail, Juniper Tree, High Sierra, California.* The comet-like shape of dead wood was yellow in reference to the surrounding bark. I used a #15 filter which separated it effectively from its immediate environment. With Super-XX roll film (no longer made) an exposure factor of 3x would have been normal; as this picture was made in the high mountains (about 10,000 feet) I knew the light was more bluish than normal so I used a factor of 4x. The lens extension required an additional 1.5x, so the total factor was 6x. Development was N + 1. I used a 3¼ × 4¼ Zeiss Juwell camera and 14.5cm Zeiss Protar lens.

Figure 6–11. *Barn and Fence, Cape Cod, Massachusetts.* The light was soft and "milky." The darkest shadows (excepting the doors on the left) were on Zone II, and the vertical posts of the white barn fell about on Zone VIII½. The white trim around the doors was about one-half zone higher (IX). I used a light green filter (#11) which supported the foliage and slightly darkened the sky, and the development was normal. The image can be made more brilliant in printing, but the feeling of soft light may be lost and the values become a bit gross. On the other hand, I have made prints of greater richness, and the barn seems to glow with a different feeling of light.

however, be carried to the point where the lowest important values are obscured nor the highest ones blocked. The opalescent qualities of subtle tones under diffuse light can be lost if the exposure is too great or if development is carried beyond the optimum. Do not strive to achieve "luminosity" by contrast alone.

We must also, however, watch for unexpected high contrasts, and not take for granted that subjects under diffused light are always "soft." In intricate subjects there may be deeply recessed areas of very low luminance values. Similarly, the heavy shadows from hat brims or eye sockets, in portraiture, or under natural objects like stones or logs, should not be overlooked. If the exposure is in the region affected by the reciprocity effect, these low values will be even further reduced. ◁

See pages 41–42

We must remember too that open shade from blue sky usually has a high color temperature (it is "cold," tending toward blue), and the use of filters can have a considerable and unexpected effect. Filters that transmit blue will often help control contrast if it is excessive, and the "minus-blue" filters will emphasize it. The exposure factors of yellow, green, and red filters must be increased under such conditions and the factor for blue filters decreased; an adjustment of about one-half stop is usually sufficient.

There is no more beautiful illumination than that from open sky, including overcast and fog; it is favorable to the accurate rendition of related tones and colors that can be especially important when photographing fabrics, works of art, and so on. For portraiture and

the minutiae of nature it is exquisite, but it must be carefully considered and evaluated so the print suggests the full subtlety of the light.

NATURAL SUBJECTS

General Landscape

Let us consider a typical landscape situation, and then in the sections that follow I will give more detailed suggestions. If you are photographing a scene made up of rocks, trees, and a sky with delicate clouds, your first impulse might be to apply a red filter to "bring out the clouds." You should first consider what your subjective reaction to the scene is, and visualize the image accordingly. If the clouds are delicate, the application of a strong red filter would simply darken the sky and the shadows, creating a high-contrast effect that may not in any way relate to the desired mood. Considering a #6 filter possibly inadequate, you might then think of a #8, or a "minus-blue" #12 filter, which for many purposes gives the optimum effect out of doors. (The deeper #15 might produce too harsh an effect.)

Now assuming the #8 filter is appropriate to your cloud-sky problem, you must then review the other elements of the scene; photographers frequently think only of the dominant elements and disregard others, with unfortunate results. If the landscape contains numerous large forms close at hand (rocks, for example) that cast large and deep shadows, the #8 filter may cause the shadows to be rendered so dark as to destroy the desired mood, that is, a mood of enveloping and delicate light. If this side effect is anticipated, the most practical solution may be to use a #6 filter (being certain the shadows are placed not lower than Zone III with the filter accounted for), or to retain the #8 filter and give a slight exposure increase (to help the shadows) with reduced development (to control the high values which may now be slightly overexposed). The variations on this situation are endless, and some are suggested in the sections that follow.

Foliage

Nothing so definitely reveals the difference between visual and photographic rendering of values as does the photography of foliage with panchromatic film. The eye perceives yellow-green more acutely

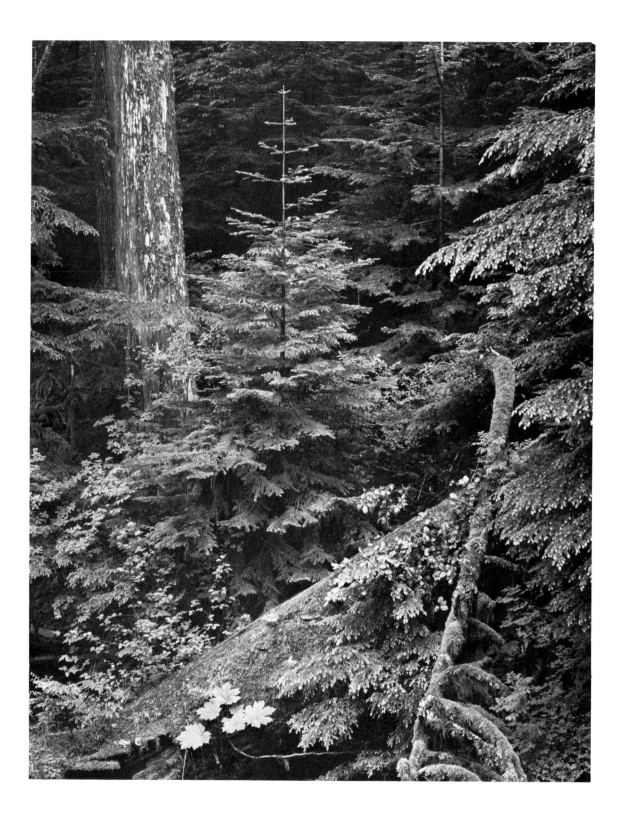

Figure 6–12. *Forest, Mount Rainier National Park, Washington.* The light was quiet, and I used a green filter (#13) with panchromatic film. (Orthochromatic film would have been better, as the reflected blue light from the sky would not have been reduced as it was by the #13 filter.) The deepest detailed shadows were placed on Zone II. Excessive contrast must be avoided with a subject of this type; the mood of the scene is quiet and sometimes difficult to preserve. This is a case where we might begin printing with a paper of soft contrast, and gradually increase the contrast to the desired degree (as will be discussed in Book 3).

than other colors of the spectrum, but panchromatic film has a reduced sensitivity in the same area. Visually the separation of foliage from other objects in the landscape depends largely upon color contrasts. In a landscape viewed through a monochromatic filter (Wratten #90), the average foliage appears on or below the middle tones of the scale. The result is a rather dark rendering of the foliage with unfiltered panchromatic film in relation to other colors that appear to be of equal visual brightness.

Foliage is composed of a great variety of colors. Dark conifers tend more to the visual blue-green, and also reflect a limited amount of extreme red, as is apparent when strong red filters are used. Bright poplars and maples have a definitely yellow-green hue. Few colors in nature have a high saturation, however, and foliage may be only about 30 percent green. In addition, specular reflections from sunlight will make certain types of foliage appear very bright but with a considerable dilution of the basic color. For example, we think of dogwood as a tree with green leaves and white flowers. But the leaves may have considerable specular reflection which, in sunlight, may be *almost* as bright as the flowers. The polarizer reduces some, but not all, of the specular shine of the leaves, since the surfaces of the leaves are not all at the polarizing angle.

When filters are used with sunlit foliage, caution must be exercised not to produce a harsh "chalk and charcoal" effect. Yellow and green filters will raise the values of sunlit areas but lower the shadows, since the latter are largely illuminated by scattered blue light and green light of very low value. Orange and red filters will lower the diffuse values of green leaves somewhat, and of course will exaggerate the depth of shadow value. When the foliage is in soft diffuse light or in full shadow, filters will have less contrast effect than in sunlight, but the values of the green foliage will be raised when yellow, green, or yellow-green filters are employed. However, as mentioned, most foliage has a rather low color saturation, and the response to filters may not be as pronounced as expected.

When contrast conditions permit, a more luminous rendition of foliage can be obtained by placing the metered values one or even two zones higher on the scale than normal, with reduced development time. This will favor the shadow values and preserve the impression of enveloping light. When the foliage appears against the blue sky it is often difficult to preserve the sense of contrast of green against blue in terms of black-and-white values. A blue filter will darken the foliage and lighten the sky. It may be better in this situation to use a monochromatic green filter like the Wratten #58. Try placing the sunlit values of the foliage on Zone VI, multiply the exposure by the published factor of the filter, and develop the negative to N + 1. The result will be approximately the following values: blue sky, Value IV; sunlit foliage, Values VI to VII. For dark conifer-

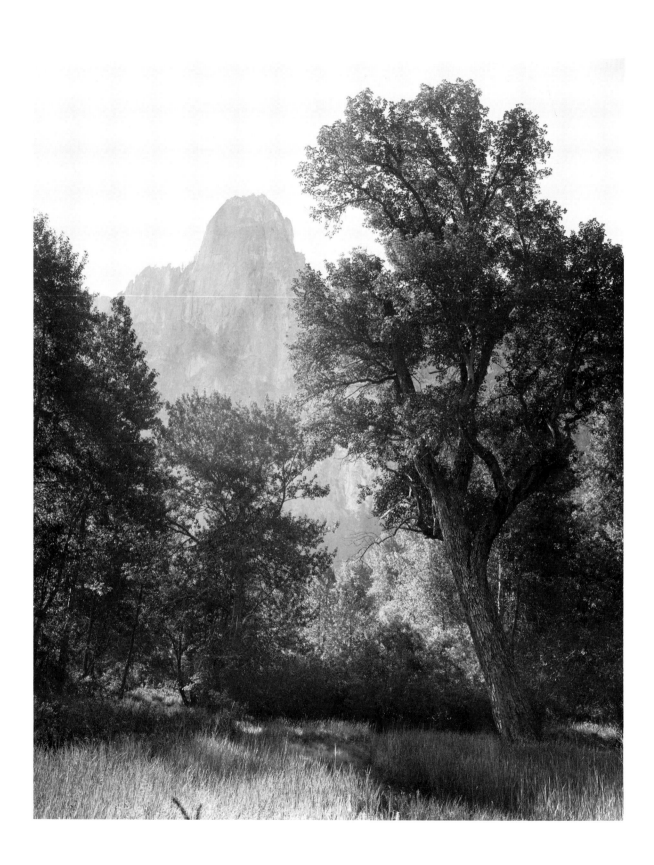

Figure 6–13. *Sentinel Rock and Oak Tree, Yosemite Valley.* This photograph was made on 6¼ × 8¼ orthochromatic glass plate in the 1920s. The orthochromatic emulsions, being sensitive to blue and green but not red, give very light or white skies and favor foliage green. This picture was taken into the sun, and the shadowed green leaves hold good value. The shadow areas are supported by the blue light reflected from the sky and by the reflected green light from the surrounding foliage. The contrast range of the subject is rather high. With an unfiltered panchromatic film the shadows would have been considerably lower in value; more exposure and less development (to control the contrast) would have been required.

ous foliage (bluish-green, of low saturation) the sunlit foliage exposed on Zone V as above should not exceed Value V½ in the print. These examples are more conceptual than otherwise; no two situations are alike.

Autumn foliage is intrinsically more colorful than average green foliage (but not necessarily *brighter*), and as a rule the yellows and reds are of higher color saturation. The use of #8, #12, and #15 filters will greatly augment the effect of brilliance in the leaves, but the proportional deepening of the shadows at the same time is likely to create overharsh contrasts. I have found that the most satisfactory effects are achieved by using a #8 or #15 filter with a higher factor than normal and giving the negative reduced development. Autumn foliage is frequently overdramatized.

Figure 6–14. *Dead Tree, Sunset Crater National Monument, Arizona.* It was late afternoon, and the dead tree was entirely in shade. The blue sky beyond (in relation to the exposure required for the tree) would have appeared as a light gray. I felt the need for a white sky to emphasize the stark shape of the tree, so I used a #47 (C-5) Wratten filter (tricolor blue) for the desired effect.

Clouds

Photographs of clouds often show a blue sky that is far too dark and sunlit clouds that are a textureless white. The use of contrast filters can darken the sky to a marked degree, but unless the exposure is kept within appropriate limits, the whites of the clouds are almost certain to lose their appearance of delicate translucency. Carelessly handled, the substance of clouds can easily be distorted into either a chalk-white, shapeless mass or a dead, gray substance of drab "cement" quality. Except under unusual circumstances, clouds and the sky seldom require a heavier filter than a Wratten #8 or #12, and placement of values on the exposure scale using such a filter should be within one zone of normal in most cases.

The rich, massive opalescence of cloud substance depends on moderate exaggeration of values. However, if landscape and clouds are to be photographed together, the problem is more complicated. Except in open scenes with fairly flat light on the landscape, you are confronted with a full scale that you cannot expect to hold entirely. At the same time a major distortion of any important value may destroy the impression of light. A landscape containing clouds that are brilliant and full of light may also possess areas of shadow that will conflict with the tonal balance of the sky if rendered too dark through overfiltration or exposure for the light areas alone. In spite of the necessity for adequate interpretation of the high values in

Figure 6–15. *Meeting House, Glendale, Utah.* This is a straight print from the negative. The mood of autumn light, enhanced by the foliage color, was gently luminous. The negative was made with the intention of conveying these qualities; there is no empty shadow nor burned-out high value. This is not the optimum print, however, but shows what the negative presents as information available for interpretive printing. The lens was moved to the right for image-management reasons (see Book 1), and the sky coverage was not sufficient; the value of the upper left corner could, however, be corrected in printing.

Figure 6–16. *Thunder Cloud, White Mountains, from the Tungsten Hills Region of the Owens Valley, California.* A light yellow filter (#8) was used, and the average of the cloud values was placed on Zone VI with N + 1 development. The effect was to produce good variations of value within the clouds. The foreground slopes (in complete cloud shadow) fell below Zone I and must be printed a strong black.

clouds, once you accept a shadow value as an essential part of the image, you must base your exposure on it and do the best you can to control the high values in development. Pre-exposure may allow you to give more consideration to the clouds in the main exposure. It is almost certain that an average meter reading of a landscape with bright clouds will place the shadows of nearby objects on or below the threshold of the negative. (See Figure 6–17.)

One of the best ways to handle a subject of this type is to use a polarizer, providing the sky areas are about 90° from the position of the sun. The polarizer will lower the value of the sky and slightly clear the atmospheric haze effect, yet will not sacrifice the shadow value of nearby objects. If the polarizer is used with a wide-angle lens, however, the sky may have an obvious uneven value due to the different degrees of polarization in different areas of the sky showing in the picture.

Figure 6–17. *Spanish Peaks, Colorado.* The light was hazy, about noontime, and the clouds were thin and without texture. For maximum brilliance I used a strong red filter (#29) and placed the foreground soil on Zone IV with N + 2 development. The piñon trees were very dark green and fell about on Zone 1; as they were further lowered by the red filter they are quite transparent in the negative. In a small print (say 5 × 7 inches) the lack of substance and texture in the trees is not too objectionable. In a print two or three times this size I would find them disturbingly empty and out of key with the other tonalities of the image. A possible solution would have been to place the trees on Zone III and give N – 1 development of the negative. The trees might have had some printable detail, but the distant mountains and clouds would have appeared softer, perhaps an improvement in interpretation. We learn much by objectively studying our own work (as well as the work of others!).

Snow

Winter photography is difficult not because of the specific problems of brightness and contrast, but because the subjective interpretation of snow involves values of the utmost subtlety. In sunlit snow scenes you are confronted with an impression of enveloping light; the contrasts may be severe, but the general sense is one of crisp, luminous brilliance. All too often you see harsh, chalky photographs of snow subjects — blocked high values and inky shadows — or the opposite: soft, fuzzy gray images without clarity or vitality. Sunlit snow usually falls appropriately around Zones VII and VIII, and shadowed areas around Values V and VI.

A scene containing both sunlit and shadowed snow is particularly difficult to manage. Shadowed snow, depending on its exposure to open sky, is at most one-fourth as bright as sunlit snow; in open forest it may be about one-eighth the luminance. But the feeling of shadowed snow is one of enveloping light, and the relationship of shadowed to sunlit snow in the print usually must be closer than in actuality if the mood is to be preserved. If it is necessary to condense the scale, I advise a #47 (blue) filter; this not only raises the values of the bluish shadowed snow, but slightly reduces the sunlit areas as well since the *minute* shadows in crystalline snow are affected.

If textural emphasis is needed, a yellow, green, or red filter will reduce both the broad and minute shadows, which are bluish. Fresh snow in particular will reveal beautiful textures if there is adequate separation of values (old packed snow may show only flat and tex-

Figure 6–18. *Winter, Yosemite Valley.* Made with a Hasselblad 500C and 120mm lens, no filter. The problem was to preserve an impression of light without allowing the image to become hard and coarse. The dark trunks of the trees were placed on Zone II; the bright snow fell on Zone VIII/IX. Development was N – 1. The tree trunks are "printed down" intentionally to about Value I; some texture appears in the print, though perhaps not in the reproduction.

tureless values under any conditions). A #8 or #12 filter should not be too strong if normal placements are used. If the texture is over-exaggerated, however, the snow loses its delicate quality and becomes granular and coarse. The deeper you see into a mass of snow or ice, the bluer becomes its substance, and a strong filter will severely exaggerate the contrast. In addition, modulations in the surface of a large snow area become more abrupt, and the luminosity may be lost. It is important to keep all values in a snow scene buoyant and full of light, and avoid letting the snow appear like sand.

◄ Figure 6–19. *Snow-Covered Trees Near Badger Pass, Yosemite National Park.* Conditions were brisk, with a deep clear sky and sparkling sun. I used a #6 filter (light yellow) and placed the deepest shadow on Zone II. The filter reduced it to about Zone I½ in actual value, slightly darkened the sky and enhanced the texture of the snow. The general shadows measured about 16, and the textured snow in the lower left was about 500 c/ft². The small areas of snow in direct sun measured about 1500 c/ft² and fell about on Zone IX. Development was normal. Had the exposure been increased the basic snow value would have been higher, and the glistening scintillations would not have been as distinct.

The polarizer used with snow in sunlight will reduce reflections at the optimum polarizing angle, but the effect is not always a happy one. The scintillations from the snow crystals lend much to the general conviction of substance, and when these are removed a "flourlike" quality may result. You may find partial polarization is preferable to full polarization.

The Ocean

Aesthetic considerations aside, the colors of the ocean are perceived chiefly in terms of reflection from the sky. If the sky is an intense, clear blue, the color of the water is a modified blue depending, of course, upon its purity, depth, and turbulence. If the sky is overcast, the ocean usually becomes a deep gray-green or even at times almost colorless. In relatively shallow regions, the qualities of the ocean floor also affect surface color, and the angle of view may also be a factor.

The blue of the ocean responds almost the same as blue sky to yellow, orange, and red filters. We have learned to accept skies of rather deep tone in black-and-white photographs, but it is difficult to tolerate excessive depth of tone in the ocean. It is seldom that a

Figure 6–20. *Surf and Rock, Timber Cove, California.* The intent of this photograph is to express force and brilliance, and considerable contrast was desired. I used a Hasselblad 500C with 250mm Sonnar lens and a #12 (minus-blue) filter. With the darkest rocks on Zone I the white water fell on Zone VIII (the central area of white water was exceptionally bright and fell as high as Zone X). Note the lighter value of the distant rocks in comparison with the nearby ones; we can assume both haze and sea spray are the cause.

Imagine yourself where I stood to make the picture. The glare on the water was severe. Visualization was complex; water without texture has a blank, plaster appearance, and thus the white water needed some variation of value (enough to suggest texture — too much would be depressed and gray). The feeling of brilliance in this case depended largely upon the intensity of the low values. I could not conceive of the rocks being gray; the effect would be drab and lifeless, just as if all the white water were a depressed value. I "saw" the scene very much as it appears on this page; the actual print is more brilliant. Subjects that involve moving water (surf or river rapids) generally require quite short exposures, as discussed in Book 1

filter stronger than a #8 is required, except under conditions of haze or when clouds and sky are important to the photograph.

From a high vantage point, the atmospheric effect usually causes a continuous lightening of tone toward the horizon; there is no such sharp demarcation of values as one finds in mountains, where range after range may stand out in definite relief against one another. If this atmospheric recession effect is eliminated by over-filtration, the ocean may appear almost as a wall — an area of single tone against the sky.

Portraiture

Perception of shape and detail is both a tactile and a visual matter. When making portraits in natural light, the subject can be clarified and emphasis changed by careful orientation to the light. Filters may be helpful in altering the rendition of flesh tones: a #8 filter is sometimes useful, but there is the possibility of creating a pasty or milky skin tone and pale lips with panchromatic film, depending on the

Figure 6–21. *Father Walsh, Mariposa, California.* One of the difficult problems in photography concerns the rendition of "white" values, which can be visualized (and printed) at many levels. The maximum white we can achieve in the print is the white of the paper base, but as we approach this extreme value we cannot hold texture or suggestion of substance. In this photograph of Father Walsh, note that the whitest area (Value X) is to be seen along the left edge of his cassock. We then have the white painted wood of the church, which in sun includes Values VIII and IX. The white area in shade approximates Value V/VI. With a head occupying a small area we can show skin at a higher value than is appropriate when the head fills the frame; in this case the sunlit side of the face is about a Value VII, and the highlight on the forehead is Value IX. The white wood and the cassock in shade (about Value V½) suggest white because of the association with the sunlit areas. The shadows, while not black, offer some key to the white values.

subject's complexion. The use of a greenish filter (#11 or #13) will tend to give more vigorous flesh values, most noticeable in the lips and ruddy or sunburned skin.

Direct sunlight is a difficult natural light source for portraiture because of its sharply defined directional quality and the relatively deep shadows it produces. It is perhaps most satisfactory early or late in the day, when the sun's rays are more nearly horizontal. In fact, axis sunlight can be luminous and revealing in portraiture. However, there are few portrait subjects who appreciate the uncompromising quality and strong shadow effects of direct sunlight, and the tendency of the subject to squint must be considered.

Occasionally strong top light (sunlight overhead) can be employed, but you should avoid the forlorn effect of a highlighted nose in a face of otherwise crepuscular gloom. This can result from taking an average reading of subject, sky, and other elements within the meter's field so that the indicated exposure is insufficient and the shadowed parts of the face fall low on the scale of the film.

Unfavorable effects may also result from glare reflected from the ground, light clothing, or other light surfaces. The eye accepts (and often overlooks!) such lighting effects that are accounted for by the

Figure 6–22. *Robinson Jeffers, Poet, Carmel, California.* This is a black-and-white version of a color photograph I made on assignment for *Fortune* magazine. For the black-and-white film I used a strong yellow (#15) filter to raise the face somewhat above the sky (he had a rather sunbronzed complexion) and deepen the value of the ocean. The figure, gate, and foliage are well rendered, although the shadows (illuminated by a deep blue sky) are quite dark.

Figure 6–23. *Mrs. Gunn on Porch, Independence, California.* With the lowest value under the chair placed on Zone I, the shadow on the face fell on Zone V. Exterior values were Zones X-XIII. I used water-bath development to control the high values. The print shows the Zone I area to be nearly full black. If I had used N–3 development I could have held the full scale of values, but the low and middle values (I to IV) would have been rendered in too-low density and contrast. Additional exposure would also have been required, and the high values would have fallen even higher on the scale. With modern films I would probably use two-solution development (see page 229).

environment. The illumination on a face from ground glare is usually acceptable in the image if the source of this illumination is a part of the general scene. But in a photograph of a head that does not include the environment, this glare effect may be ambiguous and disturbing. Watch for this at beaches, on snow fields, bright pavements, etc.

An extremely handsome light for portraiture is misty sunlight, which occurs when the sun is partly diffused through high clouds or haze. Such light is more directional than that from an overcast sky and thus lends stronger modeling to facial features, without the high contrasts of undiffused sunlight. There may, however, be rapid changes in light levels, and you should check the meter reading just before exposure.

Diffused light from the open sky or from an overcast sky reduces the contrast of the subject and may eliminate the rounded sense of

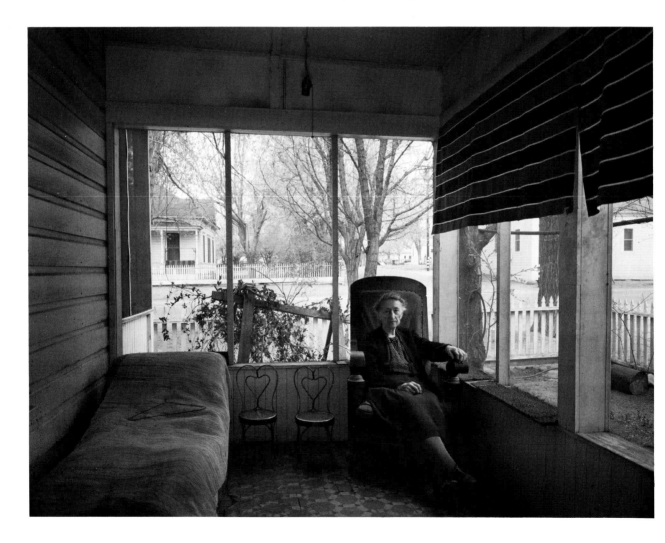

form. You can enhance the directional quality of this light by moving the subject closer to a sky-obscuring object, such as a building or foliage, so that the face is partly shielded from the light. If you wish, you can minimize the directional quality of such light by placing the subject in an open area or by careful use of reflectors. Since this light is predominantly blue, it may also exaggerate ruddy complexions.

The rendition of skin tones in diffuse natural light requires considerable care. Without the shadow quality of directional light the face may become photographically lifeless in color and value; while this effect can be attractive to the eye, the film tends to render skin thus illuminated in a depressed and puttylike tone. If the skin values are given too much exposure, the subtle variations of the higher values are lost, resulting in a rather dismal continuous gray. If they are placed too low, the skin may become granular and areas of low brightness will be too deep and "out of key." The optimum exposure should be determined by careful experimentation; to begin with, you might expose flat Caucasian skin tones on Zone V and give N+1 development. In this way the highlights will not appear too intense and the lower values should be satisfactorily retained.

Indoor natural light, from windows or skylights, can be used effectively in portraiture, and much of the same advice applies as with outdoor light. The primary difference is that such indoor lighting is usually more sharply directional, especially in a large room with distant or dark walls, and the shadows may be quite dark.

Lighting and textural effects are important elements in the interpretation of personality. Lighting effects are often overdone or repetitively stylistic; each portrait subject should evoke the appropriate treatment. ◁

See Figures 4–23, 4–24

INFRARED PHOTOGRAPHY

Infrared photography is a large subject in itself, and I do not intend to do more than touch on the issue. However, I shall give a few suggestions applicable to the use of infrared in work of expressive rather than technical objectives.

The usual exposure and development recommendations for infrared films are based on a rather extreme contrast result, which may be informative but is often unpleasant in a visual sense. Merely eliminating atmospheric effects between the camera and a mountain range a hundred miles away, or photographing a green tree as plaster white (foliage strongly reflects infrared radiation), does not necessarily achieve more than a superficially startling effect. However, I

152 Natural Light Photography

Figure 6–24. *Briceburg Grade, Sierra Nevada Foothills.* The weather conditions were quite hazy.

(A) With no filter it is obvious that the textures are weak and the clouds practically invisible.

(B) With infrared film (used with a #25 red filter) the configurations of the hills are clearly revealed. The foliage that had died or dried out in the summer heat is about middle-gray in value. Living, green foliage comes through as nearly white. Note the landscape details visible in the infrared version that are nearly invisible in the panchromatic rendering. (Because of road repair work, I was obliged to move the camera about 50 feet between exposures.) See also Figure 2–12.

A

B

do freely acknowledge that, in imaginative hands, infrared film can produce magnificent images. It is usually best to avoid large areas of sky and water in the field of view, as these are inevitably rendered very dark. However, when you are photographing into the sun the sky near the horizon may remain quite light in value.

Ordinary exposure meters cannot be used with infrared film. The exposures recommended by the manufacturer are adequate as a starting point; I personally have preferred the result of giving about twice this "normal" exposure (with a Wratten #25 filter) and soft development. I have had success with Kodak D-23 developer, giving about one-half to two-thirds normal developing time under standard conditions. Note that the recommended exposures are for sunlit subjects; exposures for objects in shadow are enormously long, as infrared rays have very feeble scattering power and thus skylight is very weak in infrared. This fact also accounts for the extremely deep shadows so apparent in most infrared photographs.

See Book 1, page 53

Most lenses require extending the lens-to-film distance slightly when using infrared film, to correct the focus. ◁ Many small-camera lenses have an index mark indicating the necessary adjustment of focus. The correction is usually in the range of 1/70 to 1/200 the lens-to-film distance; consult the manufacturer for precise information. Some lenses are corrected for infrared as well as visible wavelengths and need no focus adjustment.

Finally, be sure to use a film holder that is opaque to infrared, and process as soon as possible after exposure, in total darkness.

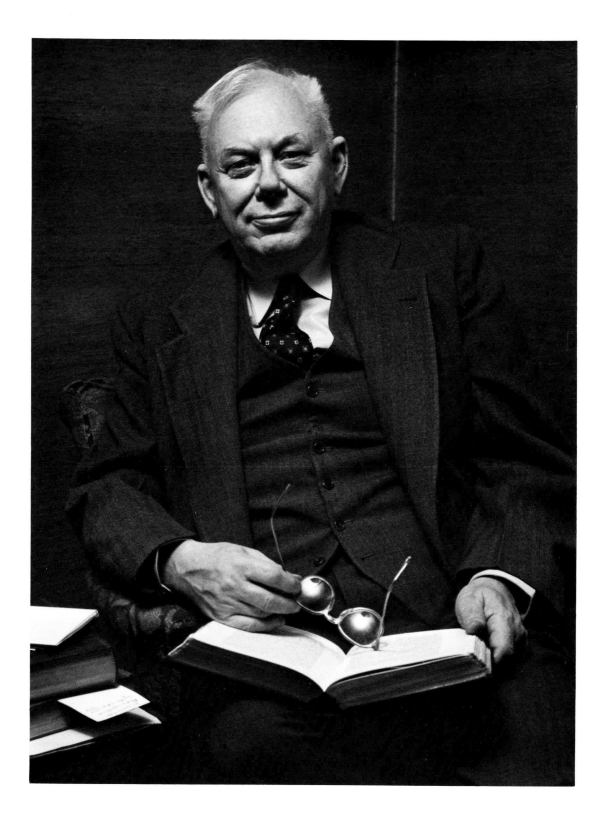

Chapter 7 Artificial Light Photography

Figure 7–1. *Dr. Dexter Perkins, Historian, University of Rochester.* This is an example of fairly sharp bounce light. I used a No. 4 photoflood in a deep cone reflector, which I directed onto a light ceiling, to produce a bright circular "light source" about 15 inches in diameter. This was located about midway between camera and subject. Had it been closer to the subject, the shadows would have been too heavy; if closer to the camera, the shadow effects would have been reduced and the features of the face less pronounced, exaggerating its roundness. Note that the reflection of the light is caught in the glasses. A "catchlight" would have added sparkle to the eyes. Caution must be used when bouncing hot lights off nearby reflective surfaces because of the risk of damage by scorching and the possibility of fire.

Light is light, and the image is composed of the effects of reflected light whether it is natural or "artificial." Within the natural world the light is used *as found*, with few exceptions, in a process that is essentially analytic. The use of artificial light, on the other hand, may be thought of as a process of synthesis, where we are free to control the amount and nature of the light and direct it as we wish on our subject to gain the desired effect. In its most controlled form the use of artificial light may involve staging a "set" with total control of the disposition of the subject, its colors, and the illumination; the concept of the image is in the set itself, and we use the camera to record it.

There has been tremendous improvement in lighting equipment and techniques in recent years, and detailed information is available from a number of sources. My intention here is to present certain concepts and approaches that will provide a good basis for understanding the potentials of artificial light. Although basic, these concepts will stand the photographer in good stead even at sophisticated levels of practice.

CONTINUOUS-BURNING LIGHT SOURCES

Tungsten bulbs in reflectors are widely used and are the least expensive kind of studio light. The *photoflood* bulbs are available in two wattages, the Number 1 at 275 watts and the Number 2 at 500

See Book 1, page 37

Figure 7–2. *Wine Casks (Paul Masson Cellars, Saratoga, California).* Illumination was from several overhead tungsten lamps in fixed ceiling reflectors. The exposure was very long, as a small lens stop was required for adequate depth of field. The meter indicated an exposure time of 1 minute; I gave 10 minutes and developed the negative for two-thirds normal time to control contrast (see page 42).

watts. Each has a color temperature of 3400°K, and is manufactured both as a conventional bulb for use in an 8-inch or 12-inch reflector, or with the reflector built in. Photofloods are also available coated with blue plastic filter material, which corrects their color balance for use with daylight color film. There is also a 3200°K photographic bulb, rated at 500 watts, which has a longer life than the photofloods and undergoes less color shift during its useful life, although this is a factor only with color films. Both these types are being superseded by smaller and more efficient tungsten-halogen and quartz lamps.

The surface properties and shape of the reflectors have a major influence on the efficiency and light distribution of all such lamps. The inner surface can be highly polished metal or "satin" finish, and nonflammable diffusing screens of glass fiber or plastic are sometimes used to soften and equalize the light. Most reflectors are designed to give a fairly broad and uniform distribution of light, but "focusing" reflectors and spotlights (which usually include a Fresnel lens ◁) tend to concentrate the light in a beam. It is worthwhile to set up each lamp so that it illuminates a uniform wall and use a meter to study the distribution of light within the field of the lamp. With a brushed aluminum reflector and properly centered bulb, the field of illumination should be continuous and quite uniform, without a strong central "hot spot." Of course, the brightness of the field will diminish somewhat near its edges due to a natural fall-off of illumination. Reflectors of certain configurations (parabolic, etc.) have an effective "focal length" that will alter the Inverse Square

Figure 7–3. *Hanging Hides, A. K. Salk Co., Santa Cruz, California.* The relatively monotonous subject values required accentuating with strong side lighting. I used two lights, one from the left on the figure and the other from the far right to light the edges of the hanging leather. The latter light was quite strong and in a fairly narrow reflector of the parabolic type. It was directed toward the fourth hanging hide from the left, so that the strong central "beam" of the lamp was aimed at the most distant hides, and the illumination from the edge of the lamp's field fell on those hides closer to it. No fill-in lighting was required; the reflections from the hides themselves and the general room illumination were adequate to support the shadows.

See page 158

Law ◁ control. This effect can be very important when flash lamps or tubes are used.

Other types of artificial light include ambient or available light from sources of all kinds, such as ordinary lamps, fluorescent fixtures, and even candlelight. For black-and-white photography the light from such sources can be metered and used without concern for the variations of color of the source, but color photography demands consideration of the color temperature of the light. Fluorescent lamps are particularly difficult in this regard because they do not have a continuous spectrum, but give off light in separate peaks at certain wavelengths. Adequate color correction can often be managed (sometimes by combining fluorescent tubes of different spectral distribution), but testing is usually required. Some fluorescent tubes are available that have a more complete spectrum.

Exposure

Studio photographers have traditionally made use of the incident-light exposure meters, both because their subjects may be too small to read with a general-purpose reflected light meter and as a means of measuring separate light sources. The incident meter is increasingly being replaced by the spot meter because of the greater precision it affords in maintaining full control of the subject contrast and luminance values.

One property of incident light that should be fully understood, however, is the relationship described by the *Inverse Square Law*. This law relates the distance from a light source to the subject and the intensity of light incident upon the subject. For a given light source, moving it so that it is twice its original distance from the subject causes the incident light on the subject to be reduced to one-quarter its original value. If, for example, an object has 16 ft-c of light incident upon it when located three feet from a lamp, it will have only 4 ft-c when the lamp is six feet away, and only 1 ft-c if the distance is twelve feet. In general terms, the Inverse Square Law states that *the intensity of light on a surface is inversely proportional to the square of the distance from the light source.* ◁ Reading the reflected light value of a surface at various distances from a lamp will confirm the Inverse Square formula.

See Figure 7–4

The Inverse Square Law is strictly true only for a "point source," but applies in a practical sense to any light that is not too large in apparent size (that is, its size as it appears from the subject). Its effect is also modified by the use of focusing reflectors and light sources that include a Fresnel lens or other means of concentrating the light beam.

The effect of the Inverse Square Law can be considered in terms of the Zone System. For example, if the shadowed side of a subject falls on Zone III and we move the lamp illuminating this surface to half its original distance from the subject, we know that it will receive four times as much light, and will therefore fall two zones higher, on Zone V. This change obviously will also affect the volume of illumination throughout the subject.

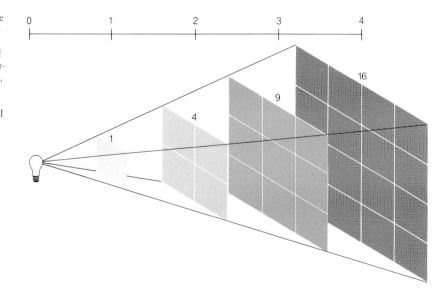

Figure 7–4. *Inverse Square Law.* The Inverse Square Law says that the intensity of light on a surface is inversely proportional to the square of the distance from light source to surface. Thus if the distance is doubled, the light intensity falls off to one-fourth its original value. For precise ratios the light source must be small compared to the distances involved.

It can be helpful in controlling lighting to think in terms of *exposure units*. If Zone I represents one unit, the other zones are related by the 1:2 ratio as follows:

Zones:	I	II	III	IV	V	VI	VII	VIII	IX
Exposure Units:	1	2	4	8	16	32	64	128	256

When using more than one light source, we can consider a change of lighting in terms of these exposure units, since accumulated exposure units are more obvious in the lower zones of the scale and have increasingly little effect as we reach higher zones. In the example above of the Zone III shadow area raised to Zone V by moving the light, the area that originally represented 4 units will reflect 16 units because of the change in lighting. Thus we have added 12 units by moving the light, and this effect will occur throughout the subject (for all areas illuminated by this lamp, provided they are about the same distance from the lamp). The overall result is as follows:

Zones:	I	II	III	IV	V	VI	VII	VIII	IX
Exposure Units:	1	2	4	8	16	32	64	128	256
Added Units:	12	12	12	12	12	12	12	12	12
Total Units:	13	14	16	20	28	44	76	140	268

As can be seen, the effect of adding 12 units of exposure throughout the scale is most apparent in the low values, and much less pronounced in higher values. The change of lighting raised the Zone III area by two zones, but by Zone VI the change is only about one-half zone, and even less at higher zones. The effect of such lighting change should be confirmed with a *spot* meter.

My procedure when I was doing professional work was to visualize the overall arrangement of an interior or studio setup and indicate on the Exposure Record where I wanted the important values to fall on the scale of exposure zones. I would then start lighting the high values first, adjusting the lights for the desired visual effect and ensuring that their luminances fell on the desired exposure zone. I would then work with the low values, bringing them up to useful levels. The reason for giving consideration first to the high values is that their total luminance is limited by the maximum light at my command, while I can always make adjustments of the low values by moving secondary lights or reflectors. If the secondary lights build

Figure 7–5. *Student Group in Library, University of Rochester.* The problem here was to achieve an illusion of appropriate balance between the interior and exterior values; the interior lighting had to be balanced with late afternoon daylight on the building seen through the window. The basic exposure was determined by the brightness of the building facade (placed on Zone V) and the sky (which fell on Zone IX). With these values determined, the next problem was to build the light on the group to simulate the existing light in the room. I directed two lights in cone reflectors at the subjects at an angle approximating that of the stand-lamp. The girl's face is illuminated by the light within the lampshade and from the distant light that was directed on the boy at the right. The distant light that was aimed at the boy in the center also gave some illumination to the girl's hair and shoulder and the back of the chair. Careful shielding of this last light would have added to the illusion of reality; the only part of the image that is not convincing is the extreme left-hand part of the chair and the obvious backlighting of the girl. If you place your thumb over these areas you will see what I mean. A third light was bounced from the wall and ceiling behind the camera to raise the shadows slightly. I used a Hasselblad camera with 80mm lens.

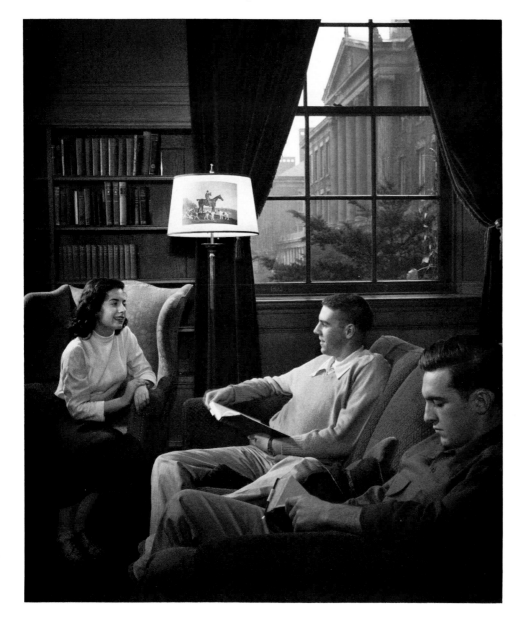

too much luminance in the high-value areas, the main lights can be reduced in power or their distance from the subject increased. We thus obviously have considerable control over the lighting values.

AN APPROACH TO LIGHTING

As with many aspects of photography, the problem of using artificial light is often attacked in reverse. The beginner often starts with lighting formulas, with no clear realization of the structural and expressive effects of controlled lighting in relation to his subject or his concepts. Perhaps no formulas are as harmful to creative achievement as the conventional "rules" of lighting. Rather than begin the study of artificial lighting with light, it is far more productive to begin *without* light and gradually add illumination with consideration for the shapes and textures of the subject. In this way the effect of each lamp can be individually evaluated and the result of a change of lamp position or reflector can be appreciated. Following this approach it becomes possible to "build" an appropriate lighting for the subject. Since the eye will adjust to a wide variation of lighting intensity and balance, the subject luminances should be carefully evaluated with a spot meter and related to the visualized concept, so that you can anticipate just what your negative will contain.

Figure 7–6. *Interior.* This is a good example of allowing the balance of illumination between interior and exterior elements to become too close. The illusion created is that of an interior with a mural on the wall. In this case, if the interior had received about half the exposure, the impression of looking through the window would have been achieved. In lighting an interior like this, of course, the problem of reflections in the glass must not be overlooked. I used small areas of bounce light to raise the values of the ceiling and walls on either side of the window. Positions of lights had to be checked carefully on the ground glass of the camera to be sure they did not cause reflections in the glass. Compare the balance in this photograph with that of Figure 7–5, where the outdoor area seen through the window is quite convincing.

Figure 7–7. *Lighting effects with a cube.*

(A) The cube appears in silhouette. A strong light was projected on the background and the cube shielded from environmental light by a dark cloth. The image conveys no sense of substance of volume.

(B) Flat (axis) light was provided from a broadly diffused source behind the camera, and the background was a black cloth. The form can be vaguely seen because of a small amount of environmental light in the studio. Neither of these two photographs depict the cube effectively; only our experience with cube shape suggests that this is other than a two-dimensional object.

A B

Lighting a Cube

Much can be learned about controlled artificial lighting by working first with a simple form like a cube. The cube should be about 12 inches on a side, made of smooth material, and painted a dead matte white. In a darkened room, or with the eyes closed, handle the cube (wearing cotton gloves to avoid finger marks) until a physical appraisal of its shape and volume, surface and edge, is grasped. We thus arrive first at an awareness of this object by nonvisual, tactile means.

See Figure 7–7(A)

The first visual and photographic experience of the cube is that of a silhouette — the outline of its form appearing against a light background. ◁ Combining our tactile appreciation of this object with the visual, the outline alone confirms solidity, thus indicating how involved is our instinctive comprehension of the external world. Although we see it as an outline, our mind recognizes it as a cube!

See Figure 7–7(B)

The next step is to see and photograph the cube in a completely flat axis light — that is, light from a point close to the axis of the lens. ◁ The axis light, in order to achieve its purpose (to fill every part of the subject as seen from the lens with a consistent value of illumination) should be behind the camera; if it is in front of the camera, shadows cast by the subject will appear in the background larger than the cube itself. The ideal light for this purpose would be a ring tube encircling the camera at the focal plane. A light behind the camera, raised sufficiently to avoid casting the camera's shadow on the cube, is adequate. If all three visible faces of the cube are at approximately the same angle to the lens axis and to the light, all will have about the same luminance value. The cube must, however, be sufficiently distant from the light to avoid significant fall-off of illumination from its near edges to the distant ones. The background should be either very light or quite dark. Note that in this example,

Figure 7–8. *Lighting effects with a cube.*

(A) A main light on the right produces a Value VII and grazes the top surface, giving a Value V. The second light (on the left) gives the left side about a Value IV, but was lowered to avoid allowing light to fall on the top surface. The background is a Value I.

(B) The same lighting as A but twice as intense produces Values VIII, VI, and V. The background remains Value I.

(C) With the right-hand light again doubled in intensity and raised so more light falls on the top surface, these two values are now IX and VIII. The left-hand light was quadrupled in intensity, and the left side is now a Value VII. We thus now have the three top values of the scale, VII, VIII and IX.

(D) The side lights are about the same as in A but the lighting of the top surface is from a spotlight overhead, placed so that none of its light strikes the sides of the cube (the lens was also carefully shielded). Since this prints as pure white it is designated Value X, so that we now have Values IV, VII, and X against a background of about Value V.

A

B

C

D

Figure 7–9. *Lighting effects with a cube.*

(A) There is varying intensity of light on the background, so that the values of the left side of the cube approximate the background values on the right side. An impression of space is added and an illusion of value-differences created as we scan various sections of the image.

(B) The background is about Value VI and merges with the right side of the cube. In a typical subject, areas may appear distinct because of color differences, yet reflect the same luminance values, and a merger of value may result when photographing with black-and-white film. The use of a #90 viewing filter will help make these mergers more noticeable. There are also occasions when the merger effect may have definite aesthetic justification.

A

B

like the first, we appreciate the volume of the cube even though only minimal visual evidence indicates its shape.

We can reduce the intensity of the axis light and add a light from the side, illuminating both the top and one side of the cube. If the top and side surfaces are at the same angle to the side light, both values will be approximately the same, but by moving the light so the angles differ, we can make one or the other brighter if desired. With this arrangement, we have a composition of four luminance values, including the background. Note too that, although we can illuminate the background separately, we have considerable control of its value by simply moving it closer to or farther from the subject. Its value will be higher or lower depending on its distance from the lamps.

See Figure 7–8

We can now experiment further with the two lights: ◁ increase the intensity of the axis light; increase the value of the background; try adding another light on the side opposite the first side light; eliminate the axis light, or the second light, and observe the harsh contrast that results. You may also add a top light, which will increase the luminance of the upper surface of the cube. We have full control over each of the four values of our composition, leading to the basic but important subjective question: what value do we want each surface to be? The possible combinations are almost unlimited, and you should study the effects of each lighting change, plus exposure changes, to determine what arrangements you find satisfying. It is best, of course, to measure each value with a spot meter to make the separate evaluations of each luminance, and then place them as desired on the scale of zones.

As you advance to more complex subjects than the cube you will find other issues that require consideration: a broad light source will produce broader highlights and more diffuse shadow edges than a point-source light. Care must be used with multiple lights that conflicting shadows do not become disturbing. Using an axis light alone with a curved or spherical subject results in the "limb effect" dis-

See page 132

cussed earlier: ◁ with a light background we see the outline of the subject clearly as a darker value, and with a dark background the edges become indistinct.

Indirect Lighting

The use of white reflecting surfaces to "bounce" light onto the subject can be extremely helpful. A simple white card, or, with a large subject, a white wall, on the opposite side of the subject from the main light can provide soft and luminous "fill" light for the shadow areas. Reflected light can also be used as the main source itself, and gives soft shadows and gentle modeling of features that can be quite beautiful and is thus frequently used in portraiture. Reflective "um-

Figure 7–10. *Adjusting microtome knife.* I made this photograph with a Hasselblad camera and 80mm lens with extension tube. The main illumination was from an intense microscope light, plus bounce light from the white ceiling. The critical focus was on the knife, and the use of the smallest stop gave adequate depth of field. The required exposure was one second. The hands were secured in position by allowing them to rest on the table and in contact with the instrument. Electronic flash would eliminate the problem of subject movement.

brellas" have become very popular for such work because they are quite efficient and can be folded for portability.

With large subjects we can frequently use an existing surface as a reflector. The ideal surface is a smooth white wall or ceiling which has a high reflectance value and produces a diffuse light (with color film it is important that the surface be a neutral white). If we direct a lamp at such a surface, the result is a circle or oval pattern of light which becomes in effect the light source. The size of this circle relates to the reflector shape and the distance of the lamp, and its size affects the quality of light on the subject: a large area of illumination (as seen from the subject) provides broader and softer lighting. In terms of the amount of light, however, the distance from the

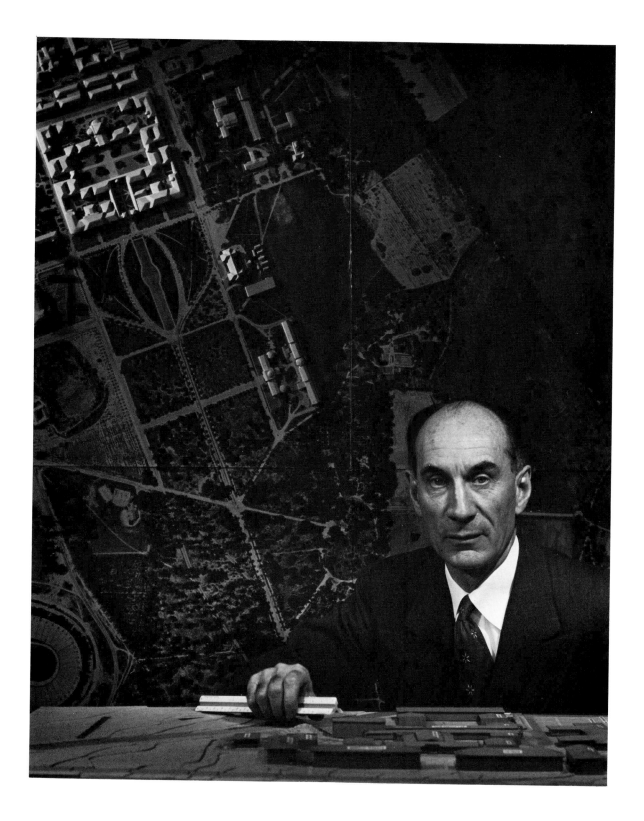

Figure 7–11. *Eldridge T. Spencer, Architect, Stanford University.* I placed one light slightly above the lens axis, a second light on the far left to illuminate the upper corner of the wall model of the university, and a third light bounced from the walls behind and to the left of the camera. I printed down the foreground table somewhat to accentuate the white ruler in his hand. This can be considered an environmental portrait, where the intention was to convey something of the personality of the subject and an impression of the university where he served as chief of planning. I used a Hasselblad camera and 80mm lens.

lamp to the reflecting surface makes little difference. The light source delivers a certain amount of light within its circle of illumination, and this is not changed by moving the light in relation to the reflecting surface, provided all the light is contained on that surface. The distance from reflector to subject, on the other hand, does affect the intensity of light on any part of the subject.

Cross Polarization

As discussed earlier, the polarizer is a useful means of eliminating glare and specular reflections in the subject. In the studio a polarizer over the lens can be used in conjunction with polarized light sources to eliminate glare completely. Sheets of polarizer material set at one orientation are placed over the light sources, and a separate polarizer

Figure 7–12. *Flowers in Vase (Painting by Henri Fantin Latour).*

(A) With the light source close to the lens axis, no shadow is cast on the painting by the frame, but the painting surface shows strong reflections. Since the camera-lens axis is perpendicular to the painting surface, a polarizing filter over the lens alone would have no effect on the disturbing glare.

(B) With a polarizing filter over the light and another over the lens, the reflections can be eliminated. In this case the exposure reading is taken with the polarizer in place over the lights, and a factor of 2.5 is applied for the polarizer over the lens.

A B

is placed over the lens. Specular reflections from the subject are thus polarized in the direction of the sheets on the lights, and by rotating the polarizer over the lens to 90° from this direction, the glare on the subject is eliminated.

FLASH

Flashbulbs and electronic flash provide, in effect, convenient "packaged light" in sizes that range from small portable flash units to large studio systems with multiple flash heads. Flashbulbs are available either clear, appropriate for color film balanced for tungsten light, or

See Book I, pages 86–88

with a blue filter coating which provides daylight illumination quality. Electronic flash also has daylight color balance. Important characteristics of flash units include the flash duration and the required synchronization with the shutter to make certain that the flash output is efficiently utilized. ◁

The chief difficulty in using flash lies in visualizing the effects of the light on the subject — the modeling of features, shadow and highlight disposition, and so forth. Many studio-sized flash units contain "modeling lights," continuous-burning lamps of moderate intensity built into the flash heads, which show visually the effect of the lighting arrangement. With some units these modeling lights are calibrated to be proportional to the flash output so that luminance ratios may be established by measurements taken from the modeling lights.

The effect of a single flash used on or near the camera — seen in countless snapshots — is a harsh, textureless lighting. With color film, such lighting also tends to produce "red eye," a red reflection from the retina (this reflection can be avoided only by moving the flash away from the lens axis, but it can be reduced by maintaining a high level of ambient light so the subject's pupils contract). The unpleasant flat quality of flash-on-camera can be reduced by making use of reflective surfaces to direct light onto the subject from one

See pages 171–172

side, or by "bouncing" the flash, ◁ but the exposure, of course, must be adjusted to compensate (except with some automatic flash units).

"Bare-bulb" flash units, which have no reflector, are designed to make use of light reflected from the environment to soften the light quality somewhat, as well as to produce "catchlights" in the eyes with portrait subjects. This type of light is of extremely small source angle, and any shadows not filled in by environmental reflection will have very sharp edges. Because the light is not directed onto the subject by a reflector, a bare-bulb flash will have a lower guide number than a comparable unit with reflector built in. Bare-bulb units are particularly useful with wide-angle lenses and I have used them for low-value fill-in lighting.

Exposure With Flash

The standard means of determining exposure with flash is by using the *guide number*, which incorporates the intensity of the flash-reflector unit and the film speed, and, with flashbulbs, the shutter speed. *The guide number divided by the flash-to-subject distance in feet gives the lens aperture.* * Guide numbers are thus in geometric

*The general formula is:

Guide number = (flash-to-subject distance) × (aperture), and knowing any two of

Figure 7–13. *Phyllis Bottome, Author.* I used two flash bulbs, each in a rectangular light box with satin finish (note the shape of the catchlights in the eyes). One light was about 6 feet from the subject and the second about 12 feet distant (both at about 45° to the subject). The ratio of illuminance from the two sources was thus 1:4. The image is intentionally soft, because of the "overlap" of the light from the two lamps, and because of relatively high exposure and reduced development of the negative. I used a 10-inch lens on 4 × 5 film.

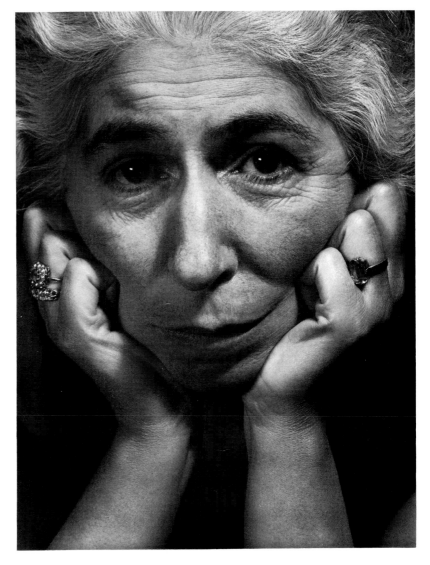

See Book 1, page 86

sequence, so that a doubling of guide number represents a 4x increase in the intensity of light.

With conventional flashbulbs, which are relatively slow burning, a change of shutter speed affects the amount of the flash output that reaches the film, so that different guide numbers are required for different shutter speeds. Electronic flash does not require such a change of guide number since its total output is used at any shutter speed up to the maximum that synchronizes with electronic flash. ◁

these quantities allows you to determine the third. If you wish to use a certain aperture, for example, the guide number divided by the aperture gives the distance in feet at which the flash must be positioned.

You should also be aware that different reflectors and changes in environment will affect the exposure, and the guide number should therefore, as its name implies, be considered only a *guide*, subject to verification and adjustment as conditions require. With electronic flash, furthermore, the "ready light" usually signals when the unit is charged to about 80 percent of capacity, and a different exposure may result if the unit is used immediately after the light comes on than if you wait several additional seconds.

Automatic electronic flash units have eliminated the need for much of the conventional exposure calculation, since they interrupt the flash pulse when the sensor has received sufficient light for exposure. The most efficient units use "thyristor" circuits to recycle the excess energy not required for an exposure, and thus speed up the recycling time. ◁ Do not overlook the fact that the reciprocity effect may influence exposure and contrast with electronic flash. ◁

Multiple flash units may be used in much the same way as conventional lamps, particularly if modeling lights are present to show the effect of the placement and strength of each flash head. The smaller flash units may be combined by wiring them together with standard cords or using a "slave" accessory which triggers an auxiliary unit when it senses the light from the main flash. In such cases the most reliable means of determining exposure is by using a flash meter, which can read the intensity of all flash illumination on the subject and indicate the aperture for normal exposure. Since these are a kind of incident-light meter, however, there is no indication of what the actual luminance values of various parts of the subject are. We must make visual judgment of the relative reflectances of various subject areas and the effect of light placement, etc. Polaroid test photographs will be of great value in such situations.

Bounce Flash

Flash is frequently bounced off walls or ceiling to avoid the harsh lighting effects that direct flash may produce. However, calculating correct exposure becomes difficult without a flash meter. A rough estimate can be made by taking the flash-to-reflector-to-subject distance and using it in the guide number calculation, adding one to two stops or more depending on the reflectance of the surface. Practice is required to judge exposure with bounce flash confidently. Some automatic flash units permit the flash head to be directed upward or toward a wall while the light sensor remains directed at the subject; they thus automatically compensate for the loss of light caused by bouncing and eliminate the need for separate calculation.

You must keep in mind with bounce flash the relationship of flash

See Book 1, page 170

See pages 41–42

Figure 7–14. *Vronsky and Babin, Duo-Pianists, San Francisco.* This was a difficult and interesting problem. The "nesting" of the two grand pianos created a considerable scale and depth-of-field problem, suggesting the use of a long lens (14 inches on a 4 × 5 camera) and relatively distant camera position. The camera was about 30 feet from the foreground figure, and about 8 feet above the floor. The distant camera position had the additional advantage of keeping the two subjects in about the same scale; moving the camera closer and using a shorter lens would have emphasized Mme. Vronsky (see Book 1) and undermined the idea of the artistic equality of both members of the team. The plane of critical focus was about four feet beyond the foreground figure, and f/32 provided adequate depth of field. It was important to control the lighting to separate the figures decisively from the background. I used four flash lamps positioned as follows: one light to the right for the woman's profile; one light above the man's head; one light bounced from a white screen to support the shadows, and one light against the background. The use of modeling lights in the flash units allowed careful balancing of the light. The exposure was controlled to expose the woman's arm on Zone VI, and the high values on the arm and head approach Zone VII.

source and reflective surface to the subject. If you are standing close to a portrait subject, for example, flash bounced from the ceiling will provide only direct overhead lighting, and may thus cause deep shadows in the eye sockets. Problems can also arise in a low-ceilinged room with, for example, a standing figure; because the ceiling is relatively close to the subject there will be a noticeable fall-off of illumination between the subject's head and lower body. In both cases you may be able to use a light wall in combination with the ceiling as a reflective surface, or you may choose to allow some light from the flash unit to "spill" directly on the subject. As with reflected light from continuous-burning sources, you must also be certain that the reflective surface is white or neutral gray if color film is used. Some flash units, such as one made by Vivitar, include a reflective panel for bouncing the flash.

Open Flash

With open flash the shutter is first opened with the subject in darkness, and the flash is then triggered one or more times to expose the film. This procedure is primarily for static subjects. The flash unit can be fired from different positions to produce the effect of several light sources (but beware of conflicting shadows), or it can be fired from a single position as many times as needed to provide the required luminance levels. A variation frequently seen is to use electronic flash with a moving subject, firing the flash unit to arrest the subject at different positions; some ambient light may be allowed on the subject so the separate images "frozen" by the flash are connected by a blurred image. Since the results cannot be seen in advance, testing with Polaroid film is very helpful.

Fill-in Flash

Flash is often used outdoors to provide supplementary fill-in illumination for a subject that is side- or back-lighted. The flash may be mounted on or near the camera, where it will raise the value of all shadow areas seen by the camera, thus reducing the contrast. The balance of direct and "fill" light is critical; with too much fill-in light the shadows become unnaturally bright and an "artificial" effect results. We have all seen photographs where the flash-illuminated area approaches or exceeds the sunlit "surround" in brightness; the photograph usually has a "staged" quality, sometimes a deliberate effect.

Electronic flash (preferably a diffused source) is ideal for fill-in use since it is relatively easy to compute exposure. The exposure from

Figure 7–15. *Various degrees of fill-in flash.*

(A) The existing sunlight gave a very harsh effect, with a range of about Zones II to VI/VII, exposed and developed normally. The skin values were placed on Zones VI and VII.

(B) Low-level diffused flash was added (2 units of light), sufficient to bring the face in shade to Zone III.

(C) The total fill-in flash was 4 units, sufficient to raise the face in shadow to Value III½.

(D) With 8 units of light added by the flash, the shadow side of the face is between Values IV and V. In this case I used an ordinary polished flash reflector which became a secondary source of direct light. Note the suggestion of acute values within the shadows of the face, and compare with the effects of broad diffused light in B and C. There is also a strong shadow cast on the background rock, which I consider unacceptable unless intentionally theatrical effects are desired. Had the flash been located at the camera only minimum shadows would have been present; the quality of the high values and highlights can be somewhat strange, however, unless the flash is broadly diffused.

A B

C D

the flash changes only with a change of distance or aperture, not with a change of shutter speed (within the range of synchronization), and it is balanced for use with daylight color film. The problem in computing exposure is to achieve a balance of "normal" exposure for the daylight-illuminated areas, and flash exposure that is sufficient to raise the shadow values to the desired level. In general terms we first use the guide number or exposure dial on the flash to determine the appropriate aperture for normal flash exposure at the given subject distance, and then use a setting one to two stops below this

normal flash exposure. We then choose the shutter speed that will give normal daylight exposure at that aperture.

Suppose you take daylight meter readings from a portrait subject and find that the shadowed skin value falls on Zone II (2 units of exposure) with normally exposed high values. If we wish the shadowed skin value to be on Zone IV (8 units) our problem is to use the flash to add 6 units. If the normal guide number for the flash unit is 64, we may use a guide number of 128, thereby reducing the flash exposure to one-quarter normal (a two-stop reduction). The skin values which would normally be on Zone VI (32 units) are thereby reduced to Zone IV (8 units) in the flash exposure. The added two units of daylight will be almost inconsequential, but to be precise, we can move the flash slightly farther from the subject. On the other hand, the sunlit portions of the subject, which are on Zone VI (32 units), will receive 8 more units from the flash, a negligible increase of one-quarter exposure zone.

Remember, the lens stop used is determined by the distance of the flash, and the shutter speed chosen in relation to the aperture to give normal exposure for the daylight-illuminated areas. It is sometimes necessary to adjust the intensity of flash illumination. If a reduction in flash exposure is required, you can use one or two layers of white cloth over the flash; the effect must be tested so we will know precisely what the actual exposure will be.

PAINTING WITH LIGHT

A technique called "painting with light" can greatly expand the versatility of incandescent lighting equipment and help the photographer contend with some difficult lighting problems. Painting with light involves moving the light source while the shutter remains open, thus giving the effect of a very broad and non-directional lighting. Painting with light can be effective for small objects in the studio, but I found this approach most useful for lighting large interiors.

One difficulty in lighting an interior space with multiple *fixed* lights is avoiding the conflicting shadows which often produce a confusing visual effect. Usually in such photographs the viewer should not be conscious of the lighting employed, either through multiple shadows or differences of lighting intensity. Painting with light enables the photographer to bathe all parts of the subject in the desired volume of light, and to add light as needed to emphasize specific areas. If desired, we can also add a static light in a separate exposure to provide fixed highlights and provide a definite single

shadow effect. Naturally, if all parts of the subject were bathed in equal values of illumination, the effect would be dull, to say the least. We therefore must plan the picture, taking into consideration the desired final effect and managing the problems of additive light values, emphasis of light, and uniform luminance throughout the image area.

The procedure requires moving the light through the subject area uniformly while rotating it in a large circle in a smooth continuous motion across the field. The photographer must be careful to keep his back to the camera at all times and to avoid letting any light "spill" in the direction of the camera. It is important therefore to use a reflector that has no ventilation holes near the socket nor any shiny reflective surfaces that could leave a streak on the film during exposure. Obviously, the exposure must be sufficiently long to permit the photographer to move across the field in front of the lens without producing a "ghost." *He must not stop moving at any time during the exposure or a ghost image will appear in the picture.*

The exposure is judged by taking luminance readings from selected parts of the subject with the lamp on and stationary. We then plan the movement of the lamp in such a way that each area it covers is exposed for the required time and properly overlapped. For example, if the lamp covers 15 feet of the subject area and we calculate an exposure of twenty seconds (corrected for the reciprocity effect), we

Figure 7–16. *"Walking Tiger" (sculpture by Arthur Putnam).* This object is a very dark bronze that reflects harsh highlights from fixed overhead lights; the eye can adjust to the resulting contrast, but film could not. Placing fixed lights around the subject would have produced complex additional highlights. "Tent" lighting (i.e., light bounced from reflective surfaces that surround the subject) might have been possible, although the broad reflections could have changed the impression of substance. I considered the best solution to paint with light, passing a light in a broad reflector across the subject while the light was raised and lowered. I made some experiments to determine the desired amount of diffuse light in relation to the highlights, which could not be controlled. With too much light, the feeling of dark bronze would have been lost. Since the painting exposures were quite long, the reciprocity factor had to be included.

Figure 7–17. *Cocktail Lounge, St. Francis Hotel, San Francisco.* During the long exposure by available light from the Lucite ceiling, I used a spotlight to "paint" the black leather under the bar to bring out the tufted surface. An assistant carried the light, following a line roughly parallel to the bar. It was not a continuous movement; the spotlight was operated from a series of positions which offered a clear space between the tables and chairs, and at each station the light was moved in a circle about two feet in diameter. Thus the highlights on the tufts in the leather were limited to their proper areas. Had the surface been painted continuously the highlights would have been elongated, and there might have been unfortunate accents of light on the stools. The print was made rather soft to preserve all values in reproduction. In most such situations I believe the potentials of existing illumination should be explored *before* applying artificial light. This bar, unfortunately, is no longer extant.

See page 158, Figure 7–18

know that each 15-foot area of the subject must receive illumination from the lamp for a 20-second period. We would thus plan to move the lamp across the subject area covering 15 feet in each 20 seconds, with the lamp in continuous rotating motion. We must begin with the *axis* of the lamp directed at the very *edge* of the picture area; do not make the mistake of allowing only the edge of the lamp's field to illuminate the edge of the subject, or a fall-off of illumination will result.

Once we grasp the principle, we find that it is really very simple! We should first rehearse all the motions to be sure that our timing is smooth and consistent, that our cables do not catch on furniture, and that nothing interferes with our continuous movement across the field. The camera must be firmly fixed on a tripod, and an assistant is required to open and close the shutter for each lighting episode. Tests can be made with Polaroid film to verify the exposure plan and to ensure uniform illumination. In a high-ceilinged room, for example, a second sweep through the subject area may be needed with the light directed upward, and we must be sure it does not obviously intrude on the first.

It is essential to *plan* the operation thoroughly. Sketch a diagram of the area to scale, showing the disposition of the furniture and the appropriate areas from which to direct the continuously-moving light. You can then estimate the accumulated light on the different planes as each of the prime planes are illuminated, based upon the Inverse Square Law. ◁

Most interiors require several "painting" exposures to accommodate different planes of the subject. These can be calculated using the Inverse Square Law, beginning with the plane closest to the camera and determining the exposure for each more-distant plane that results. For the second exposure we then move the lamp forward to the second subject plane and give the additional exposure required. If, for example, we have two primary subject planes at distances of 12 and 24 feet from the original lamp position, our first exposure should be planned for the closer plane. This exposure will be equivalent to one-quarter of the required exposure at the second plane, so that when we move the lamp to "paint" the second plane we use only the *additional* exposure required. It is usually preferable from an aesthetic viewpoint to allow the more-distant planes to be slightly higher in value than nearby areas, so we might choose to disregard the accumulated exposure values in this case.

Obviously all room lights should be turned off during the painting exposures, but they may be turned on for a separate exposure at the end. We may also have to cover windows in the picture area (from the outside) during the "painting" exposures, and these may be uncovered at the end for a separate exposure. Better still, make the principle exposures at night. After sunrise, an additional exposure

Figure 7–18. *Living Room.* This represents a fairly complex problem of painting with light. A large satin-finished aluminum reflector was used for the principal moving light. The beamed ceiling in the background was "painted" with a small cone reflector. The distant room was lighted by reflecting light from a hidden light gray wall. The windows were exposed in late afternoon, and the principal exposures were made that evening. After the "painting" exposures, the room lights were turned on and exposed separately. The ceiling lights were properly exposed, but the shaded lamps were slightly overexposed. I was concerned about this possibility, and therefore selected pyrocatechin as a compensating developer (although not the highly compensating pyrocatechin compensating formula — see page 255).

Note the floor shadows from the small table; these were produced by the ceiling lamps. There are no shadows from the chair legs, as they were illuminated only by the constantly moving lamp. The reflection on the corner of the far left wall was caused by the proximity of the light at the start of the third "scan." The "hot spot" on the right hand wall occurred in the same way. The paths followed for the "painting" exposures are shown in the drawing.

can be made for the light coming through the windows. Balance the exposures so that the luminance of the window area in daylight is higher than the interior walls, so there is a definite contrast between window and walls. ◁ With color film, the filtration may be changed as needed to balance the interior light and the daylight.

The use of moving lights might appear complicated, but once understood, it can be most rewarding.

See Figure 7–6

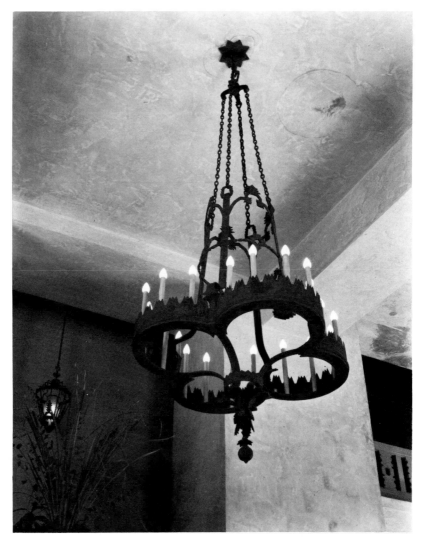

Figure 7–19. *Iron Chandelier, The Ahwanee Hotel, Yosemite.* The iron is quite dark in relation to the walls, and its bottom surface therefore required painting with light. The walls were exposed on Zone VII, which gave a good separation between their values and the lights. The general illumination of the alcove in the lower left was about two values lower than the walls. The lamps there were exposed for the same time as the lamps on the large fixture.

| Chapter 8 | # Darkroom Processes |

See page 17

Roughly the same chemical principles apply to the processing of negatives and of prints, and the basic events should be well understood. It begins with light striking the sensitive emulsion and producing an "electrochemical" effect on the silver halide crystals within the emulsion. ◁ In simple terms, the action of the light alters the electrical charge within the silver halide crystal, rendering it responsive to the action of the developer.

After exposure the negative carries the invisible *latent image* made up of these altered crystals, which will be reduced to metallic silver by the developer. This reaction takes place throughout the negative (or print) in proportion to the amount of light received at each location, thus yielding a higher density of reduced silver in areas that received relatively large exposure. Other factors that affect the total density include the nature of the developer, the time and temperature of development, and the amount of agitation.

After development the negative contains minute particles of metallic silver combined with residual silver halide that was not exposed and therefore did not develop. If left on the film this halide would discolor upon exposure to light, spoiling the image. Following development, therefore, the film is transferred to a mild acid stop bath, which neutralizes the alkaline developer remaining in the emulsion, and thence to an acidic fixing bath. The primary function of a fixer is the removal of the unreduced silver halide remaining in the emulsion. The most usual fixing agent is sodium thiosulfate (referred to as "hypo"), although ammonium thiosulfate is used in "rapid" fixers. When the fixer has completed its essential task any

Figure 8–1. *Sand Dunes, Oceano, California.* The luminance of the sand was placed on Zone V, and N + 1 development raised its value to VI and emphasized its texture. To further enhance texture I used a Grade 3 contrast paper. The photograph was made with a 50mm lens on the Hasselblad, set at the smallest aperture to obtain maximum depth of field. The bright hazy line along the top of the dune was caused by blowing sand.

trace of remaining thiosulfate compounds must be eliminated by a thorough hypo-clearing and washing procedure described later, since residual fixer complexes will also eventually discolor and stain the image. This brief overview of the processes should aid in understanding the more detailed information that follows.

DEVELOPERS AND DEVELOPMENT

The variety of developers available is sometimes bewildering, and each photographer usually has his own favorites, not always determined by realistic assessment! I certainly recommend beginning with one of the prepared developer formulas, available dry or as a liquid concentrate to be mixed with water for preparing the working solution. The film developer should be considered a critical element in the photographic process, and mixed carefully according to directions, using only clean containers and mixing vessels. I recommend using only distilled water for mixing developer unless the tap water is very pure. Tap water quality varies from location to location (and over time at one location), and may contain calcium, sodium, iron, chlorine, and organic matter. The developer temperature is critical, and standard practice is to use 68°F (20°C) if possible, and to maintain the temperature very accurately throughout development. ◁ In tropical conditions where higher temperatures are unavoidable, sodium *sulfate* is frequently added to the developer to control swelling of the film (further information on such procedures is available from Eastman Kodak Co. and other manufacturers). I would avoid such procedures unless they are absolutely necessary.

See pages 201–204

Care should be exercised to choose a developer appropriate to the film and application, since the developer will have some effect on factors such as grain size and appearance, separation of values or loss of detail, smoothness of value progression, and acutance. Grain size ◁ is affected by processing because the single grains, which are themselves microscopic, gather or "clump" together, creating larger grains that can disturb the quality of the image. I remind you that the "grain" we see in the print is not the grain itself but the effect of light passing through the spaces between the grain clumps. As with the dots of the printing-press plates (halftones) the grains are themselves of the same density, but the number and size of grains in a given area define the effective density. (With color images a minute dye area replaces the original particulate silver grains, and this dye image has quite different optical characteristics from a black-and-white image.)

See pages 19–21

The nature of the grain and its distribution also affect acutance. A "sharp" grain gives the impression of high acutance while a softer grain type, as caused by developers containing a silver solvent, shows a diffuse edge. *Acutance* refers to the sharpness of an edge in the image, while *resolution* refers to the ability to distinguish fine detail. The finely separated lines that indicate a certain degree of resolution may be either sharp and decisive, in a negative of high acutance, or softened and diffused (though still distinguishable) in a negative of the same resolution but lower acutance. It is worth noting that an inferior optical image can appear improved by a sharp grain structure, and a superior optical image weakened by unsharp grain and silver diffusion within the image.

Manufacturers usually recommend certain developers for their products with the intention of balancing various factors, including emulsion characteristics, efficient processing time, reasonably fine grain, and the characteristics of standard printing papers. The photographer should attempt to establish a norm with one of the standard developers, such as HC-110 ◁ and then deviate only when a real improvement is found. Briefly, the developer types may be described as follows:

See page 187

Standard developers. For general use in tank or tray with roll, pack, or sheet films, these developers usually provide excellent tonal characteristics with moderate grain and high acutance. There are numerous examples, including Kodak HC-110, D-23, and D-76, and Edwal FG-7. All but D-23 are available in packaged form.

Fine-grain developers. With small format negatives grain size is an important consideration, and many developers offer a real (or imagined!) reduction in grain size. The true fine-grain developers do not alter the basic grain structure, and thus retain high acutance, but with a relatively slight affect on grain size. A more pronounced reduction in graininess is available with developers that contain a silver solvent, usually sodium sulfite (in Kodak D-23, D-25, and to a degree D-76, and others). The reduction in grain size is accompanied by a reduction in acutance, however, and the negatives usually have a soft quality lacking in "edge." I have confirmed that the action of sodium sulfite as a silver solvent is a function of the time the negative is subjected to it: for example, the Kodak D-23 formula (containing only metol and sodium sulfite) gives reasonably fine grain due to the solvent action of the sulfite. The sulfite itself provides the required alkalinity in which the metol will function. The D-25 developer is the same as D-23 but with the addition of sodium bisulfite (a buffer). This decreases the alkalinity, thereby prolonging the development time and subjecting the negative to longer contact with

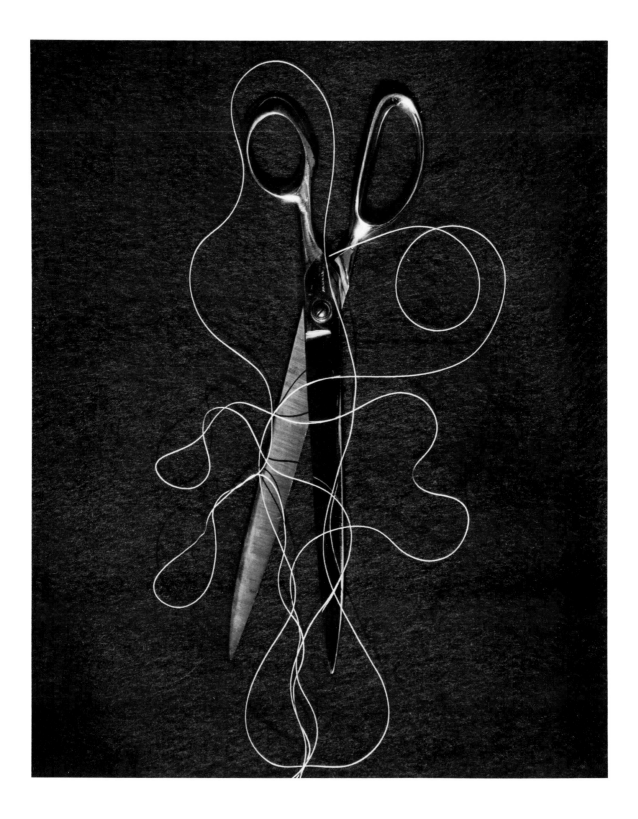

Figure 8–2. *Scissors and Thread, San Francisco (c. 1932).* This is an early photograph representing the Group f/64 period. The scissors were laid on a dark blanket in full sun and the camera placed directly above (with care to avoid any shadow from a tripod leg). The thread was gathered and dropped over the scissors quite a few times until a visually acceptable arrangement resulted. Exposure was normal (determined by empirical methods, since only relatively primitive exposure meters existed at this time). I used the ABC Pyro formula for the normal development time.

See page 220

the sodium sulfite. The result is that the sulfite has additional solvent action on the silver particles, enhancing the fine-grain effect but with a further loss of acutance. D-76, a formula of more energy than D-23 but with the same amount of sodium sulfite per liter, has a shorter development time, and consequently there is less action of the sulfite on the negative grain. My preference has always been for sharp, well-defined grain which yields crisp enlargements and enhances apparent image sharpness. Many fine-grain developers exact a further penalty by reducing the effective speed of the film.

High-energy developers. These are strong developing solutions used primarily for high-contrast work, such as "process" photography, or for very rapid processing. Kodak D-11 is an example. These are not recommended for general photography, except for special effects.

Special-purpose developers. Developers are specially formulated for use in reproduction, X-ray, direct-positive, and other specific applications.

In choosing a developer, the photographer must keep in mind the nature of his subject, the degree of enlargement planned and the type of enlarger illumination, and the ultimate use of his photographs. When photographing detailed subjects, such as landscape or architecture, it is usually preferable to maintain maximum acutance, even if a somewhat larger grain size must be tolerated. The same principle may apply if your photographs are intended for reproduction; some image detail is likely to be lost in the printing process, and thus maintaining maximum impression of detail in the original print is desirable. With portraiture or other subjects involving people, on the other hand, you may prefer the slightly softer feeling, with smooth tonal progression and reduced grain size, that is available with some fine-grain developers.

The type of enlarger light source must be considered as well. Condenser (collimated) light sources emphasize crispness and contrast, as do point-source enlargers, while diffused-light sources provide smoother tones and far better high-value separation. I use a diffused-source enlarger for almost all my work. With a more collimated light source I would require a softer negative ◁ and could possibly tolerate somewhat lower grain acutance, but with diffused light I try to maintain maximum sharpness and acutance in the negative. (Ample focal length and optical quality of the enlarger lens are very important in this respect, as will be discussed in Book 3.) The considerations of grain quality and size are most critical at high magnifications, and

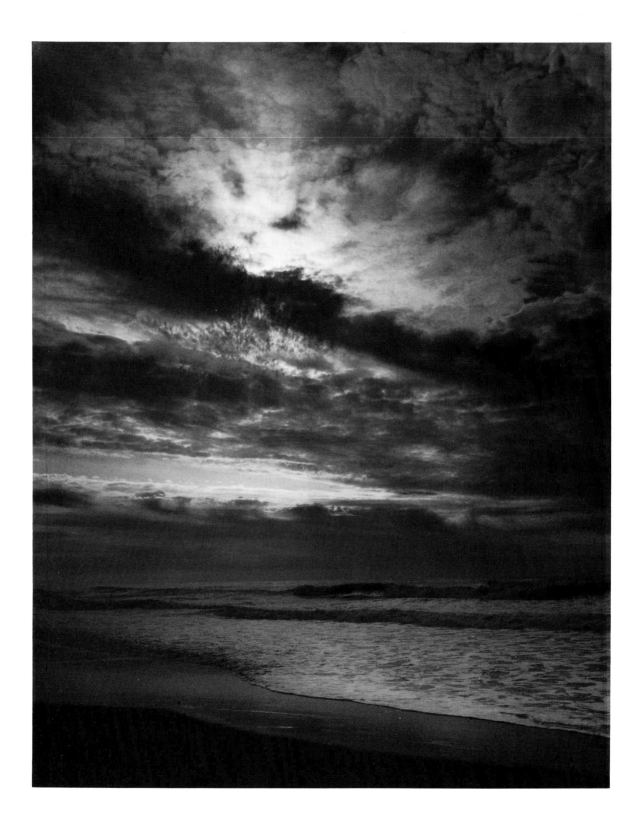

Figure 8–3. *Sunset, Northern California Coast.* This print was made from a Polaroid Type 55 Land film negative. The low values were exposed on Zone III or above to keep within the scale of the film.

See pages 226–228

therefore are of greatest importance with 35mm negatives which are routinely enlarged 8x (linear dimension) or more.

It is wise in any case not to make too much of the issue of developer choice, since the effects of variations are perhaps not as vital as many suppose them to be. My preference, at this writing, is the Kodak HC-110 proprietary formula, since I find it applicable to much of my work in large format and roll film. I prefer to prepare the basic stock solution from the concentrate, (since it is difficult to be accurate when preparing the working solution directly from concentrate), and I then dilute this stock solution 1:7 for normal development. I have used it 1:15 for contraction, and occasionally 1:30 or more for compensating effects, ◁ and for extra strength in the negative, I dilute it only 1:3. I have found this developer very dependable, giving excellent grain and acutance.

Components of Developers

A developer actually contains a number of ingredients besides the developing agent itself. Being familiar with them will enable you occasionally to make a useful adjustment in a formula to meet certain requirements.

Developing agent. These organic compounds have the capability of reducing exposed silver halide to metallic silver. Metol (Kodak's Elon), Phenidone hydroquinone, amidol, pyrogallol (pyro), and glycin are among the most common. Most general-purpose developers contain a metol-hydroquinone combination; the metol provides good detail throughout and the hydroquinone increases the contrast and produces greater high-value density. Modern thin-emulsion films do not react quite the way earlier thick-emulsion films did, and there are probably new developing agents in many proprietary formulas (manufacturers are understandably reluctant to reveal the details of such formulations).

Each developing agent and formulation has its own characteristics that influence the final effect. Most standard developers used as recommended yield greater high-value densities than I personally prefer. I favor developers of the *compensating* or *semi-compensating* type, meaning those that give proportionally full development to the shadow and middle values while limiting the degree of development in high values. A developer of the semi-compensating type, such as Kodak D-23, ◁ uses metol alone as a reducing agent in a solution of relatively low pH, or alkalinity, and can produce admirable results. Prolonged development in solutions of this type can yield vigorous high-value density, thus making such developers quite versatile.

See page 183

Developers containing hydroquinone, or those with metol alone in a higher pH solution, do not have this valuable compensating action (although turn-of-the-century British photographers, photographing the interiors of cathedrals, are said to have used weak hydroquinone solutions, leaving their plates in a deep tray of developer for hours!). I find that with the average metol-hydroquinone developer, the high-value densities are too severe by the time the required shadow densities are reached. Reducing development to obtain the desired high-value density may produce insufficient shadow contrast (depending on the developer). A compensating developer combines the properties of low-contrast development in high-value areas, and higher-contrast development in the shadows. The effect is to bring out subtle differences in tones in shadowed areas of the subject that the eye can perceive but that are often beyond the capacity of the film to separate decisively with the usual developers. There are certain development procedures that can also achieve this effect. ◁

See Chapter 10

Preservative. Since a developing agent tends to oxidize rapidly in water, a preservative is added to prolong its life, as well as to prevent stained negatives and prints. Sodium sulfite is usually added for this purpose (as noted above, it also is a silver solvent during long development times). ◁ In large quantities, as in D-23, it produces a mild alkalinity. In solution A of the ABC Pyro formula, ◁ sodium sulfite is added to prevent oxidization of the developer agent (pyro).

See pages 183–185
See Appendix 3, page 255

Accelerator. The accelerator supplies the alkaline environment required by most developing agents. Sodium carbonate and sodium hydroxide are commonly used as accelerators; borax or Kodalk (a proprietary chemical), sodium metaborate, or sodium carbonate will produce a mild buffered alkalinity. (A buffer is a chemical salt which releases only part of its available ions at any one time; as that part is used up an additional amount is released, thus tending to maintain a constant degree of alkalinity during the course of solution life.) The amount and strength of the alkali used have a decisive effect on the developer action and the resulting quality of the negative. Highly alkaline developers, typically using sodium hydroxide (caustic soda) as an accelerator, are useful with graphic arts films where high contrast is desired, but they have a short shelf life and must usually be stored as two separate solutions to be mixed just before use.

Restrainer. Left unchecked, the developing agent would reduce some unexposed silver halide, resulting in overall fog. Potassium bromide is usually added as a restrainer to reduce the fog level; benzotriazole may also be used, but it does not have the same effect with all developing agents. The restrainer increases contrast by inhibiting the

reduction of silver in lightly exposed areas, thereby producing lower densities in the shadow areas of the negative. The addition of potassium bromide also favors finer grain, owing to its restraining action on silver reduction. The fog level that comes from age, heat, and so on, can often be reduced by adding potassium bromide or benzotriazole to the developer. However, the amount of restrainer in a film developer must be measured carefully, especially with developing agents of low reduction potential, since restrainers tend to reduce film speed and useful shadow density. Bromides are also a by-product of the development itself; since they form at the interface between film and developer, they must be removed by agitation or they will inhibit further development. ◁ Benzotriazole is marketed as Kodak Anti-Fog No. 1.

See pages 204–205

Replenishers

The developer solution loses strength as it is used because of its activity in reducing exposed silver halide and because of the accumulation of contaminants — chiefly soluble bromides — that are a by-product of the chemical reaction. A replenisher is a chemical formulation designed to restore the developer to full activity so it can be reused, up to a certain limit. Replenishment is effective and economical when the developer is used in tanks of at least a gallon or more, and is used primarily in large-volume labs. My preference is for the "one-shot" developer, which is used once and then discarded. The results are more consistent and the expense is only slightly greater than replenishing developers.

If a replenisher is to be used, it should be mixed and added exactly according to the manufacturer's directions. Merely adding more of the original developer does not restore the solution to its original strength. It is best to add replenisher according to the measured quantity of film that has been processed in a solution. The important criterion is the area of film processed: one 8×10 film sheet, or four sheets of 4×5 film, has an area of 80 square inches. Careful records must be kept on the amount of film processed, and replenishment must be done on a regular schedule. In all cases, the developing solution should be discarded if there is the slightest question as to its effectiveness, and usually before reaching the theoretical limit of replenishment. One advantage of replenishing large tanks of developer solution lies in the fact that, as negatives are developed, a certain amount of silver is released into the solution; with very long development times this silver will "plate" upon the developed emulsion, thereby adding density and contrast — with limits, of course.

Developer Keeping Qualities

Most standard developers keep well under favorable conditions, but all lose strength in time. Keeping qualities are related to:

1. Purity of water used for stock solutions. Water of high purity and of a pH of 7 (neutral) is ideal. Distilled water is not exactly pH7, but is free of metallic ions and organic substances, and is adequate for mixing all developer solutions. "Softened" water has its metallic ions exchanged for sodium ions and is well filtered, but the presence of the substitute ions may affect the developer. Water "hardness" relates to its calcium content, and after "softening" it may have only around 20 ppm (parts per million). I understand that 180 to 200 ppm of calcium is about ideal for most photographic processes.

2. Chemical formula. Developers containing sodium sulfite (such as D-23, D-76, and most standard tank developers) are slow to oxidize, but nevertheless must be protected from air. Pyro developers oxidize rapidly when mixed in working solution, and it is important to use them immediately.

3. Containers. Light speeds up oxidation, and thus developers should be stored in stainless steel or dark brown glass bottles. Certain plastic materials pass oxygen molecules; you may note that the inside of some plastic bottles used for developers becomes quite brownish in time, indicating that oxygen has passed through the walls and interacted with the developer.

4. Contamination. It is important not to allow the developer to be contaminated by other darkroom chemicals during processing. In addition, touching the film with fingers contaminated by stop bath or fixer *before* development is certain to leave marks. You must also be very careful to rinse all vessels and graduates thoroughly immediately after use.

OTHER DARKROOM CHEMICALS

Stop Bath

After development the negative is transferred to a stop bath, which serves several functions: (1) since it is acidic, it neutralizes the alkaline developer remaining in the emulsion, thus immediately arresting development; (2) it helps prevent neutralizing of the acid fixing bath by residual alkaline developer carried in the emulsion; (3) it helps prevent staining and the formation of scum on the negative.

To many workers the stop bath is merely a splash of acid in a vague amount of water. It should, instead, be compounded as directed. With too little acid, the solution is easily neutralized by the alkaline developer in the emulsion and may not stop development effectively or uniformly. Too much acid can generate gas bubbles within the emulsion, producing small blisters or pinholes. Be extremely careful if you mix stop bath by diluting glacial acetic acid, since it is very strong in this concentration (glacial acetic acid is usually diluted to a 28 percent stock solution by mixing 3 parts acid with 8 parts water; mix 1½ oz. of this solution in a quart of water for use).

One quart or liter of stop bath solution is usually adequate for up to 2000 square inches of emulsion. Kodak makes an "indicator" stop bath which changes color as it approaches exhaustion. I find that when the slightly "slimy" feeling on the fingers produced by the alkaline developer is no longer removed by immersion in the stop bath, the stop bath is effectively exhausted.

Fixer

As discussed, the function of the fixer is to remove the unreduced silver halide remaining in the emulsion after development. The most widely used fixing agent is sodium thiosulfate, referred to as hypo (because it was once known as sodium hyposulfite). A fixing bath is usually acidic (although chemically this may not be essential, a neutral or slightly alkaline fixer may arrest development unevenly and cause the production of stain from the oxidizing developer). Sodium bisulfite (or sodium sulfite and acetic acid) are usually added to establish the acidity, and in some formulas boric acid or Kodalk may be added as a buffer to stabilize the pH and reduce the usual acidic odor. Formulas described as "hardening fixers" include a substance (usually potassium alum) that hardens the emulsion to prevent damage from abrasion or frilling. If a plain hypo bath is used, transferring film to it from an acid bath may precipitate the sulfur from the thiosulfate, resulting in a milky substance and reducing the effectiveness of the fixer. A non-hardening fixer may be used which contains sodium bisulfite or potassium metabisulfate. These fixers are slightly acidic, and since they do not contain any hardener, the film will be quite soft and subject to damage, especially under warm conditions.

Excessive fixing must be avoided, since it can lead to sulfiding of the silver, and the fixer may begin to bleach the image by removing silver as well as the unreduced silver halides. This bleaching effect is first visible in the low-density areas (the shadow areas on the

negative, high values on the print). The rapid fixer formulas are especially likely to bleach image silver and must not be overused.

See Appendix 3, page 256

I use the Kodak F-6 formula for all fixing baths. ◁ The addition of Kodalk or borax serves to reduce the acidic odor without affecting the performance of the fixer. Since the water temperature in my darkroom is rarely above 70°F from the tap, I am able to reduce the hardener (potassium alum) by about one-third. I believe that the reduced hardener makes more efficient washing possible.

Hypo Clearing Solution

After the negatives have been fixed and given a generous rinse, they should be placed in a hypo-clearing solution. Several brands are available (such as Kodak Hypo Clearing Agent), and most contain inorganic salts that remove hypo more quickly than just washing in plain water. Follow the manufacturer's directions for the treatment and washing requirements, although I usually give additional washing beyond the suggested minimum times. For additional permanence, the film can be treated in a weak selenium toner bath, followed by a final wash (selenium also has potential for use in intensifying negatives ◁). Do not confuse Hypo Clearing Agent with Kodak's Hypo Eliminator, which is used with prints only and may cause damage if used with negatives.

See pages 235–237

STORAGE OF NEGATIVES

Negatives should be stored in acid-free envelopes in a cool environment of low or moderate humidity. I keep my negatives in a vault in which the temperature is maintained at 60–65°F and the relative humidity is held at 45 percent.

There has been some opinion that materials such as glassine or most plastics do not provide archival conditions for storage of negatives. I now store negatives in translucent folds of untreated polyester (through which the negatives can be seen adequately for identification), which is then inserted in an outer envelope of archival paper. The open end of the polyester fold should be at the open end of the envelope to permit the negative to "breathe," and the envelope should be filed with the open end up or sideways, never down against the bottom of the filing box or tray. If the envelopes are stacked lying flat, proper breathing will be inhibited. In humid conditions you may insert packets of silica gel in the negative filing box to absorb moisture (the gel can be dried out in an oven for repeated use.) Never store negatives (or papers) in the darkroom; the humidity and chemical fumes can cause serious deterioration.

If you are storing old nitrate-base negatives, I must stress the potential dangers. The nitrate tends to disintegrate, particularly if the negatives are not stored properly (i.e., if they are packed together without interleaving, and without proper temperature and humidity control). As the negatives deteriorate they become highly flammable and release gases that can be harmful to other films. Valuable images on nitrate-base film should be carefully duplicated and the original then destroyed; use great care if you burn such negatives, since they can be quite explosive.

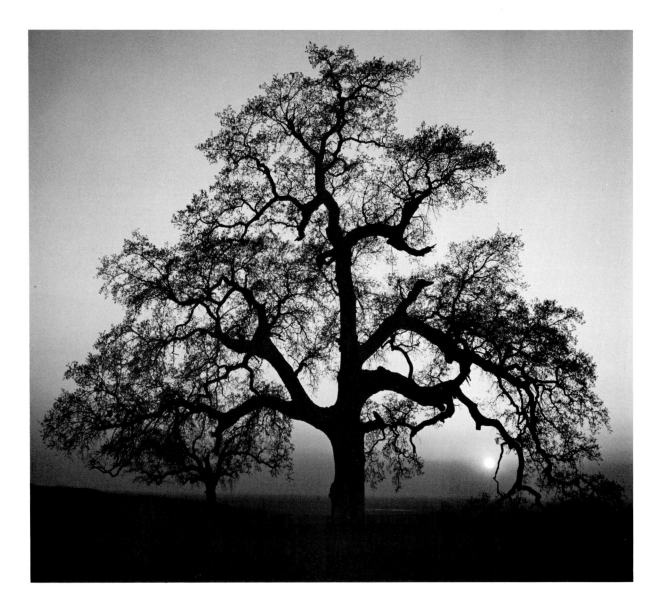

Chapter 9

Darkroom Equipment and Procedures

Each photographer establishes his own system of processing which relates to his darkroom design, equipment, and personal convenience. I believe that the following material on darkroom facilities and procedures is fairly basic, consisting of established practices and my own methods as they have evolved over a period of several decades.

THE DARKROOM

As his work evolves, each photographer will have individual requirements in a darkroom and work space that relate to his or her personal needs and comfort. Edward Weston produced his extraordinary photographic prints in a spartan darkroom where the most elaborate device was an old dry-mounting press; his prints were made without enlarger, using only a contact printing frame beneath a bare light bulb suspended from the ceiling. My darkroom, on the other hand, is fairly elaborate, because I have done a considerable amount of professional work that has required efficiency and special capabilities, such as being able to make prints of 30×40 inches or larger.

A darkroom can be a small closet-sized space in which the occasional photographer processes some film and makes a few prints, or it can be a tightly functioning area equipped to turn out higher volumes of professional or creative work. I do not mean to imply that

Figure 9–1. *Oak Tree, Sunset, Near Sacramento.* I used reduced exposure to preserve the hazy sky values and silhouette the tree, with normal development. The camera was a Hasselblad with the 80mm Planar lens.

every photographer should follow a fixed ideal design in assembling a darkroom. What is important, however, is that the space and facilities function well for the individual. Some of the more elaborate darkrooms I have seen were the least practical, as they were not designed for efficient operation. I will discuss the principles of darkroom design here with specific reference to the requirements for processing negatives; the darkroom will also, of course, include space and equipment for printing, which is discussed in Book 3.

The darkroom should be designed in such a way as to permit maintaining separate "wet" and "dry" areas, and it should be a rule *never* to allow wet procedures to intrude on the dry side. If possible it is usually best to use one side of the darkroom for the sink and wet procedures, and keep the opposite side "dry," with an aisle of about three feet between them. Circumstances sometimes require designing the worktable and sink in sequence, in which case a partition at least two feet high should separate the two to ensure that the dry area is not splashed with water or solutions. The dry side should include ample working space for loading film holders and developing hangers or reels, plus the space required for the enlarger and related

Figure 9–2. *Darkroom floor plan.*

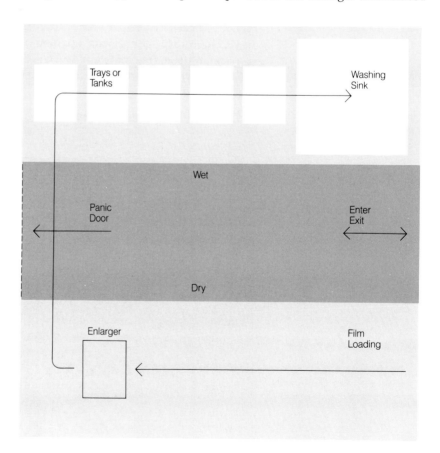

equipment. I recommend placing the enlarger directly opposite the sink area where the print developer tray will be. The dry side of the darkroom should also include storage space for lenses, magnifiers, and other tools and accessories required for use of the enlarger. Film and paper, though, should be stored *outside* the darkroom because of possible chemical fumes and humidity.

The sink can be a ready-made unit of stainless steel or fiberglass, or it can be constructed from wood and heavily coated with fiberglass, epoxy paint, or other waterproof and chemical-resistant materials. The sink should have a flat bottom surface large enough to contain at least four trays of the largest size you expect to use, with splashboard on the wall side. Be sure the sink is supported on a strong frame and that the bottom is tilted toward a drain located in one corner. If you expect to use a print washer in the sink, include space to accommodate it. Shelves, storage cabinets, and racks for trays can be built below tables and the sink. I suggest making a rough mock-up of the sink to determine practical dimensions and optimum height.

Adequate ventilation is a necessity, to remove fumes and provide fresh air during work sessions. Light-tight exhaust fans are available at moderate cost, and should be installed above or near the sink where chemicals are used (be sure, however, that vibrations from the fan cannot affect the enlarger). An additional air vent, also available in a light-tight construction, should be located at the opposite end or side of the darkroom to provide cross-ventilation. A negative-ion device may be worthwhile, especially for those who have respiratory conditions; it definitely "freshens" the air.

Plumbing for the sink should include at least one hot-cold mixing faucet. It is most convenient to use a double swivel tap to which a length of flexible hose is attached, and a separate outlet may be provided for permanent installation of the print washer. Temperature-controlled mixing valves can be very helpful, and ideally one would be used for the washer outlet and a separate one for general work in the sink; the latter can be used with a large deep tray to provide a water jacket in which film developing tanks, etc., can be placed to maintain constant temperature. An adequate supply of hot water must be assured, and I strongly recommend including a water filter system in the darkroom plumbing (in some areas the quality of water supplies makes this mandatory).

Keeping the darkroom clean is essential, and construction should be planned so that all surfaces are waterproof and washable. Install "cove" molding where the walls meet the floor and at the tops of worktables and sink. Formica makes good material for counter tops and cabinets, and bottom shelves should be above the floor to permit access underneath for cleaning and to prevent the accumulation of

moisture. If possible, include a sump drain in the floor (be sure the floor slopes toward the drain), to permit hosing down the entire floor surface. This can be especially important if chemicals have been spilled, since if allowed to dry they can turn into a powder which forms dust on negatives, lenses, etc. Such dust can be injurious to health if the ventilation is inadequate, and some people have allergic reactions to such chemicals. Anyone who has spilled glacial acetic acid in his darkroom appreciates an efficient sump! Be sure to conform to local building codes in all plumbing, electrical installation, and emergency exits; in addition to the possible safety hazard, construction that does not conform to code may invalidate fire and liability insurance.

Use a paint that is waterproof and washable on all interior walls and the ceiling. A light color will make efficient use of the safelight illumination as well as providing a pleasant environment. I personally favor a rather light neutral color (about 70 percent reflectance) for walls and ceiling. White ceilings are best for the use of reflecting safelights, such as the highly efficient sodium units. However, walls near the enlarger should be *flat black* to minimize reflection of enlarger light onto the printing paper.

Workroom

A separate workroom should be provided if possible. Since much of its use relates to print drying racks and mounting equipment, this area will be discussed in more detail in Book 3. The workroom should, however, include space for drying negatives — preferably a cabinet with filtered air vents. I do not recommend drying negatives at a temperature higher than that of the normal environment, which is usually close to the working temperatures of the solutions. In a damp climate, humidity control may be necessary; about 50 percent relative humidity is ideal. The workroom can also include storage facilities for films and papers, as well as finished negatives and prints, plus a light table, densitometers, and other equipment. Like the darkroom itself, this area must be kept very clean, and should be constructed with this necessity in mind.

FILM PROCESSING EQUIPMENT

Roll film tanks and reels. Tanks for processing roll films are available in plastic or stainless steel. Nearly all are of the "daylight" variety, which allows all processing steps to be carried out in normal

light once the film has been wound on reels and enclosed in the tank. My preference is for the stainless steel tanks since they are durable and easy to clean. The complete unit includes the tanks, one or more film reels (depending on the tank size), a tank cover with a light-baffled vent for adding and draining chemicals, a small lid for capping the vent, and a rod for lifting the reel or reels out of the tank. It requires some practice to load stainless steel reels properly, ◁ but once mastered the process becomes completely automatic and foolproof.

See page 213

Large tanks are available that hold up to eight 120-size rolls, or sixteen 35mm rolls. These are very useful when large quantities of film must be developed. With all daylight tanks, and especially with such large tanks, the time required for filling and draining the tank through the vented lid affects the uniformity of development. It is better to fill the tank with developer before processing starts and then quickly immerse the loaded film reels on rods (in total darkness, of course), after which the tank can be covered and lights turned on. ◁

See pages 212–215

For very large quantities of film, special deep tanks can be purchased from manufacturers such as Calumet, Pako, or Burke & James. The films are suspended from hanging rods with clamps. In shallower tanks, the film rolls are bent over the smooth rods, and the ends held together with a weighted clamp.

The small metal caps that fit over the drain vent of the stainless steel tanks permit agitation by inverting the tank. Such caps, and the lids themselves, are usually *not* truly interchangeable from one tank to another, and using the wrong lid or cap can result in leaking if it is too loose or binding if it is too tight. If you have a variety of tanks, covers, and caps in your darkroom, be sure to assemble the entire tank unit before loading the film, or number the components in sets (by engraving or plastic adhesive tabs) to ensure the proper fit of all pieces.

Sheet film processing equipment. My personal preference is to develop sheet or film-pack film in a tray. I find this assures more even development than tank development, provided the trays are large enough to allow for generous movement during agitation. Insufficient agitation in too-small trays can cause the edge portion of the negative to develop more than the center, resulting in higher edge densities.

If you choose to use tanks, I recommend the open-top tank and conventional hangers that support all four edges of the film (not the metal-rod type known as X-ray film hangers, which clip onto the edge of the film and can cause scratching). At least four tanks or trays will be required, one each for developer, stop bath, fixing bath,

and rinse, plus a film washing device. Although open tanks must be used in total darkness during processing, they are preferable to the daylight processing tanks for sheet films, which often cause streaks and uneven development due to agitation irregularities.

Film washers. Film can be washed in a standard tank or by using one of the special film washers available. Such washers are designed to permit water to flow continuously over the negatives from one side to the other, or from top to bottom. A rapid flow of water is not necessary for efficient washing, but the water must be exchanged uniformly and frequently — at least one complete exchange every five minutes — and fresh water must reach all parts of all negatives. If a conventional tank is used for washing, be sure to empty it frequently during the washing process. In my darkroom I have a narrow stainless steel tube attached to a water hose. For washing roll films the tube is inserted through the center of the reels so the water flows into the tank at the bottom, passes upward across the film, and overflows the tank at the top. The tube can similarly be inserted in a sheet-film tank for washing. Several *thorough* rinsings of the film before washing serve to remove much of the fixer on the film surface and thereby assure a more complete wash in minimum time.

Thermometer. A precise darkroom thermometer is essential for uniform and predictable processing of negatives. The modern dial thermometers are usually very good, and the Kodak Process Thermometer is one of the best of the conventional type. Electronic thermometers have many advantages, but the good ones are not inexpensive. Photographic thermometers must be especially accurate in the range from about 60° to 80°F where most processing is done. They should be handled carefully and used only for photographic processing, with careful rinsing after each use. Some of the less-expensive thermometers are inaccurate, and I do not recommend trying to find a bargain for this important acquisition.

Graduates. Accurate graduates should be purchased in a variety of sizes up to one quart or one liter. Glass or high-quality acid-resistant plastic graduates are best for the small sizes, where it is important to see the precise level of fluid, and stainless steel is good for the large sizes.

Scales. I use a "gross" scale for measuring bulk chemicals, such as hypo, in quantities up to about 25 pounds. A good lab balance should be acquired if you find you need to mix your own developer and other formulas.

Containers. The size and type of liquid-chemical containers is somewhat determined by the volume of work done and the amount of storage time anticipated. I use stainless steel tanks with floating lids that slow down the process of oxidation of the solutions, in 25-gallon size for fixer and 5-gallon size for stock print developer solution. For smaller amounts, gallon or half-gallon brown glass bottles will suffice. For film developer I prefer one-quart glass or dark plastic containers. I usually mix my developer in one-gallon quantities and then distribute the solution in the smaller bottles. Since each bottle is completely full and sealed until needed, the developer in unopened containers is protected from the air. Remember that exposure to air hastens the deterioration of all solutions, and is especially damaging to developers. Fill the containers to be stored to the top and seal them tightly, and be sure to label all containers with the date of mixing. If plastic containers are used, be sure they are heavy and do not "breathe," which allows oxygen to reach the solution.

Timers. A variety of timers is available, including some designed to be used both to time film development and to control an enlarger. I do not use an enlarger timer, but for processing film a digital or luminous-dial clock timer is essential. The timing of film development in particular is critical, and the timer must be accurate. For printing and enlarging, I prefer to use an electric metronome rather than a clock timer that shuts off at a pre-set time. I want to keep my eyes on the print for dodging and burning, not on the clock!

TIME, TEMPERATURE, AND AGITATION

Time and Temperature of Development

All chemical processes are sensitive to temperature to some extent. In photographic chemistry, development in particular occurs at a rate that is directly a function of solution temperature: an increase in temperature speeds up the process, thereby reducing the time needed to reach a certain degree of development. It is thus necessary to standardize both the time and temperature if predictable results are to be obtained with each developer.

For most black-and-white processing, 68°F (20°C) has been adopted as the standard temperature. Higher temperature, up to about 75°F

(24°C) may be more practical in a warm climate, where room and tap water temperatures are higher, but warm temperatures make the emulsion softer and more susceptible to abrasion and scratching. Conversely, temperatures below 68°F extend the development time by slowing down the chemical reactions.

Manufacturers usually provide a time-temperature table or graph to indicate "normal" processing. Knowing the temperature you will be using (68°F unless there is a specific reason to use some other temperature), you can consult the table and read the required development time to achieve and "normal" negative. The development time-temperature data provide a useful starting point, but full control requires testing to establish normal development appropriate to your own film-developer combination, agitation, and other variables. ◁

See Appendix 1, page 239

The response of different developing agents to temperature change is by no means identical. Metol, for instance, has a fairly consistent response to temperature change over a wide range — that is, the required change in developing time is directly proportional to the temperature change in degrees. Some other agents, such as hydroquinone, lose much of their activity below a certain temperature (around 55°F or 12°C with hydroquinone), and the character of development changes. Developer formulations containing more than one reducing agent thus may change both in the rate of development and the characteristics of the final negative if the temperature differs from the norm — the strongest argument in favor of standardizing at 68°.

The temperature of other solutions is less critical, but should not be allowed to vary by more than 2° or 3°F (about 1°C) from the developer temperature. The reason is that a sudden change of temperature when film is moved from one solution to another can cause swelling or contraction of the emulsion, and the grains may cluster together into larger aggregates. In severe cases the result is *reticulation*, a "wrinkling" of the emulsion visible in the enlargement as an overall pattern that somewhat resembles very large grain. All temperatures should be closely monitored with an accurate thermometer; below about 60°F (16°C) even the washing process is slowed down and becomes uncertain in its effectiveness.

Water jacket. The most practical means of maintaining solution temperatures during processing is by using a water jacket around tanks or trays. A container large enough for several gallons of water of the right temperature (enough to reach about two-thirds the height of the processing tanks) is ideal. A jacket tank of hard rubber or

plastic will maintain the temperature at a more consistent level than a metal container; the temperature will also be more stable if a relatively large volume of water is used. Both these factors are especially important if you process in total darkness and thus cannot monitor the jacket or solution temperature during the processing itself. The jacket container should have a drain tap or overflow that allows adding warm or cold water without submerging the processing tank or trays.

The correct solution temperature can be reached initially by placing the bottles in a jacket of warm or cool water. Bear in mind, however, that pouring developer into a tray or tank may cause further temperature variation, and the final temperature must be established in the vessel used for development just before processing begins. If you use a daylight tank for roll film, you can bring the tank and reels to the right temperature by standing them in the water jacket before adding the developer; use a weight on the tank to keep it from floating or overturning, and be *certain* that no water can enter if the tank contains the film on reels. It will be much easier to maintain the correct temperature during processing if you keep the proper environmental temperature in your darkroom. For processing in the dark, you should check the temperature of the developer and the water jacket just before turning off the lights. You should also occasionally check the developer temperature at the end of process-

Figure 9–3. *Trays in water jackets for temperature control.* The use of large trays as "water jackets" provides temperature control during development. The processing trays are placed on racks to allow the temperature-controlled water to circulate beneath them. From left, the processing trays are water pre-soak, developer, stop bath, and fixer. The large tank contains cold water to soak the hands in prior to handling films in the developer, since heat from the hands alone can raise the temperature by several degrees during processing.

ing; if it is more than about one or two degrees Fahrenheit different from the ideal, you should improve the water jacket control.

A good quality temperature control water-mixing valve can maintain a preset temperature within one-half degree. Using such a valve it is a simple matter to circulate water of the right temperature in the jacket throughout processing, thus being certain of good control. Such precise jacket temperature is especially important if color processing is to be done, since a one-half degree variation in color chemistry can cause shifts in color balance as well as in the overall degree of development.

Agitation

As the developer reduces the silver halides of the emulsion, the developer at the interface (that is, that part of the developer in immediate contact with the emulsion) becomes exhausted and must be replaced with fresh developer by agitation. Development begins when the film first comes in contact with the developer solution, and agitation is important at this stage to be sure the developer is evenly infused into the emulsion. Once the development is under way, certain by-products of the process (notably bromides, the same chemicals that are used as restrainers because they inhibit development) act to slow down or stop development, and their presence

See pages 188–189

A

B

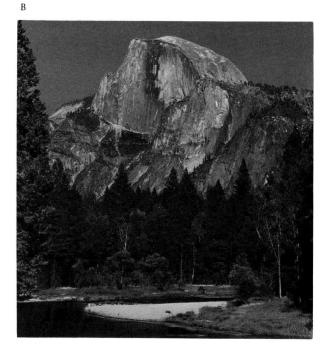

can cause "bromide streaks" or "silver streaks" if they are not removed by agitation.

Establishing and maintaining a consistent system of agitation is therefore very important, but the amount of agitation must be carefully controlled. Excessive agitation causes an increase in contrast of the negative. It can also cause streaks and nonuniform development if currents within the developer solution cause more agitation in one part of the negative than others; this occurs typically along the edges of the negatives, and is visible as density changes in areas that should be uniform. Insufficient agitation usually results in streaks and mottling of the film. The best test for proper agitation is to develop an entire negative exposed to a uniform surface placed about on Zone VI. Excess density along the edges of the negative usually indicates too-vigorous agitation or an improper agitation pattern; overall mottling and uneven density usually are symptoms of underagitation. Specific agitation methods will be discussed in the sections that follow.

PROCESSING PROCEDURES

The first step in preparing for film development is to gather all the necessary equipment and materials and lay them out in proper se-

C

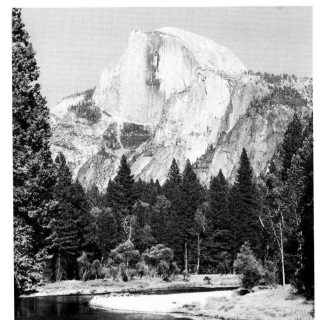

Figure 9–4. *Effect of agitation.* Three negatives of identical exposure were developed in Kodak D-23 at normal dilution for 8 minutes, as follows:

(A) Intermittent agitation (rocking the tray every 10 seconds).

(B) No agitation (except a slight pressure every 30 to 40 seconds to keep the film under the solution).

(C) Constant agitation.

The three negatives were printed identically, and the comparison suggests the importance of a consistent agitation plan. A represents the best negative to print, by far, although B and C, of course, could be printed better if required.

quence. The water jacket for the tank or trays should be prepared and used to bring all solutions to the right temperature. Check that the thermometer, timer, wash tray or tank, towels, and all other required equipment are in place, especially those you must be able to find readily in the dark. On the dry side of the darkroom, lay out the film holders or rolls, cassette opener if 35mm film is being processed, and whatever tanks, reels or holders, covers, and so forth are needed. I strongly advise rehearsals of the development sequence to establish a facility in this crucial processing stage.

Tank Development of Sheet Films

Mix chemicals, pour into tanks, and place in water jacket. Include one tank of plain water at 68°F (20°C) to "pre-soak" the film before developing. The pre-soaking allows the emulsion to swell and stabilize before it is immersed in the developer; this assures more uniform development. Arrange the film holders on the worktable and place the film hangers on a frame (usually two rods protruding from the wall, or in an empty and *dry* development tank). A second frame or tank should be nearby to hold the hangers after inserting the film. Open the hinged retainer on each hanger. Before turning off the

Figure 9–5. *Equipment arranged for unloading film holders.* Before turning off the lights, check the label on each film holder to be sure all require similar development. Film hangers, if used, should be laid out with the hinged retainer open and the hangers facing upward; load the film *emulsion side up* when hangers are oriented this way. After each hanger is loaded, it can be suspended in a clean and dry film tank, which is then carried to the sink area where development is to be done, or the hangers can be suspended on rods projecting from the wall until all are loaded. For tray processing, unload the film holders into an empty film box for storage until ready to begin development. Throughout the loading, processing, and washing procedures, keep the emulsion side of all films facing the same way to reduce the possibility of scratching.

lights, check the processing area: the tanks must be in proper sequence, the timer set, and the solutions and jacket water at the desired temperature (be sure you rinse the thermometer between solutions!). You must also be certain that the film hangers are completely dry, and that your hands are free of chemicals and completely dry before handling the film.

With the lights out, remove the film from the holder (being careful not to touch the surface with your fingers) and slide it into the hanger, closing the hinged lip to secure it. When all hangers have been loaded (with the film emulsion sides all facing in the same direction) lift them all together and immerse in the pre-soak bath of water. Agitate them constantly for about 30 seconds (using the agitation procedure described below), and then move the holders as a group to the developer tank. For the first 20 seconds the films are in the developer, repeatedly lift the hangers an inch or so and drop them back so the impact on the tank edge dislodges any bubbles adhering to the surface. The timer should now be started; the delay in starting the timer is necessary because the developer must displace the water in the emulsion before development can begin. You may prefer to add 20 seconds to the optimum development time and start the timer as soon as the hangers are moved to the developer tank, but in either case the delay must be included in the total time in the developer.

Figure 9–6. *Agitation of sheet film in hangers.* An agitation cycle when developing film in hangers consists of lifting the set of hangers out of the tank, tilting it to one side, re-inserting the hangers into the tank, and then lifting and tilting to the other side. This procedure ensures that developer drains from all channels of the film hanger. Be sure that the hangers are held evenly as shown.

It is important to adhere to a consistent agitation pattern. I suggest agitating the film continuously for 30 seconds, then for 5 seconds each minute, using the following sequence: lift the set of hangers out of the developer, tilt them to one side, replace, then lift again, tilt to the other side, replace, then lift slightly and drop. ◁ Simply lifting all the hangers out of the developer is not sufficient to provide good agitation. They must be lifted and tilted at about 45° in each direction, as described, to ensure that the developer and by-products drain from the channels along the edge of the film. The tanks used should be wide enough to permit the lift-tilt agitation pattern and a certain amount of side movement, without being so wide that a hanger could drop down into the solution. It is important to keep the hangers in line when agitating or moving them from one tank to another; otherwise there is considerable danger of scratching adjacent films.

See Figure 9–6

When the developing time has elapsed, lift out the set of hangers and place them in the stop bath, agitating with the same lift-tilt sequence for about 30 seconds. Then move them to the fixer and continue the same agitation for about 30 seconds. Agitate in the fixer every minute for about 4 or 5 minutes (the lights may be turned on after the first 2 or 3 minutes). After fixing, the films may be rinsed and transferred to the film washer or placed in a tank of water. If they are to be held in water storage for a time before washing, agitate them and change the water at frequent intervals.

A

B

Tray Development of Sheet Films

I believe tray development to be the simplest method, although care must be exercised at all stages in handling the films. I rarely have a scratched negative, and I find that development is uniform and consistent. Agitation is more complex than with tank development, and careful attention must be paid to the frequency and timing.

We begin by setting up the trays, including a tray of water for presoaking, using a water jacket for temperature control. The trays should be level and rest on an open grid frame or rack an inch or two above the bottom of the water jacket so that water can circulate underneath them. To facilitate handling, I use trays that are at least one size larger than the films: 11×14 for 8×10 film, and 8×10 trays for 5×7 and 4×5 films. Avoid trays with smooth flat bottoms since the negatives can be hard to lift away from such a smooth surface. Trays with ridges or grooves on the bottom, such as the FR Prin-Trays, make it easier to handle the negatives.

After preparing the solutions and trays, I arrange the sheet film holders on the worktable, being sure they are in proper position for identification in the dark. I also use one or more empty film boxes with light-tight covers to store the films after unloading the holder; separate boxes are needed if different development is required for some negatives.

I find it helpful to use two trays for developer, dividing the total volume of solution between them and passing the film from one tray

Figure 9–7. *Handling films during tray development.*

(A) Insert each film separately into the water pre-soak, and then transfer one at a time into the developer. Holding each film by the edges as shown, place it in the solution with a "wiping" motion, in this case gently sliding the film to the *right;* if the film is "pushed" to the *left* it may gouge and scratch the surface of the sheet below.

(B) As each film is inserted into the solution, gently press it down with the balls of the fingers, being careful not to scratch the surface with fingernails.

(C) Agitate at regular intervals by sliding the bottom sheet out of the solution and pressing it down on top of the stack. With practice, as many as eight sheets can be developed simultaneously by this method, with little danger of scratching.

C

to the other and back again during agitation. You will also need similar trays for stop bath, fixer, rinse water, and a deeper tray with a gentle water flow for storage. Since you will be immersing your fingers in the developer solution, the warmth of your hands will tend to raise its temperature; this effect can be minimized by using a reasonably large volume of developer and by keeping a tank of cold water nearby in which to dip your fingers prior to each manipulation in the developer.

After some practice, as many as six or eight films can easily be developed at one time. A single batch can include a larger number, but this requires a high-dilution developer with a longer processing time, and a greater volume of solution.

When all the preparations have been made, turn off the lights and unload the holders (be certain your hands are thoroughly dry). Then take the films to be developed and, with the emulsion side up, gently "fan" them so each can be individually handled (hold them only by the edges). You can then place them one by one in a water bath, pressing each down under the surface. If the films are fanned, touching the edge only of the next one to go into the water bath does no harm, but if water gets between the films they will stick together and may be damaged. Agitate the sheets in the water bath by placing your fingers under the back of the bottom film, lifting it up and away, and replacing it on the top of the pile. This last action should be downward with a "wiping" action, taking care to avoid letting the edge or corner of the film scratch the one below it. The emulsion

Figure 9–8. *Causes of negative scratches.* The film emulsion is very delicate during development, and can easily be damaged by a corner of another film. Be extremely careful when adding a film to the solution, or when moving films during agitation, not to allow the corner of one sheet to touch another sheet. Use the "wiping" motion shown in Figure 9–7 whenever moving the sheets.

will be very soft at this point, and the corner or edge of one negative can easily scratch another (as can too-long fingernails!). Each sheet can be *gently* pressed down into the solution with the balls of the fingers.

You should attempt to establish a complete cycle of agitation that involves moving each film from the bottom to the top of the stack once per cycle. This will allow you to be sure that the first film into the developer is also the first one into the stop bath, and first into the fixer; thus the total developing time for each film will automatically be the same, taking into account the time required to immerse each sheet in the solution. One way to keep track is by using the code notches cut into the corner of sheet films. When the notch is in the upper right corner, the film is emulsion-up. The first film into the presoak, however, may be reversed *end-for-end* so that its upper right has no code notch (even though the emulsion side is still facing up). This will enable you to find that sheet easily in the dark and to make it the first one into each successive processing bath.

After about a minute of pre-soaking in water (with constant agitation), gather the films gently in a corner of the tray and lift them carefully together. Since they are wet, they will slide easily, and care must be used to handle them securely without damaging them. Place them one after the other in the developer (this should take about 2 seconds each). When all are in, count 20 seconds while agitating as above and then turn on the timer; as with tank development, the delay is necessary to allow the developer to displace the water soaked into the emulsion.

With six sheets and a normal developing time of about 6 minutes, I would agitate by moving one sheet from the bottom to the top of the stack, or into the second developer tray, every 5 seconds throughout the development time. This pattern, with six films, assures that each one is moved every 30 seconds. You will have to adjust the frequency if you develop a different number of sheets. When developing only three films, for example, you should increase the interval to 10 seconds, so that each one is similarly moved once every 30 seconds. Remember that consistency of agitation according to a strict plan is very important. Constant agitation (a tempting method in this situation) yields higher contrast. I do not advise it as it shortens development time and requires more rapid handling, with greater chance of scratching.

Once the development is complete, gather the negatives in a corner of the tray, lift them out, and immerse them one by one in the stop bath, beginning with the sheet that went first into the developer. Give continuous agitation as rapidly as you can without damage to the films for three or four exchanges to arrest development fully. Then again gather the films and transfer them into the fixing

bath. After a few minutes — say four or five complete cycles at a moderate rate — you can turn on the lights and complete the fixing process. Do not tempt fate by turning on the lights too soon!

With film-pack films, which are thinner and therefore somewhat harder to handle than sheet films, I follow basically the same procedure, normally developing no more than one-half film pack (8 films) at one time. It is important to start with very dry fingers when handling the dry films, and be sure to use the pre-soak for at least 30 seconds. It makes little difference how long the films are in the pre-soak, provided it is long enough for a thorough wetting. Should the films stick together in the water, pull them apart *very gently* while holding them under the water. After the pre-soak I transfer the entire group to the developer and immediately begin the agitation cycle. If the negatives stick together in the developer they should be separated as soon as possible to prevent markings. With a thorough pre-soaking, however, there should be little danger of their sticking together in the developer.

Roll Film Development

The solutions and a pre-soak bath are prepared in advance and brought to the correct temperature as previously described. My procedure is to fill the tank with developer and place it in the water

Figure 9–9. *Washing films after tray processing.* After fixing, the films can be washed by soaking in one tray of water, and then moving them to another tray with fresh water. Rinse thoroughly as the films are moved to help remove residual hypo. Films are less susceptible to scratching at this point because of the hardening effect of standard fixers, but they still must be handled with care. Some photographers prefer to use a sheet film washer or load the sheets on hangers for washing.

jacket with the cover conveniently close by: it's exasperating not to be able to find the cover in the dark! Then lay out on the worktable the cassette opener (if 35mm film is being processed) and scissors to cut the leader (35mm film) or tape (120 film), plus reels. Be sure the reels face in the right direction for loading and that they are dry, and have suspension rods at hand if used.

In darkness, remove the film from the cassette or spool and, with 35mm film, cut off the leader. To load the reel, curve the film slightly between thumb and forefinger, and insert the end under the clamp at the center of the reel. ◁ Then pull the film gently so that it does not sag, and, being certain it rests evenly in each groove, turn the reel slowly and evenly so that the film "tracks" smoothly into the grooves. The film should be given a *slight* edge pressure, but never more than required to "invite" the roll into the grooves. This procedure requires some skill, and should be practiced using a discarded roll, in daylight and then in the dark. It is of the utmost importance that the film not be buckled, pinched, or cracked, and that it rides freely between the grooves. If the film is allowed to cross over into the wrong track, it will contact an adjacent layer, and the surface not exposed to developer will be blank. The film should feel slightly loose in the grooves if it is properly wound on the reel.

Once the reels are loaded, place them on the T-shaped suspension rod and immerse them in the water pre-soak for at least 30 seconds. Agitate at this stage by lifting the reels, rotating them a half-turn each way, and then dropping them back into the tank to dislodge

See Figure 9–11

Figure 9–10. *Equipment arranged for loading roll film tank.* Begin by laying out the film, reels, suspension rod, tank, and lid on a clean and dry table. For 35mm film, a cassette opener and scissors for cutting off the leader strip must also be at hand. Check that the reels are oriented properly to allow the film to be wound onto the spiral (note that the outer ends of the spiral point toward the right). I often place the rolls in a 4×5 film box or box lid to make them easier to find in the dark; it is exasperating to misplace a roll, or have one roll off the table onto the floor. When the reels are loaded, they can be placed on the suspension rod and stored in the light-proof tank until you are ready to process them.

A

B

Figure 9–11. *Loading roll film reels.*
(A) In total darkness, unwind the film from its spool, and cut or tear off the tape attaching it to the paper backing. Then insert one end of the film under the spring clip at the center of the reel. Gently squeeze together the edges of the film and rotate the reel counterclockwise to wind the film into place.

(B) Careless handling of the film during loading will result in crimps or "pinch marks" in the developed negative. Be *certain* to feed the film onto the reel straight (perpendicular to the axis of the reel). Sidewise pressure can cause the film to buckle and "escape" from the spiral groove of the reel. Should this occur unwind the film as far as necessary to be certain it is back in the groove. Practice this situation both in the light and in the dark.

Figure 9–12. *Inserting roll film into developer.* For uniform development it is important to insert the film all at once into the tank filled with developer, rather than pouring the developer through the tank lid. Immersion in developer normally follows a 30-second pre-soak. Once the film has been transferred to the developer, agitate for 30 seconds before starting the timer to allow the developer solution to replace the water in the emulsion. The tank can then be covered and processing continued with the lights on.

any air bubbles from the film. Then transfer them to the developer tank and cover the tank securely. The lights can now be turned on, and the tank should be rapped against the sink to dislodge bubbles, and agitated continuously for the first 30 seconds.

For some reason the agitation of roll films in tanks presents problems, chiefly uneven development. Most photographers arrive at an agitation system that works satisfactorily and produces even development, but you may have to experiment to find the best approach for your processing methods. I have obtained the most satisfactory results using agitation in a "torus" pattern, which is not easy to describe accurately but is nevertheless a simple procedure. With the tank lid and cap secured, I grasp the tank and lid firmly and, as I invert it, I also give it a twisting motion so that it is both inverted and rotated. I go through this movement twice in about 5 seconds (I consider this the ideal agitation period) at the appropriate intervals. For development times up to about 10 minutes, agitate every 30 seconds; for longer developing times agitate every minute for the first 10 minutes, and every 1 or 2 minutes thereafter. The heat of the hands can be transmitted to the developer through a steel tank; hence soak the hands in a tank of cold water prior to grasping the developer tank for agitation.

At the end of development, turn off the lights, remove the reels from the tank, and transfer them to the stop bath. They should be agitated rather vigorously (lifted, rotated, and replaced) for about 30 seconds, then drained and transferred to the fixer. The stop bath and fixer can be in separate roll film tanks or in sheet film tanks if these are deep enough to cover the reels. If the tank is uncovered, you can agitate by simply lifting and dropping the reels gently in both solutions. With a covered roll-film tank, of course, a similar agitation pattern to that used in development is best. Do not neglect agitation in either stop bath or fixer, and be sure not to expose the film to light until it has had 2 or 3 minutes' fixing time.

Washing, Drying, and Storage

Since the film base is impervious to photographic solutions (only the emulsion absorbs chemicals) the washing time is much shorter than with fiber-based paper prints. After removing the negatives from the fixer, give a thorough rinsing before placing the film in the wash. The most efficient washing requires a gentle but continuous flow of water around and through each reel. If you have the slightest doubt about the efficiency of your washer, empty and refill it at frequent intervals throughout the wash process. Roll films spooled on reels

and sheet films on hangers should also be moved about during washing to remove fixer solution that tends to accumulate along the edges within the grooves. Sheet film that has been tray processed should be agitated throughout the wash period by the same procedure used in development; I usually move the films at least 12 times from one tank to another filled with fresh water.

Using an efficient washer, I give the negatives an initial 5-minute wash, followed by treatment for 3 minutes in a hypo-clearing agent and a final 10 minutes of washing. For maximum permanence you may treat the negatives in a dilute selenium toner bath before final wash. It is advisable to control the temperature of the wash water carefully to avoid thermal shock to the negatives. Even though the emulsion has been hardened by the action of the fixer, it should not be exposed to warm water, and water that is too cold slows down the removal of residual chemicals. The optimum wash temperature is the same as that used for the processing solutions, or at most about 5°F lower. The quality of the wash water should also be checked; the water should be well filtered to remove grit, metallic particles and organic matter.

If water is in short supply, a series of repeated soakings in containers of fresh water can be efficient in removing hypo. The recommended procedure is to give at least one-half hour of continuous soakings, with agitation, changing the water every five minutes.

After the final wash, remove the negatives and immerse them for

Figure 9–13. *Washing roll film.* I use a stainless steel tube attached to a hose for film washing. The tube can be inserted to the bottom of the tank, so that water is forced up past the film to overflow at the top. It is worthwhile to empty the tank several times during washing to ensure complete removal of residual chemicals. Special film washers are also available for roll (or sheet) films.

about one minute in a very dilute solution of a wetting agent such as Kodak Photo-Flo. Keep the negatives separated in this solution but do not agitate vigorously, to avoid foaming of the solution. The wetting agent allows the water to run off the negatives freely, and should permit drying without the need to wipe the film. If you do find your negatives show water spots while drying, you should carefully wipe them off with a tuft of clean cotton or a *soft* rubber squeegee after treatment in the wetting agent.

Sheet film negatives will dry best if hung by one corner. I have found that wooden clothespins hung at intervals from an overhead wire work best. I have tried plastic clothespins, but find they do not grip the film securely, and metal clamps usually leave rough areas on the film, which can cause scratches if they come into contact with another sheet (trim them off after drying.) The films should be held only by the margins; never allow the clothespins to grasp the image area of the negative. Be sure the films are separated and cannot touch one another during drying. Do not try to dry sheet film in the developing hangers (if used), because water collects in the corners and the grooves, preventing uniform drying. Roll film should be removed from the reel and suspended from the same clothespin arrangement, with an additional clothespin attached at the bottom as a weight to prevent curling. As stated earlier, I recommend drying film at room temperature only. If dust is a problem, you may need to construct a drying cabinet with filtered vents at top and bottom to permit air to circulate without admitting dust.

See page 192

The negatives must be fully dry before being inserted into envelopes (roll films should be cut into strips). ◁ Should incompletely dried negatives stick together or adhere to envelopes, do not attempt to pull them apart or you may damage the emulsion. Instead, allow them to soak in clean water; in time they will separate by themselves or can be pulled apart very gently. It should also be pointed out that you must avoid partially wetting a dry negative. If this happens, the wet portion of the emulsion swells and distorts the negative, and it may be impossible to flatten it out again. Any time a part of a negative gets wet, be sure to immerse the entire negative in water immediately. After it has fully soaked up water, treat it with wetting agent and dry as usual. If done without delay, this procedure can sometimes save a negative that otherwise may be ruined.

Chapter 10 Value Control in Processing

Figure 10–1. *Aspens, New Mexico.*
This is a good example of using pyro
for expansion, with minimum expo-
sure and very full development. The
subject was in full shade, and illumi-
nation of the tree trunks was provided
by reflections from distant brilliant
thunder clouds to the left and right of
the camera position. The leaves were
of autumnal yellow, the aspen trunks
pale green, and the background foliage
in general was russet in hue. A normal
black-and-white photograph, exposed
according to an average meter reading,
would have been drab and flat. The ef-
fect visualized was thus a considerable
departure from reality.

I used a #15 (deep yellow) filter,
placed the general background values
on Zone II, and gave N + 2 develop-
ment. The filter raised the placement
of the leaves by about one value, and I
also anticipated printing on higher-
than-normal contrast paper. I chose
the ABC Pyro formula (see page 255)
as I desired maximum sharpness for
the leaves and minimum solvent-ef-
fect "blocking." In great enlarge-
ments, the leaves show value
differences, and even worm holes are
clearly defined in the bright areas.

It should be understood by now that visualization may relate to
realistic interpretations or intentional departures from reality,
through controls that include negative exposure and related devel-
opment. It is logical to consider value-control procedure first in
terms of relatively realistic values, using modifications in processing
to achieve a balanced negative with good detail throughout from
subjects that are of higher- or lower-than-normal contrast.

It is important to work from a full understanding of the charac-
teristics of current materials and the standards of "normal" process-
ing. The advent of thin-emulsion films has brought a number of
changes in the behavior of films and the appropriate means of pro-
cessing them. As discussed earlier, for example, the characteristic
curves of many current films have a very long straight-line region,
whereas older emulsions began to reach a "shoulder" (where the
high densities lose separation) by about Value VIII or IX. The use of
development contraction with earlier films was of great importance
in making possible the recording of long-scale subjects without hav-
ing the high values "block up." The longer straight-line region of
contemporary films makes this problem less severe, and the films
have a greater tolerance for higher-than-normal exposure.

At the same time, the thin-emulsion films are far less controllable
through development modifications than thick emulsions, espe-
cially in expansions. Our recent testing has confirmed that the pro-
cedures of expansion and contraction can be relied on to provide
control over a range of about two to three values, but often no more.

The net effect of these characteristics is that films today may be considered somewhat "fail-safe." They will tolerate some overexposure without blocking up (although underexposure is still quite critical), and they are more forgiving of carelessness in development procedure in most cases. While these qualities may increase the likelihood of achieving a tolerable negative, they also unfortunately reduce the films' responsiveness to precise controls. Thus, where formerly we had greater control over the scale of the negative values and could usually print on a normal-contrast printing paper, we now must often consider the use of papers of higher or lower contrast grades as part of our visualization. It remains true, however, that securing optimum contrast with adequate texture on the negative will greatly enhance our ability to achieve the optimum print.

NORMAL DEVELOPMENT

See Appendix 1, page 239

We must first establish the "normal" before we can depart from it in a useful way. Testing procedures given in the Appendix, ◁ or similar methods of determining optimum processing, should be carried out and the results applied in practical photography to confirm their effectiveness. In general terms, I have found that approximate values for normal negative densities are about as follows:

	Diffusion enlarger, density above filmbase-plus-fog	Condenser enlarger, density above filmbase-plus-fog
Value I	0.09 to 0.11	0.08 to 0.11
Value V	0.65 to 0.75	0.60 to 0.70
Value VIII	1.25 to 1.35	1.15 to 1.25

As will be seen in Book 3, the use of a diffusion enlarger, which I strongly favor, produces somewhat lower contrast than a condenser enlarger, and thus the normal negative for a diffusion light source requires a longer scale to print normally on a Grade 2 paper. Since many 35mm photographers choose the slightly higher acutance given by condenser enlargers, they should standardize on a softer negative, as indicated in the second column.

I must stress that these density values are approximate and relate to materials available at this writing. You may have to establish somewhat different standards if you find these do not suit your working methods. What is important, however, is determining the appropriate *range* of densities on the negative so that your normal negative can be expected to print satisfactorily on your standard paper in most instances. The density values I prefer for diffusion enlargers have a

range of about 1.20 (from Value I to Value VIII), which I have found to be optimum for printing on Grade 2 paper. However, the Grade 2 contrast varies among the different manufacturers, and the trend in recent years seems to be to favor a shorter exposure scale for the so-called normal papers; thus this optimum range must be subject to continual review and revision as required. You will also find that different values may work best for you depending on your enlarger, printing procedures (including standard paper), and personal tastes.

I urge you to establish through trials your standards for "normal" by means of negative-density values, rather than the more empirical method of trying to match the negative to a particular paper by simply testing to see if it prints successfully. We are, of course, concerned with how the negative prints as the ultimate objective of our tests, but there is too much variation from one batch to another of papers to use a single printing test to establish the standard. By using negative-density standards we eliminate many of the variables of the printing procedure, with the understanding, however, that the density standards may be altered if we find they consistently require an adjustment in printing over a period of time.

I realize that most photographers do not own a densitometer, but it is well worth the effort to find a means of reading negative densities. It is usually possible to have a commercial lab read your negatives for a small fee. You can also find some relatively inexpensive densitometers on the market if you decide to invest in one, and you may be able to find one secondhand. You can also secure fairly accurate density measurements using a calibrated negative step tablet (available from Eastman Kodak). Cut a mask that shows one step at a time of the tablet and a similar small area of the negative you are reading. Make the comparison visually in subdued room light on a uniform-luminance light box. If you have a spot meter, you may be able to read negative densities in this manner with it; each one-third stop exposure interval on the meter will correspond to a density increment of 0.10. With this method, the negative density area must be larger than for a conventional densitometer (at least a one-half inch square) so the meter will not have to be held uncomfortably close for readings.

EXPANSION AND CONTRACTION

Expansion and contraction are important elements of visualization. When we observe a subject before us and visualize the values of the print, we consider first the shadow values and let the important high

A

B

Figure 10–2. *Effect of contraction.*
(A) With the shadowed fence exposed on Zone IV, the fully illuminated wood and foliage fall on Zone IX, too high to print on normal-contrast paper.

(B) The same exposure, with N-2 development, yields a negative density range that prints satisfactorily on normal paper. Note also the softer and more luminous rendering of the foreground foliage. The film was Kodak Tri-X film pack, developed in HC-110.

values "fall." If we find, however, that we have a long-scale subject with an important high value that falls on Zone IX, and we wish it to be a Value VIII, a one-zone contraction (N − 1) is indicated. If our high value falls too low on the scale, Zone VII for example, and we wish it to be a Value VIII in the final print, N + 1 is needed.

Hence the purpose of expansion and contraction is to alter the density value scale of a negative that has been exposed to a higher or lower luminance range than normal. The objective is to secure a negative that will print on a "normal" contrast paper with a minimum of printing controls (developer modification, print exposure-development ratio change, local controls, and so on).

To repeat: we use *exposure* to control the low values on the negative, making a test for effective film speed that produces a density of 0.10 above filmbase-plus-fog for a Zone I exposure; we then apply *development* control to achieve the appropriate high-value densities. I have found that 1.30 above fb-f is a useful standard for Value VIII, for diffusion-type enlargers. The optimum *range* of densities for a full-scale negative, from Value I to Value VIII, is thus 1.30 minus 0.10, or 1.20. This is the density range I expect for a negative exposed to Zones I to VIII and normally developed, and it relates to a typical Grade 2 printing paper.

For a one-zone expansion, we determine the development time that produces this range of densities for a subject that is one zone

shorter in scale. N + 1 development will yield this 1.20 density range for a negative exposed to Zones I to VII, instead of I to VIII. Similarly, N − 1 is the development time that yields a 1.20 density range for a negative exposed to Zones I to IX.

I have used Value VIII as a standard for high-value density specifically because of its importance as the lightest area in a full-scale image that retains some texture. Contemporary materials have a quite long useful range of density values. Once we can control the densities at Zone I, II, and III (through exposure) and Zones VII, VIII, and IX (through exposure and development), we can be quite confident that the intermediate values will be readily printable, with detail and "information" throughout the negative. Higher values than VIII do exist on the negative and the print, however, and particularly with the current long-straight-line films, we may have separation up to Value XII or higher on the negative.

In practice it is not always feasible to expand or contract the negative scale to achieve exactly the desired density range, particularly when using roll films or with very flat or very high contrast subjects. We thus include the use of various paper grades and other printing controls in our procedures for contrast control, and we should consider these at the time we are originally visualizing the image.

See page 90

Remember that increasing development usually moves the toe of the film to the *left* on the log Exposure scale, ◁ indicating that somewhat *less* exposure is required to reach threshold than with normal development. It is often possible to place the low values about one-half zone lower than normal, especially if you attempt expansion beyond N + 1. With reduced development the threshold moves to the *right* on the characteristic curve, and you should allow one-half to one stop *more* exposure if N − 2 development is planned. Such an exposure increase will also have some effect on the high values, and experience is required to judge the right adjustment.

Local Contrast

See Figures 4–29, 4–30

It should be clear from the sample curves ◁ that a one-zone expansion or contraction at a high value does not produce a full one-zone change lower on the scale. Using N + 1 development to raise a Zone VII exposure to a density Value VIII does not necessarily raise a Zone V exposure by a full zone. There are times when we wish to apply expansion and contraction because of their effect on *middle* values (Values IV, V, and VI), either because no important high value area appears in the image, or because we wish to alter the local contrast

See Figures 4–23, 4–24

within a middle-value area. ◁

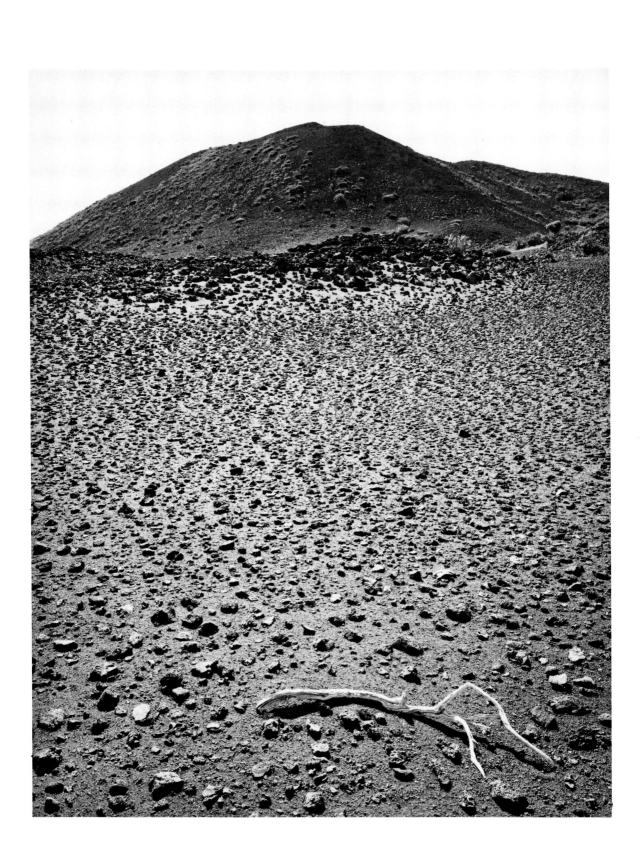

Figure 10–3. *Volcanic Landscape, Hawaii (c. 1957).* This image is an excellent example of textural emphasis. It was exposed in 2 P.M. sunlight without a filter, and given N + 2 development. The sky was hazy and very bright, and the air was very clear in the general area. The average luminance (read with a Weston Master V widefield meter) was placed on Zone V. The small shadows of the white branch fell on or below Zone I. The crisp contrast was augmented by printing on Grade 4 paper. There would have been no advantage in using a filter; there was almost no color in the scene and the sky was practically white.

If control of the middle and upper-middle values is of great importance in your work (as it might be in portraiture, for example), you can use the density standards for Value V (0.70 net density for diffusion enlarger) or Value VI (0.90) to determine the development time required for a full one-zone expansion or contraction in this central region. (You may also be able to estimate these times with sufficient accuracy if you conduct careful tests at the Zone VIII standard density.) A one-zone expansion or contraction in this central region of the curve will, of course, have an effect greater than one zone at higher densities, and it is therefore to be expected that you might have difficulty controlling any high values that might be present. You must make your decision in such cases based on the relative importance of high values if they exist in the subject.

For example, a subject of four-zone luminance scale (1:8) can be exposed on Zones III to VI, and N + 1 development may be used to produce density values that will print as III to VII. Not only is the high value raised by one zone or density value, but we will find that the local contrast range within each zone is also expanded. Similarly we can apply N − 1 to reduce the negative density values of Zone VII and VI exposures to Values VI and V, a procedure that can be effective in portraiture. N − 2 development is rarely required for local-contrast effect in the middle values, but it can be very rewarding for control of high values.

Contemporary Films

Nearly all current thin-emulsion films will permit expansion to N + 1 without difficulty, and a few permit N + 2. Kodak's thick-emulsion Super XX sheet film is one of the few that permit N + 3 or higher, although this film has considerable graininess which is exaggerated by extended development. Kodak has also recently introduced a film called Technical Pan (formerly SO-115, now Type 2415). Use of this film might be considered when a high degree of expansion is desired, since with normal development it has extremely high contrast. ◁ Although we have not tested the film extensively, the data indicates that it should give about the equivalent of N + 4 with standard processing. With a softer-working formula (Kodak recommends the so-called POTA developer ◁) it can give extremely fine grained negatives of about normal contrast. With testing it thus might prove useful for subjects requiring normal through N + 4 or N + 5 processing.

With most current films, expansion can generally be expected to increase graininess. This fact effectively limits expansion with most roll films to about N + 1, since these negatives are normally enlarged

See Appendix 2

See page 254

considerably. In cases where more expansion is desired with a standard film, you should consider combining increased development with intensification, ◁ as well as the use of higher-contrast printing papers.

See pages 235–237

A substantial increase in development is required with current films to reach an effective $N + 1$. Most films seem to need about 50 percent or greater development increase for a one-zone expansion. One of the factors that limits expansion *beyond* this point is that the low values begin to build up density with further development increases, thus raising the entire characteristic curve. When this occurs the high values may show a further density increase, but the *range* of densities shows little further expansion. This is one area where a densitometer or other means for reading densities accurately is important; a negative given greatly expanded development may appear visually to have higher contrast, but the filmbase-plus-fog density must be subtracted to determine the range of *net* densities.

Reducing development to $N - 1$ is quite practical with most current emulsions, and $N - 2$ is workable with many. At $N - 2$ and less, the loss of local contrast in low-density values often becomes a problem, and a process that provides compensating effect may be preferable. Developing times shorter than about five minutes are difficult to control precisely, and if less development time is indicated for contraction I suggest using a higher developer dilution and correspondingly longer time for equivalent effect. Reduced development time also requires great care in agitation to avoid streaking and uneven development.

HIGHLY DILUTE DEVELOPERS

See page 187

A developer of the compensating or semi-compensating type has higher activity in the low-density values than in the high values. ◁ It thus provides for full development and separation within the "shadows" without producing excessive density in high values. Although some developers are designed for compensating effect, I have found the use of highly dilute HC-110 quite satisfactory as a compensating formula. (Highly oxidizing developers such as pyro are not recommended for high-dilution development because of the probable staining effect.)

In general a highly dilute developer will behave like the same developer at normal strength if the time is extended sufficiently, provided that the normal amount of stock developer is present in the dilute solution and agitation is normal. But if agitation is less

Figure 10–4. *Forest, Garland Regional Park, California.* The compensating effect of highly dilute developer is well demonstrated in this image. I used Kodak Tri-X Professional roll film developed in HC-110 diluted 1:30 from *stock* (not from concentrate). My intention was to convey the impression of soft, enveloping light. The camera was a Hasselblad with the 40mm Distagon lens.

frequent and the film is allowed to "stand" in contact with the highly dilute solution, a certain amount of compensating effect may occur. You may understand this effect if you think of the "interface" where the developer is in contact with the emulsion. In areas representing high exposure where there is a large amount of silver to be reduced, the developer quickly exhausts itself. In areas that received less exposure, with correspondingly less silver to be reduced, the solution remains active for a longer time and thus gives more development.

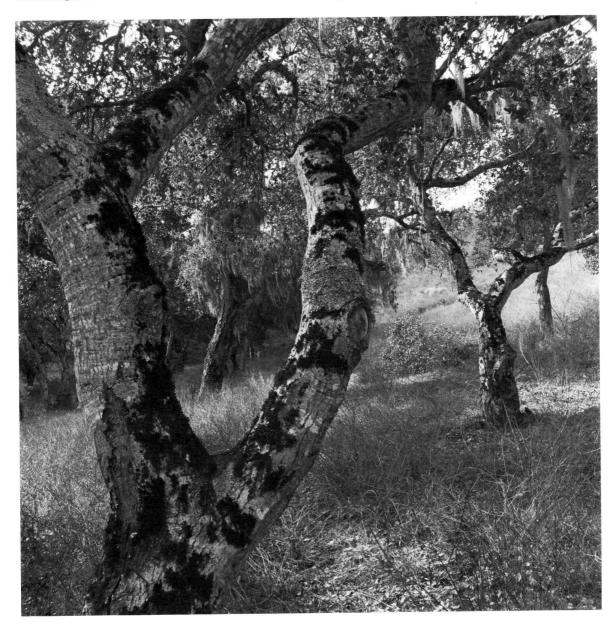

We normally offset this effect by agitating frequently to replace the exhausted developer throughout the emulsion with fresh solution, but lessening the agitation achieves compensating development.

This procedure can be used when very soft development is desired, and when shadow areas are important and require extra luminosity. In such cases we should place the shadow values about one zone higher than normal; compensating development will then ensure that they develop fully without creating excessive high-value density. Our tests indicated that HC-110 diluted 1:30 *from stock solution* makes an effective compensating formula. Developing times (at 68°F) will be around 18 to 20 minutes, and the agitation intervals must be reduced to about 15 seconds every 3 or 4 minutes. You should pre-soak the film in water for at least 30 seconds before developing, and agitate constantly during the first minute in the developer. When used with sheet films, it may be best to develop a single sheet at one time. If more than one sheet must be processed, be sure to separate them in different areas of the tray so they do not overlap during the long periods between agitations, and they must not float on the surface of the developer.

To hold one to four 4×5 films in a horizontal position, we have found that a film developing holder designed for nitrogen-burst tank agitation can be used in a conventional 11×14 tray. The holder will keep the films separated and flat, well under the surface of the solutions. It should not, however, be used for ordinary vertical agitation in a conventional tank. The holders, made by PPI and sold by Calumet, are also made for 5×7 and 8×10 films.

With roll films developed in a tank, let the tank rest alternately upright and inverted between agitations. Be sure the tank does not leak; use a wide rubber band around the seam between tank and cover and another one to hold on the small cap, or open the tank and invert the film reels.

Our tests with this procedure are preliminary, but it definitely merits consideration for compensating effect. Establishing the right time of agitation and intervals between agitation is of great importance, and you should experiment to find the minimum total agitation that produces uniform negatives without streaks or mottle.

Remember also that *a definite amount of developer energy is required for a given film area*. You must therefore be sure that the highly diluted solution contains the quantity of developer stock solution used for normal development based on the number of rolls or square inches of sheet film. Thus the total volume of liquid used will be considerably larger with the diluted formula than for normal processing, and you will have to use larger vessels than usual, or fewer loaded reels in a given roll-film tank.

WATER-BATH AND TWO-SOLUTION DEVELOPMENT

These are time-tested procedures for reducing overall contrast while supporting shadow densities in a manner similar to the dilute developer method. The principle is to allow developer to soak into the emulsion and then transfer the negative to a bath of water or mild alkali where it is allowed to rest without agitation. The developer within the high-value areas of the negative quickly becomes exhausted while the developer continues to work in the lower values. This cycle can be repeated one or more times as needed to secure the desired density range. Remember to expose about one zone higher than normal. ◁

Both processes were of great effectiveness with thick-emulsion films, but water-bath development does not appear to be as effective with thin emulsions, probably because they cannot absorb much developer solution. The two-solution process, however, does appear to have compensating effect with current films. In particular our tests of Tri-X sheet film developed in D-23, with a second bath made up of a 1 percent Kodalk solution, have shown compensating effect. The procedure is to immerse the negative in D-23 for 2 to 3 minutes with constant agitation, followed by a soaking in the Kodak solution

See page 84

Figure 10–5. *Effect of two-solution development.*

(A) Using Kodak Super-XX 4×5 film, I placed the average of the roof surface on Zone III. Development was normal in HC-110.

(B) The same film, given two-solution development. Note the greatly improved detail in all sunlit areas.

A

B

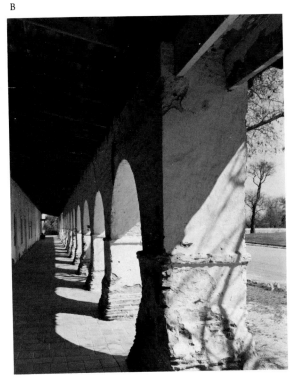

Figure 10–6. *Sun and Shade in Forest, Yosemite National Park.* The subject was a typical high-contrast forest scene: light gray rock covered with lichens, dark shadows of tree trunk and foliage and stone. An average reading would have rendered the shadows too weak and the high values of the rock would have been overexposed. N – 1 or N – 2 development would have compressed the total luminance scale into a printable range, but the shadows would have been dark and thin, and the effect of light would have been lost.

I thus chose to use the water-bath process. I exposed the shadows on Zone V, and the high values fell about on Zone XI. Using D-23 developer, I

for at least 3 minutes without agitation. The time the film is in this alkaline bath is not critical, since development stops when the carried-over developer solution is exhausted. The result is a very soft negative with fully developed shadows; the filmbase-plus-fog level also goes up with this procedure, but this is simply "printed through" to achieve the desired black values in the print.

gave only three short immersions in the developer and three immersions of three minutes each in the water bath. To make the same photograph today, I would choose a film such as Kodak Tri-X or Ilford FP-5, and would employ the two-solution process.

The problem is to fully support the shadows while restraining the density of the high values of the rock. In such situations I advise making two or three identical negatives and experimenting with the process for optimum results. Modern films with their longer straight-line section (see pages 87–88) would better preserve the textures of the high values.

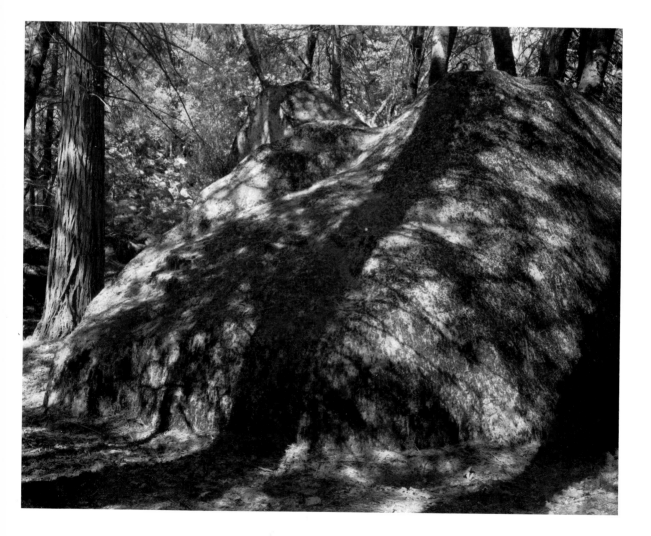

There are some variations on the procedure that might prove useful:

1. Immerse the film in D-23 for 30 seconds to 1 minute, followed by 1 to 3 minutes in the alkali solution. The film is then rinsed thoroughly in a *weak* acid stop bath solution followed by a *thorough* rinse in water. It can then be returned to the developer for a second cycle. Repeated cycles without the acid stop bath following the alkali causes the alkali to be carried back into the developer and increases its activity, reducing the advantages of the two-solution process. With relatively short times in the developer, the process might continue through three to five cycles, as needed. The results should be

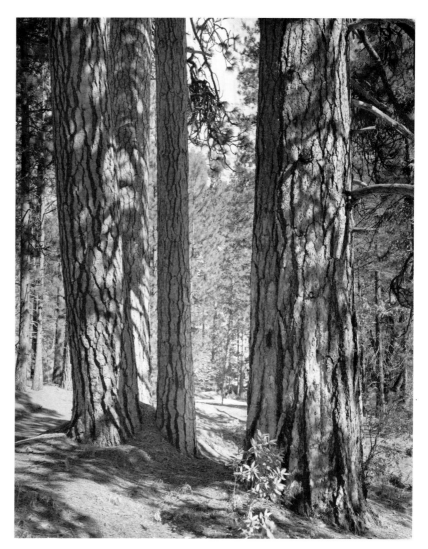

Figure 10–7. *Yellow Pines, Yosemite National Park.* This is an excellent example of water-bath development. The shadowed areas of the tree trunks were placed on Zone V, and the earth in the distance fell about on Zone X. The impression of light is quite well preserved. Two points to observe: (1) The very dark interstices of the tree trunks remain dark, as they represent quite low luminances. Had this subject been given pre-exposure, all areas of the film would have the minimum pre-exposure density, which must be "printed through" if we wish to preserve any impression of *black.* (2) In this image, made on thick-emulsion film with an abrupt shoulder, the high values tend to flatten out, and a "pasty" effect can be obtained. The long straight-line region of most current thin-emulsion films practically eliminates this problem.

Figure 10–8. *Interior Door and Court, Santuario, New Mexico.* The interior doors were placed on Zone III, and the sunlit court values fell on Zone XI. I used water bath processing with Edwal FG-7 as the developer, with about ten changes between the developer (30 seconds with continuous agitation) and water (about 60 seconds, no agitation). With modern films I would expect a similar effect with the two-solution process.

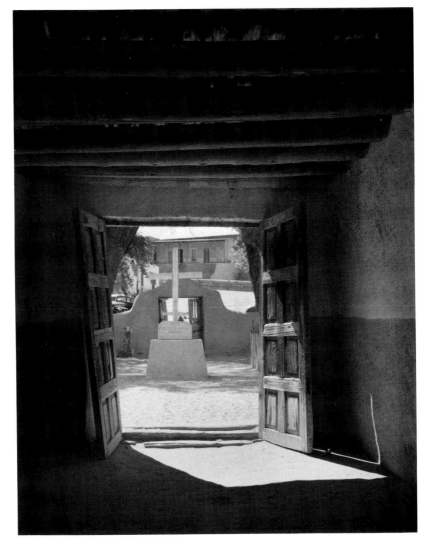

a negative that is more fully developed than with the single cycle, and therefore with additional compensating effect. If roll film on a reel is developed in this way, I advise inverting the roll before each soaking in alkali to minimize any "settling" effect while it stands in the second bath.

2. The film can be given the equivalent of N − 1 or N − 2 development, and then allowed to stand in the alkali bath for several minutes to reinforce the shadow densities. The negative can be expected to have nearly normal density range, but with some reinforcement of development in the shadows.

SPECIAL-PURPOSE DEVELOPERS

In my opinion the proprietary developers available today more than satisfy the requirements of general photography. However, there are a few developing agents and formulas that have special characteristics and may be helpful in some situations.

Pyro (pyrogallic acid)

Pyro, one of the oldest of developing agents, has a "tanning" effect on the emulsion, especially with thick-emulsion films. It hardens the emulsion during development and thus reduces the lateral migration of silver, creating a high degree of acutance. It also has a staining action which is proportionate to the amount of silver reduced. The degree of staining depends on the amount of alkali and preservative used, how much oxidation has occurred before development begins, and the temperature and time of development. The stain is superimposed on the image silver; since it is yellow, it absorbs the blue light component of the enlarger illumination during printing and thus acts like added density. Thus a pyro negative that may appear quite flat to the eye may print with unexpected contrast.

See Appendix 3, page 255

Edward Weston used the ABC Pyro formula ◁ with about one-third less carbonate (the alkali) in solution C. He gave long development times, and since pyro acts somewhat as a desensitizing agent, he could inspect his negatives with a faint green safelight near the end of the development time. I do not recommend this procedure with the faster modern films, however, because of the difficulty of judging densities accurately and the risk of fogging the film. It may be viable with an orthochromatic film, where a fairly strong red safelight can be used. ABC Pyro is a rather soft-working formula; it can be made more active (and more unstable) by increasing the alkali.

Pyro is quite hard to control and not always predictable when applying time-temperature development. The amount of image stain produced depends on the degree of oxidation of the solution, and the oxidation varies with the concentration of pyro, sulfite, and alkali in the solution and the time the solution has been exposed to air. There are nevertheless photographers who find that the qualities offered by pyro development outweigh its inconsistencies.

The Kodak D-7 formula is a variation that adds metol to the pyro. The effect is to counteract somewhat the loss of effective speed with pyro alone.

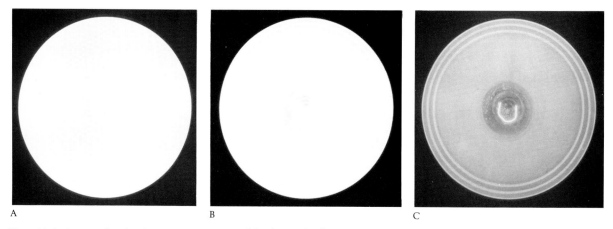

A B C

Figure 10–9. *Pyrocatechin development.*
The subject is a clear glass tungsten
lamp in a reflector.

(A) With the average luminance on
Zone XIII, normal development in
DK-60A yields almost no detail.

(B) Reducing the exposure to Zone
IX, with the same development as A,
causes some improvement in detail.

(C) Pyrocatechin developer permits
full exposure on Zone XIII while
preserving maximum separation and
detail. With some contemporary thin-
emulsion films the pyrocatechin-
developer effect may not be as pro-
nounced. Experiments should be made
before this developer is applied to seri-
ous work.

See Appendix 3, page 255

Pyrocatechin (catechol)

This developer is somewhat similar to pyro in tanning and staining
action. Used in the compensating formula, ◁ it can give remarkable
results with extremely high contrast subjects, maintaining separa-
tion throughout the high subject values. Its tanning action seems to
prevent penetration of the developer into lower layers of the emul-
sion, thus giving soft development to high densities. It therefore
permits a certain amount of control with high-contrast subjects,
with some loss of effective speed. This effect is better realized with
"thick-emulsion" films than with the newer thin-emulsion films.

Amidol

Amidol is an agent with high reduction potential, meaning it is
highly efficient in the amount of silver halide reduced by a given
amount of the developer. In the past I have recommended the use of
amidol as a water-bath developer because of its reducing strength,
but I have since found its use unpredictable because of the tendency
to produce uneven stain. It is now sometimes used for print devel-
opers, although in a comparative test I preferred the quality and print
color achieved with Dektol (a metol-hydroquinone developer).

Phenidone

Phenidone is Ilford's name for a developing agent that is sometimes
used to replace metol in metol-hydroquinone formulas. Much
smaller quantities of Phenidone than metol are required, and there
is less likelihood of allergic reaction. Phenidone-A is used in the
POTA developer formula, ◁ which is the phenidone equivalent of

See Appendix 3, page 254

D-23 and the old Windisch metol compensating formula. Used with conventional films this formula can give very soft negatives without a major loss of effective speed. It is also recommended by Kodak for achieving normal contrast negatives with its Technical Pan film (Type 2415), which otherwise gives very high contrast. Phenidone does not dissolve readily in water, so the solution must be mixed at about 100°F, then cooled and used immediately.

INTENSIFICATION AND REDUCTION

See Figure 6–2

Intensification and reduction are valuable for altering the densities of a negative after development. They are especially worth consideration for use with roll film, where development control of individual frames is not practical, as well as with sheet films where extra contrast control is required. With a film limited in expansion to $N+1$, for example, the combination of expansion plus intensification may yield $N+2$ or even $N+3$ in total contrast range. They should also be considered for certain local contrast control effects; I used IN-5 for intensification of the foreground in my *Moonrise, Hernandez, N.M.*, ◁ to increase the density and contrast within that severely underexposed area; it did not affect the grain or the color of the negative.

Intensification

Some formulas for intensifiers are not permanent, and these should be avoided. I also do not recommend the bleach-and-redevelop methods, since they can be hard to control. I have had good results with the Kodak IN-5 formula. This is a *proportional* intensifier, meaning it has significant effect in high-density areas with much less effect in low densities. It thus produces results similar to expanded development.

I have also found that the selenium toner often used with prints makes an effective negative intensifier, although I still consider this procedure somewhat experimental. The selenium appears to act as a proportional intensifier, and I would expect the procedure to be quite permanent.

See Appendix 2

In our tests with selenium we have achieved the equivalent of a one-zone density increase at about Values VIII or IX, with almost no density change at Values I or II. ◁ The procedure was to soak the negative thoroughly in water and re-fix it for several minutes in a *plain* hypo solution. It was then placed in selenium-toner solution

Figure 10–10. *Effect of Selenium Intensification*. Although normally used for toning of papers, selenium toner can provide intensification effect with negatives. Negatives A and B were printed identically, but B received selenium intensification. The white wall is higher in value, and the leaves have more brilliance and separation of values.

A

B

diluted 1:2 or 1:3 with Kodak Hypo Clearing Agent for about 5 minutes, followed by plain Hypo Clearing Agent (working strength) and washing. One advantage of this process is that there appears to be no increase in grain size, unlike many other intensifiers, making it especially useful with roll films.

With proportional intensifiers like IN-5 and selenium, the degree of intensification relates to the density. It is thus worthwhile to plan exposure and development accordingly whenever possible. A flat negative that has no density above Value VI will probably benefit from intensification, but the effect will be greater if the exposure and development are increased to produce a Value VII density for the same area. Kodak also says its IN-5 formula is more effective and faster working with fine-grain films than with coarse-grain films.

In all cases I advise you to experiment with intensification by making tests using duplicate negatives for comparison. If you have an important negative that needs intensification, test the procedure first with a discarded negative of the same emulsion.

Reduction

Reducers are used to remove density from a developed negative. There are three general types:

1. *Cutting reducers* affect the low values first, and thus are useful for clearing negative fog. The effect is to increase the overall contrast of the negative.

2. *Proportional* reducers subtract density throughout the negative with the effect similar to giving slightly less development.

3. *Superproportional* reducers affect the higher densities of the negative more than low densities, as if much less development had been given to the negative. This is a somewhat tricky process, with uncertain results.

See Appendix 3, page 257 Cutting reducers like the Kodak R-4a formula ◁ are probably the most widely used, and are relatively easy to control. After thorough fixing and washing, the negative is placed in the solution (using a white tray will make it easier to observe the effect). After a minute or so remove the film and rinse it well before examining it. If it is returned to the reducer solution, examine it every 30 seconds or so thereafter. When the desired degree of reduction is achieved, thoroughly rinse the negative. I then usually give it a few minutes immersion in an acid-hardening fixer bath, followed by thorough washing. Sometimes a slight scum may be found on the surface after reduction; after thorough rinsing, this scum can be removed by carefully using a wad of cotton, followed by further rinsing and washing.

The proportional reducer (R-4b) is used by first immersing the negative in Solution A for 1 to 5 minutes, and then in Solution B for

5 minutes. If further reduction is desired, the process can be repeated. I prefer to immerse the reduced negative in an acid fixing bath after the final rinse, and then give a good wash.

The standard procedure for both intensification and reduction must include thorough fixing and washing *before* treatment, and in some cases pre-treatment in a separate hardener (like Kodak's SH-1 formalin formula) is advisable, especially in hot weather.

Appendix 1 **Film Testing Procedures**

Before discussing testing procedures I would like to repeat that this material (and many of the recommendations throughout this book) represent my personal experience and philosophy. I strongly encourage each individual to develop his own concepts in photography. The function of this book is partly to help the individual clarify his own approach through improved understanding of the materials and more focused methods of personal application. My intention in describing my procedures is not to impose them to the exclusion of others, but to allow the photographer to learn from my experience in whatever ways may be applicable to his personal expressive intentions. I believe it is important that the individual's progress in the medium be supported by a foundation of craft which, once mastered, can be applied as appropriate to the photographer's work.

The tests that follow have been designed to account for the variables that exist in each person's working system — shutter and aperture, meter, lens flare, and procedures of development. We first establish the appropriate film speed that ensures the optimum exposure (as determined by the recording of the low values), and then test for the degree of development that provides the desired high-value density. Once these two extreme values are controlled the normal scale will be quite predictable, and good quality negatives that print readily on "normal" paper should be assured. Subsequent tests may then be employed for expansion and contraction of the negative scale.

In conducting such tests it is important to establish a single system of equipment and materials. Choose a film and developer you use often, and be sure to use the same camera, shutter and lens throughout. Your exposure meter, lens diaphragm, shutter, and darkroom thermometer must be reliable — calibrated by a technician if possible. Once this "system" has been tested, any variations introduced by a change of equipment (such as the possible difference in aperture calibration or flare introduced by changing lenses) should be quite apparent if they are significant. For a change of film and/or development, of course, new tests must be conducted.

You must also be extremely careful throughout the test procedures; if you allow any variations to occur, such as a change of lighting or inconsistent development procedure, it will be impossible to reach any firm conclusions from the tests. *Keep detailed notes throughout,* both to be certain that you draw the appropriate conclusions and to allow you to check on procedure if the results are not as expected.

The test for film speed requires making a series of exposures, each of which represents a Zone I exposure at a different film speed. Once you determine which exposure is actually optimum for Zone I, you will know the effective speed to use with that film. The procedure is the same whether using roll or sheet film, but with sheet film you must be certain that you can identify each sheet; you may cut or punch special code notches in the edges of the sheets for this purpose before loading the film holders (you can identify up to 5 sheets by carefully trimming 0, 1, 2, 3, or 4 corners). With roll films (especially 35mm) it is possible to combine the film speed and development tests on a single roll, as described later, but it is usually best to begin by conducting the tests separately until the procedure is familiar and well understood.

1. Load your camera or film holders with the film to be tested, and record all details in a notebook: camera, lens, film, manufacturer's ASA speed, etc.

2. Locate a uniform-value test subject, such as a sheet of mat board. In daylight, a middle-gray surface is good for films rated at ASA 50 or slower, but for faster films a darker surface will give a better range of apertures and shutter speeds in most cases. I suggest conducting the tests in daylight, either in open shade on a cloudless day or under a consistent cloud cover. The use of tungsten lighting may result in a film speed up to one-half stop different from the daylight film speed. (If most of your photography involves the use of tungsten lights, you may wish to conduct the tests under such conditions.) An alternative is to use blue-coated tungsten bulbs to simulate daylight. Record the lighting in your notes.

3. Place the camera on a tripod and position it in such a way that the card fills all or most of the frame. The general background should be of middle value. Be sure the card is at an angle at which it reflects no glare toward the camera, and the camera must not cast a shadow on the card. Focus the lens at infinity; you do not wish to record any texture on the card, and it is important to avoid exposure variation due to lens extension.

4. Set the manufacturer's ASA speed on your meter and make a reading from the card. Be sure to read the luminance from the direction of the camera, and without allowing the meter to cast a shadow on the card. If you use a spot meter, check that the luminance of the card is precisely the same over its entire surface.

5. Determine Zone I exposure for the luminance value read from the card (i.e., *place* the luminance on Zone I; this is four stops less than, or one-sixteenth, the exposure indicated directly from the meter reading of the gray card.) From the range of possible Zone I exposure settings that result choose a middle-range shutter speed, avoiding the two fastest and the slowest speeds on your shutter since they are often inaccurate. Then check that the corresponding aperture required for Zone I exposure is one that will allow one full stop of adjustment in either direction so you can make the required series of exposures as given below. If your meter reading does not allow you to meet these requirements for aperture and shutter speed, you will have to

adjust the lighting on the card, choose a card of different reflectance, or use neutral-density filters. Record in your notes both the luminance reading of the card and the aperture/shutter speed chosen for the Zone I exposure.

6. Then determine the series of exposures you will make according to the table given below. Each exposure will differ by one-third stop, and thus each will represent a Zone I exposure at a different ASA number. (The ASA and other film speed systems are calibrated in thirds of stops, ◁ so it is best to estimate these settings even if your lens has detents at half stops.)

See page 18

Exposure Series for Film Speed Test

	ASA-number	f-stop	shutter-speed
1. No Exposure (to allow you to read fb-f density)			
2. Normal Zone I exposure	_____ (manufacturer's) ASA number)	_____	_____
3. one-third stop *less*	_____ (1 ASA number higher)	_____	_____
4. two-thirds stop *less*	_____ (2 ASA numbers higher)	_____	_____
5. one stop *less*	_____ (3 ASA numbers higher)	_____	_____
6. one-third stop *more* (than #2)	_____ (1 ASA number lower)	_____	_____
7. two-thirds stop *more*	_____ (2 ASA numbers lower)	_____	_____
8. one stop *more*	_____ (3 ASA numbers lower)	_____	_____

The ASA numbers in this table can be filled in from the list below. If you are uncertain about the relationship of exposure and ASA numbers, simply set each ASA number of your meter and read the f-stops that fall opposite your chosen shutter speed. The first frame or sheet is given no exposure but processed normally, to permit reading the filmbase-plus-fog density. If you have a densitometer with a narrow probe, you can measure the fb-f density from the margins of the film, or from the spaces separating the exposures on a film roll.

The standard ASA number sequence is as follows:
12, *16*, 20, 25, *32*, 40, 50, *64*, 80, 100, *125*, 160, 200, *250*, 320, 400, *500*, 600, 800, *1000*, 1200, 1600, etc.
(The numbers in italics are those that relate to whole f-stops when using the Exposure Formula. ◁)

See pages 66–67

7. Once you have worked out the sequence of exposures, you may proceed to set each one on the camera and use it to expose a separate sheet or frame of film. *Check the luminance of the test card immediately before making the exposures, and throughout the exposure series.* If you have unexposed film on a roll after completing the exposure series, use it for making photographs so the roll is fully exposed.

The film should be given normal processing using the manufacturer's recommended procedures or your own usual processing methods. Once the film is dry, read the density of each sheet or frame, including the unexposed one, using a densitometer if possible. ◁ Then subtract the filmbase-plus-fog density value, and record the *net density* of each exposure.)

See page 221

The net density value closest to 0.10 represents the desired Zone I exposure, and the corresponding ASA number is the optimum film speed. If two exposures are about equally close to 0.10 density, choose the higher density (lower ASA number). If none of the exposures yields approximately the anticipated 0.10 density, check all procedures and your exposure calculations, and then look for an equipment problem like a malfunctioning shutter, incorrectly calibrated apertures, or faulty meter, and repeat the test.

Normal Development Test

Once the optimum film speed has been established you are assured that all portions of the negative scale receive appropriate exposure. The density of the high values is then controlled by the degree of development. Normal development is thus established by making a series of Zone VIII exposures and adjusting the development time until the desired density is achieved. (In previous books I recommended Zone V as the pivotal reference, in relation to earlier films. I am now advising Zone VIII as the reference point for the high negative-density values, because of the long straight-line characteristic of modern emulsions. Zone V is a reference value for the "local contrast" effect. ◁)

See pages 80–83
See page 220

As stated in the text, ◁ I have found that a Zone VIII density of about 1.25 to 1.35 is optimum with diffusion enlargers, or 1.15 to 1.25 with condenser enlargers. The corresponding densities for Zone V exposures are 0.65 to 0.75 with diffusion enlargers, or 0.60 to 0.70 with condenser. You may use these values for the development test, but you should judiciously adjust them if you find that they do not consistently produce the optimum negative scale in your own work.

To test for normal development, set up the test card under uniform illumination as before. You must again be careful to control all test conditions, and use the same equipment and materials as in the first test. Read the luminance of the card, and determine the exposure to place the luminance on Zone V and then on Zone VIII, using the film speed established in the first test (Zone V is the exposure indicated by the meter, and Zone VIII is three stops, or 8x, more than the meter-indicated exposure). Expose about three or four sheets at the Zone V exposure and the same number at the Zone VIII exposure. With roll film you may make a single exposure at each setting, and then use the remainder of the roll for other photographs (perhaps

experimenting with placements of subject luminances). Or your may expose an entire roll alternating Zone V and Zone VIII exposures, separating each pair by an unexposed frame, and then cut off one pair at a time to develop along with a normally exposed roll. You should include an unexposed sheet or frame, whatever test procedure you follow, to allow you to check that the fb-f level is the same as in the first test.

Develop one Zone V–Zone VIII pair together. Then subtract the fb-f density and compare the results with the values given above. If the Zone VIII density is too high, the negatve has received too much development; if it is too low, the negative is underdeveloped. Try increasing or decreasing the development time by 10–25 percent, and then process another set of negatives. The Value V densities are given as a check on the middle range densities both at Zone V and Zone VIII exposures.

If you use 35mm film, you can combine the film-speed and normal-development tests on a single roll, once the procedures are familiar. First make an exposure series that represents Zone I placements at different ASA speeds, as described in the first test procedure; then make a series of Zone V and Zone VIII exposures over the same range of film speeds. Once you have determined the optimum film speed based on the Zone I density, you can measure the Zone V and Zone VIII densities for *only* the frames exposed at the same speed to determine whether the development is appropriate.

The ultimate test of all procedures, of course, is their usefulness in making photographs. The first few times you use a new film speed or development time, it is worthwhile to measure and record the subject luminances with extra care, and inspect the developed negatives to be sure detail is preserved in low-value areas where you expect it. Then make a print without manipulation to see how the scale of the negative suits your paper and printing procedures. With experience you will find that careful inspection of negatives will indicate whether a change in materials or the functioning of equipment has caused any significant variation in exposure or processing effects.

I have found that the manufacturer's ASA speeds for most films are higher than I prefer, and do not give an adequate Zone I density. If the higher speed rating is used, the effective threshold is raised to about Zone II.

Expansion and Contraction

The tests for expanded and contracted development are similar to the normal development test, except that the exposure is altered. To find N + 1 development, for example, several Zone VII exposures are made at the working film speed, and the development time is increased until the normal Zone VIII density is achieved. For N + 2, expose for Zone VI and develop to a Zone VIII density.* For N − 1, expose on Zone IX and reduce development from the normal time until Zone VIII density is obtained.

It is important in these tests to consider only *net* density, or density above filmbase-plus-fog. Since the fb-f levels will change as the processing time

*Most films today do not expand to a full N + 2. The use of the selenium intensifier (see page 235) may yield an effective N + 2 when used in conjunction with N + 1 processing.

changes, you should include unexposed film in each development and measure the resulting fb-f density for that development time. You thus ensure that the range of densities from Zone I to Zone VIII in the negative will match the characteristics of normal printing paper.

Most current films seem to require about 40 percent to 60 percent more development than normal to reach a true N + 1. Your first attempt to establishing N + 1 development time might therefore be 40 percent longer than normal. For N − 1, try a reduction of about 30 percent as a starting point.

See page 80

Expansion and contraction also affect the local contrast, the recording of texture and substance within each value. ◁ There are times when N + 2 development, for example, is used to emphasize texture in low and middle values rather than to expand the overall scale of the negative. If a textured surface is used as the target in the development tests, the Zone V exposure can be printed as a visual check on the effect of expansion and contraction on local contrast.

Appendix 2 # Film Test Data

Because of the substantial changes in photographic emulsions that have occurred since my earlier technical books appeared, I felt it was necessary to conduct thorough film tests in preparing this revision. My photographic assistant, John Sexton, has conducted thorough and careful tests under my supervision, and the results are summarized below. I must emphasize, however, that all results shown here represent materials available at this writing, and processed according to my own procedures. Variations are inevitable, and I urge you to use this information only as a starting point for testing and monitoring your own procedures.

All films were developed at 68°F. Roll films were processed in Nikor-type stainless steel tanks on stainless steel reels, with agitation for 5 seconds every 30 seconds. Sheet films were tray processed with continuous agitation (one cycle through the stack every 30 seconds). The exposure index listings were arrived at through the use of the Exposure Formula, with the meter "K factor" eliminated. The development times are calculated to print on a diffusion-source enlarger. The negatives should have a density range of approximately 1.20 (from Value I to VIII for normal development, Value I to VII for N + 1 development, etc.) If a condenser-source enlarger is used for printing, the times should be reduced by about 20 percent.

DEVELOPING TIMES WITH KODAK HC-110 DEVELOPER						
		1:7 DILUTION			1:15 DILUTION	
35mm	EI	N − 1	NORM	N + 1	N − 1	NORM
Ilford Pan F	20	—	—	4.5	5	7
Kodak Panatomic X	20	—	—	5	5.25	7.75
Kodak Plus X	64	—	—	8	6.5	10
Ilford FP-4	80	—	4.75	8	7	10.75
Kodak Tri X	200	5.25	6.75	9	—	—
Ilford HP-5	160	4.75	6.5	8.5	—	—
120						
Kodak Panatomic X	20	—	—	6.5	6	8.5
Kodak Plus X Prof.	64	—	4.5	8	7	10.5
Ilford FP-4	64	—	5	7.5	7	11
Kodak Verichrome Pan	100	—	—	5.5	5.25	8
Kodak Tri X Prof.	200	—	5.5	8.5	8	—
Sheet						
Kodak Plus X	64	—	5.25	7.5	8	12
Ilford FP-4	64	—	6	9	9	—
Kodak Super XX	100	—	5.5	8.5	—	9
Kodak Tri X	160	—	4.25	6.5	6	9

Kodak Tri-X Professional 4 × 5 Sheet

This "family" of curves for Tri-X sheet film shows the effect of various degrees of expansion and contraction. Note that the toe area drops somewhat with N − 1 development, but not enough to require additional exposure. The development times were those indicated in the table; for N + 2 the development was 10¾ minutes in HC-110 dilution B (1:7).

Kodak Panatomic-X 35mm Film

The normal and N − 1 development curves are shown. As discussed in the text (page 94), I recommend using N − 1 for roll films where subjects of different contrast are recorded on a single roll.

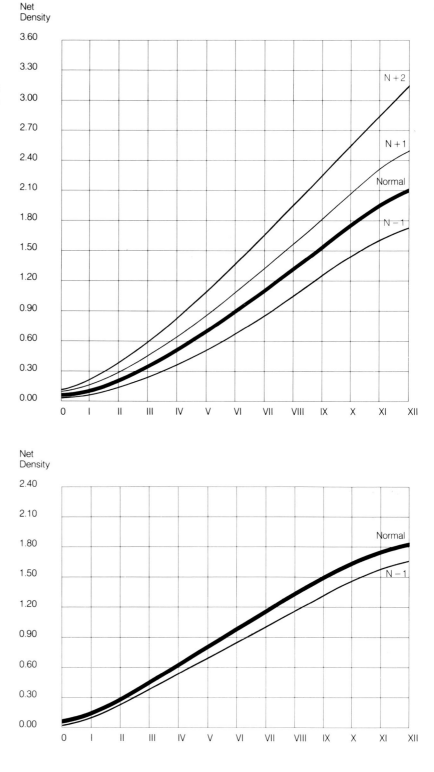

Kodak Super XX 4 × 5 Sheet Film

The two curves represent Kodak Super-XX film, one of the last of the thick-emulsion films, given normal development and total development (25 minutes in HC-110 dilution A, or 1:3 from stock). Note that the increased development moves the toe to the left, and introduces a shoulder, while still producing a great increase in contrast and density range. Most current films would probably not yield such high contrast, simply because the low-value densities tend to rise along with the higher densities at greatly expanded development times.

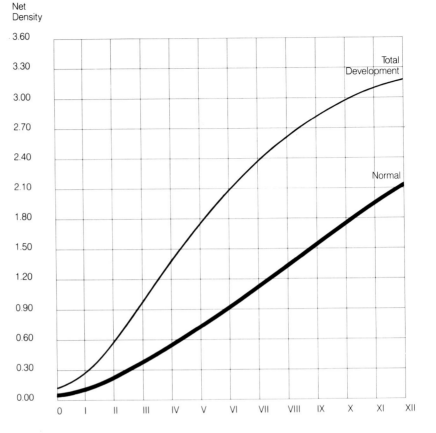

Effect of Two-Solution Development

Two-solution development provides a significant reduction in high-value densities with minimal effect in the low-value densities. The effect can be seen by comparing the two-solution curve shown here with the N − 1 curve (page 91), where a greater drop in density in the low values can be observed. One-half to one zone more exposure should be given to support the low values when two-solution development is planned. The film was Kodak Tri-X Professional 4 × 5 Film.

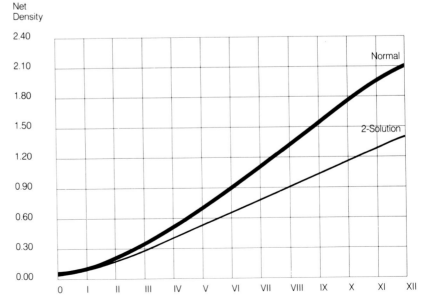

Effect of Highly Dilute Developer

The compensating effect of highly dilute developer can be seen in the curves for Ilford FP-4 120 film. The lower curve represents development for 15 minutes at 68°F in HC-110 diluted 1:30 from stock; the result is about equal to N − 4 in density range, but without the loss in the shadows that would result from reaching N − 4 by reduced development time alone. It is nonetheless important to give extra exposure to support the shadows. Agitation must be reduced, but not to the point where uneven development results.

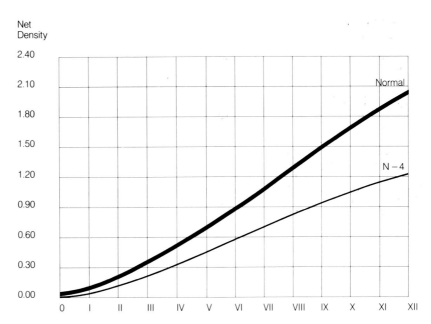

Effect of Farmer's Reducer (R-4A)

This test was conducted with Kodak Tri-X Professional 4 × 5 film that had been given normal development in HC-110. The pre-packaged Kodak Farmer's Reducer was used. As a "cutting" reducer it has substantial effect on the lower values, as well as in the high values. It thus produced only a relatively minor change in the overall slope of the curve, but clears the fog as it reduces low densities. Kodak recommends it for overexposed or fogged negatives. EI40 was used to simulate overexposure.

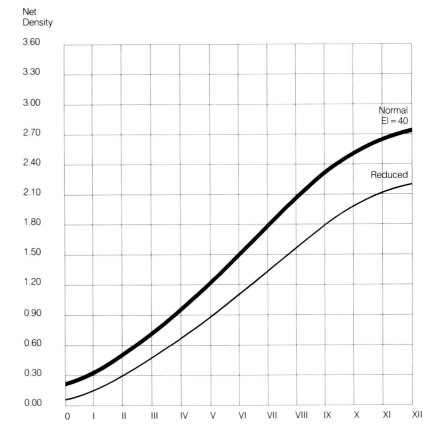

Effect of Selenium Toner for
Intensification

Kodak Plus-X Professional 4×5 sheet
film was used. The selenium toner so-
lution was diluted 1:2 with Kodak
Hypo Clearing Agent, and the nega-
tive treated for 5 minutes at 68°F. The
increase in contrast indicated by this
pair of curves is very similar to N + 1
development, since the density range
from Zone I to VII on the toned nega-
tive is the same as the range from
Zone I to VIII on the untoned nega-
tive. I would expect the use of the
IN-5 formula to have similar effect,
but the selenium process is far simpler
to use.

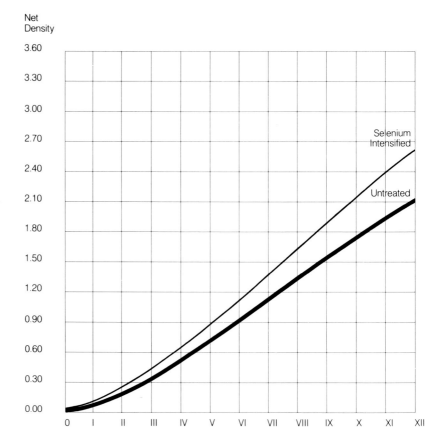

Effect of Chromium Intensifier (IN-4)

Kodak recommends the use of the pre-
hardener SH-1 before use of this in-
tensifier. Since this is a bleach-and-
redevelop process, it is not possible to
monitor its effect continuously, al-
though repeated treatment in IN-4 is
possible. I strongly favor either IN-5 or
selenium treatment over this proce-
dure, since they are more easily
controlled.

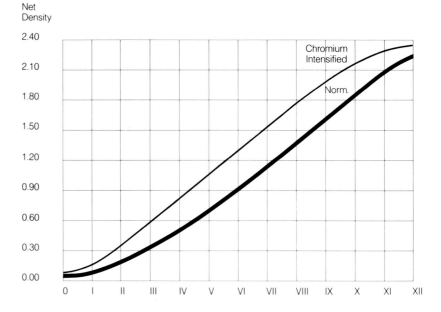

Kodak Technical Pan (Type 2415)
4 × 5 sheet film

This is an extremely fine grain and high contrast film often used for copy and scientific work. The very steep curve is typical of the film's response, and would be equivalent to more than N + 4 development with a conventional film. It was produced using HC-110 1:7 from stock, for 10 minutes at 68°F. The lower curve represents an attempt to reach a normal range of values by developing in the POTA developer (see page 254) for 6½ minutes at 68°F. The result is extremely fine grain with an exposure index of about 16, possibly a useful system where high magnification with very high resolution are required. This film might thus be helpful when normal to greatly expanded development is required.

Ilford XP-1 Chromogenic Film

We tested a prototype 35mm roll of this film, which uses dyes rather than silver to form a black-and-white image. The curve represents the manufacturer's recommended development, which gives slightly lower contrast than our standard for normal contrast with conventional film. We found the exposure index to be 160 (comparable to Tri-X), with very fine grain and apparently high acutance. Because the negative has considerable coloration from the dyes, printing with a "cold light" enlarger produces very long printing times and higher contrast than the use of a tungsten enlarger bulb. My primary concern in using such a film is the stability of the dyes compared with that of a silver image on a conventional negative.

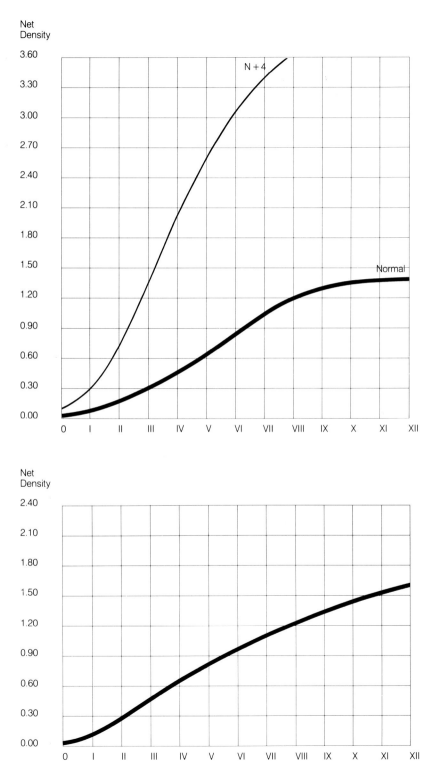

Appendix 3 **Chemical Formulas**

The majority of photographic formulas used today are made from prepared chemicals, which are very convenient and of high purity. These solutions must be mixed as directed; be especially careful to observe the temperature requirements. Developer formulas frequently must be mixed in warm water to dissolve effectively, but water that is too hot will produce immediate discoloration of the solution. This is a sign of oxidation indicating some loss of strength of the developer which, of course, reduces its effectiveness. It is thus important to have a reliable thermometer, and to measure temperature accurately. It is usually best to start with about three-fourths of the total final volume of water at the prescribed temperature, and then slowly pour the prepared chemical into it, stirring vigorously and not allowing concentrations of the chemicals to gather at the bottom of the tank. When the chemicals are *thoroughly* mixed, cold water can be added to bring the solution to room temperature (keep stirring while adding the cold water).

Once mixed, a developer solution begins to deteriorate. At first, depending on the character of the developer, the rate of deterioration is slow and the effects inconsequential. But as the developer components oxidize in the water solution, the effective strength diminishes. Kodak gives tables relating to the "life" of various solutions; while helpful, these cannot anticipate the effects of water impurities, areas of the solution exposed to air, or deviations from the recommended mixing temperatures, etc.

Since exposure to air is a major cause of developer deterioration, it is best to store the stock solutions in small, tightly stoppered bottles, each filled to the top; the unused portion of the solution thus remains sealed and protected from exposure to air. Other solutions such as fixing bath may be kept in larger bottles or in tanks with floating lids, which also provide some protection from exposure to the air. Once a developer has been diluted to working strength, it is not advisable to keep it longer than the time of its actual use.

When mixing a special developer from the component chemicals, such as the formulas given below, be sure to follow any special recommendations given with the formula. The general rules to observe are mix the chemicals *in the order given* in the formula, at the prescribed temperature, and be sure each chemical is completely dissolved before adding the next. In most cases, distilled water is best for mixing developer formulas, unless you are confident of the water purity in your area. Be sure to store all chemicals in a cool place; open bottles of dry chemicals must also be sealed and protected from moisture. Chemicals, whether dry or in a solution, should be stored in brown glass bottles or in the opaque plastic containers which are impermeable to oxygen. All mixing and storage vessels must be very clean, and should be carefully rinsed or washed after each use.

FORMULAS

Developers

D-23	*1 quart*	*1 liter*
water (125°F, or 52°C)	24 oz.	750 cc
Elon (metol)	1/4 oz.	7.5 grams
Sodium sulfite, dessic.	3 oz. 145 gr.	100 grams
cold water to make	32 oz.	1 liter

D-25		
water (125°F or 52°C)	24 oz.	750 cc
Elon (metol)	1/4 oz.	7.5 grams
Sodium sulfite, dessic.	3 oz. 145 gr.	100 grams
Sodium bisulfite	1/2 oz.	15 grams
cold water to make	32 oz.	1 liter

D-76		
water (125°F or 52°C)	24 oz.	750 cc
Elon (metol)	29 grains	2.0 grams
Sodium sulfite, dessic.	3 oz. 145 gr.	100 grams
Hydroquinone	73 grains	5 grams
Borax (decahydrate)	29 grains	2.0 grams
cold water to make	32 oz.	1 liter

D-76 is a standard developer, although not one I use often in my own work. Those photographers who use it generally prefer to buy the pre-mixed dry chemicals available from Eastman Kodak.

HC-110

HC-110 is sold by Eastman Kodak as a syrupy liquid concentrate. The concentrate is diluted with water to make a *stock solution*, and this is

further diluted to make *working solutions.* The stock solution is prepared by mixing the 16-ounce container of HC-110 with distilled water (preferably) to make one-half gallon of the solution. Start with 32 ounces of water, add the concentrate, and then add water to make one-half gallon (64 ounces).

It is possible to mix working solutions directly from the concentrate, but this is not usually practical for small quantities because of the difficulty of measuring the concentrate with sufficient accuracy. The most frequently used dilutions are Dilution A, which is 1 part of stock solution mixed with 3 parts of water, and Dilution B, 1 part stock solution with 7 parts water. For minus development I mix the stock solution 1:15 with water, and for compensating effect I dilute the stock solution 1:31 or weaker.

POTA developer

Sodium sulfite	30 grams
1-Phenyl-3-pyrazolidone (Ilford Phenidone-A, or Kodak BD-84)	1.5 grams
water to make	1 liter

Dissolve the chemicals in water at about 100°F, then cool to working temperature and use immediately, since the solution deteriorates rapidly after mixing. Distilled water is recommended.

This formula is useful to achieve normal contrast with the recently introduced Kodak Technical Pan Film (2415), which tends to have a very high gamma (contrast) with standard developers. It may also be useful with other films when very low contrast development is desired. Development time should be about 6½ minutes for sheet film, and 11½ minutes for 35mm film at 68°F.

Two-Solution Development

The most effective two-solution formula I have found consists of D-23 for Solution A (developer), and, for Solution B (alkali bath), a 1 percent solution of Kodak Balanced Alkali (Kodalk), or 10 grams per liter. I have not conducted exhaustive tests with current films, but our preliminary data indicate that two-solution development can be effective for supporting shadow values while reducing high-value densities. ◁ I include the method here for those who wish to experiment with it. It is important to expose the low values about one zone higher than normal if this procedure is to be used.

See page 229

The negative is immersed in Solution A for 3 to 7 minutes, followed by a 3-minute bath in Solution B, without agitation. In the past, if the film tended to fog, I have added small amounts of a 10 percent potassium bromide solution to the second solution. The strength of the high densities will be controlled primarily by the time the negative is developed in Solution A; during the immersion in the alkali solution, the developer is soon exhausted in the high densities while its activity continues in lower values. The Kodalk solution can be made stronger — up to about a 10 percent solution, or 100 grams per liter — and its activity will increase, but with the possibility of increased grain. I advise careful testing before using this process.

Pyrocatechin Compensating Formula

Solution A

water (distilled)	100 cc
Sodium sulfite, dessic.	1.25 grams
Pyrocatechin	8.0 grams

Solution B

Sodium hydroxide	1.0 gram
cold water to make	100 cc

Mix these two solutions in the following proportions immediately before use:

20 parts of A
50 parts of B
500 parts of water

This developer is primarily useful to retain definition in negative areas above Zone X (very high placements). The emulsion speed is reduced about 50 percent in lower parts of the scale. It produces a stain which increases the printing contrast, so do not attempt to evaluate negative densities without printing. Development times should be around 10 to 15 minutes at 68°F, although I have not tested this solution with current films. The developer is used once after mixing and then discarded.

ABC Pyro Formula

Stock Solution A

Sodium bisulphite	140 grains	9.8 grams
Pyro (pyrogallol)	2 oz.	60 grams
Potassium bromide	16 gr.	1.1 grams
water to make	32 oz.	1000 cc

Stock Solution B

Water	32 oz.	1000 cc
Sodium sulphite, dessic.	3½ oz.	105 grams

Stock Solution C

Water	32 oz.	1000 cc
Sodium carbonate, monohyd.	2½ oz.	90 grams

Developer must be mixed fresh immediately before use. The normal proportions for tray development are 1 part each of solutions A, B, and C, with 7 parts of water. Development times should be about 6 minutes at 65°F (18°C). One gallon can be mixed for tank development by taking 9 ounces each of A, B, and C, and adding water to make one gallon. Development should be about 12 minutes at 65°F (18°C). To minimize oxidation effects I mix Solutions B, C, and the water, and then add Solution A immediately before use.

Stop Bath

Acetic acid (28%)	1½ oz.	45 cc
water to make	32 oz.	1 liter

Glacial acetic acid may be diluted to 28 percent by mixing 3 parts of glacial acetic acid with 8 parts of water. Glacial acetic acid is very irritating; protect hands and eyes from liquid and fumes.

Fixing Baths

Kodak F-5 (acid hardening fixer)

Water (125°F or 52°C)	20 oz.	600 cc
Sodium thiosulfate (hypo)	8 oz.	240 grams
Sodium sulfite, dessic.	1/2 oz.	15 grams
Acetic acid (28%)	1 1/2 fl. oz.	48 cc
Boric acid, crystals	1/4 oz.	7.5 grams
Potassium alum	1/2 oz.	15 grams
cold water to make	32 oz.	1 liter

Kodak F-6

The F-5 formula above has an odor that can be objectionable. I prefer F-6 which is an odorless formula made by eliminating the boric acid from the F-5 fixer and substituting 1/2 oz. per quart, or 15 grams per liter, of Kodalk.

With both formulas be sure to mix in the order given. The temperature will drop rapidly as the hypo is mixed in the warm water. If the acid is added before the sulfite is completely dissolved in the hypo solution, the latter will be irrevocably precipitated.

Intensifiers

Kodak IN-5

Stock Solution No. 1 (store in brown bottle)

Silver nitrate, crystals	2 oz.	60 grams
Distilled water to make	32 oz.	1 liter

Stock Solution No. 2

Sodium sulfite, dessic.	2	60 grams
water to make	32	1 liter

Stock Solution No. 3

Sodium thiosulfate (hypo)	3 1/2 oz.	105 grams
water to make	32 oz.	1 liter

Stock Solution No. 4 (store in brown bottle)

Sodium sulfite, dessic.	1/2 oz.	15 grams
Elon (metol)	350 grains	24 grams
water to make	96 oz.	3 liters

Prepare the intensifier solution for use as follows: Slowly add 1 part of solution No. 2 to 1 part of solution No. 1, shaking or stirring to obtain

thorough mixing. The white precipitate which appears is then dissolved by the addition of 1 part of solution No. 3. Allow the resulting solution to stand a few minutes until clear. Then add, with stirring, 3 parts of solution No. 4. The intensifier is then ready for use, and the film should be treated immediately. The degree of intensification obtained depends upon the time of treatment, which should not exceed 25 minutes. After intensification immerse the film for 2 minutes in a plain 30 percent hypo solution (10 oz. hypo per quart of solution, or 300 grams per liter). Then wash thoroughly. Once mixed, the intensifier solution is stable for about 30 minutes at 68°F (20°C).

Stains are sometimes produced during intensification unless the following precautions are observed: 1. The negative should be fixed and washed thoroughly before treatment, and must be free of scum or stain. 2. The negative should be hardened in the SH-1 hardener solution before intensification. 3. Only one negative should be treated at a time, and it should be agitated continuously during treatment.

Selenium Intensifier

See pages 235–237

I have had very good success using selenium toner for intensifying negatives. ◁ To use, the toner is diluted 1:2 with Kodak Hypo Clearing solution and the negative is immersed for 5 to 10 minutes with constant agitation. At dilutions of 1:100 to 1:200, selenium toner may be used to enhance the permanence of negatives; however, this procedure should be tested with the film you are using since, with a few special-purpose films, it has occasionally caused discoloration.

Reducers

Kodak R-4a (Farmer's Reducer)

Stock Solution A

Potassium ferricyanide (anhyd.)	37.5 grams
water to make	1/2 liter

Stock Solution B

Sodium thiosulfate (hypo) (pentahydrated)	480 grams
water to make	2 liters

See page 237

This is the single-bath Farmer's Reducer formula, which provides "cutting" reduction for negatives. ◁ To use, take 30 cc of Solution A, 120 cc of Solution B, and water to make 1 liter. Add A to B, add the water, and *immediately* immerse the negative in the solution. The reducing action must be watched closely, and the negative transferred to a water wash before the desired effect is reached. The formula is slower working if the amount of Solution A is reduced by one-half. Kodak sells a pre-mixed Farmer's Reducer.

Kodak R-4b (Farmer's Reducer, two-bath version)

Solution A

Potassium ferricyanide (anhyd.)	7.5 grams
water to make	1 liter

Solution B

Sodium thiosulfate (pentahyd.)	200 grams
water to make	1 liter

This two-bath version gives proportional reduction. Kodak thus recommends this formula to correct for over-development, and the single-solution formula for overexposure because of its cutting effect.

The negatives are immersed in Solution A for one to four minutes, with constant agitation (at 65° to 70°F, or 18.5° to 21°C). They are then transferred to Solution B for 5 minutes, followed by washing. The process can be repeated if required. I advise a final immersion in fixer when the reduction has been completed, followed by thorough hypo-clearing and washing.

Hardener

With warm temperatures (75°–80°F), a hardening bath is recommended before reducing negatives. The following formula has been in use for more than a century.

Kodak SH-1 Supplementary Hardener:

Water	500 cc
Formaldehyde (37% solution)	10 cc
Sodium carbonate, dessic.	6 grams
water to make	1 liter

Filter Spectral Characteristics

See Figure 2–2

If we wish to know the specific transmission characteristics of a filter we can refer to its spectrophotometric curve, a graph that shows the filter's transmission (or density) at each wavelength. By relating the wavelengths to color, ◁ we can examine the curve and determine the proportion of incident light of each color that will be transmitted by that filter. Complete curves and data can be found in *Kodak Filters for Scientific and Technical Use* (publication No. B3, available from Eastman Kodak Co.).

Such curves are often most useful in comparing two filters. For example, the curve for the Wratten #8 filter indicates that it transmits green, yellow, and red wavelengths quite readily, with a sharp fall-off in transmission below 500 nm that indicates absorption of blue wavelengths. The Wratten #6 filter, weaker than the #8, can be seen to transmit greater amounts of blue light.

Filters that transmit a narrow range of wavelengths with a sharp boundary between wavelengths transmitted and those absorbed are referred to as "sharp cutting," or "narrow band," filters. For most general photography, filters are usually "broad band," with a more gradual transition between the wavelengths of high absorption and those of high transmission. If we are choosing a filter specifically to separate two adjacent colors of the spectrum, however, we might need a sharp cutting filter for the effect desired.

If you contemplate combining two filters for special effect, a general idea of the total effect can be seen by overlaying their curves; any area of low transmission for *either* filter will be absorbed by the combination, and an area of high transmission for *both* filters will be freely transmitted. The Kodak filter data book cited above includes information on calculating the total transmission and density of combined filters.

At first glance you may find it confusing that none of the filters transmit more than about 90 percent of the light at any wavelength; how then are certain colors rendered *lighter* in the photograph than when no filter is used?

With a #8 filter, for example, about 88 percent of the yellow light is transmitted to the film, yet a yellow object appears lighter in the print than when no filter is used. The reason, of course, is because of the exposure factor. If the #8 filter transmits 88 percent of the yellow light and a factor of 2 is applied to the exposure, a total of about 176 percent yellow light reaches the film compared to the normal exposure with no filter.

Filter exposure factors are based on the transmission characteristics of the filters, the color of the light, and the color response characteristics of the negative. Adjust the basic exposure factor as materials and lighting demand.

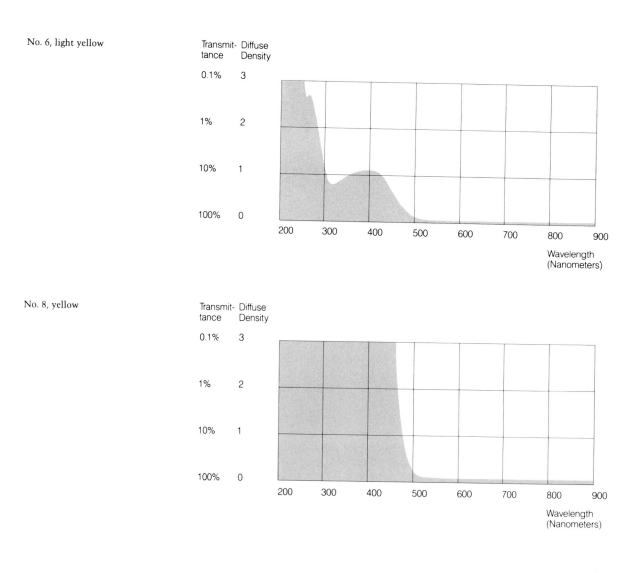

No. 25, red tri-color

Transmit-tance	Diffuse Density
0.1%	3
1%	2
10%	1
100%	0

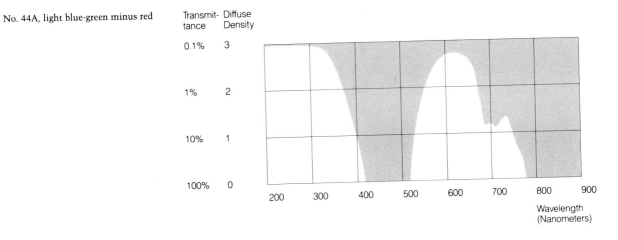

Wavelength
(Nanometers)

No. 44A, light blue-green minus red

Transmit-tance	Diffuse Density
0.1%	3
1%	2
10%	1
100%	0

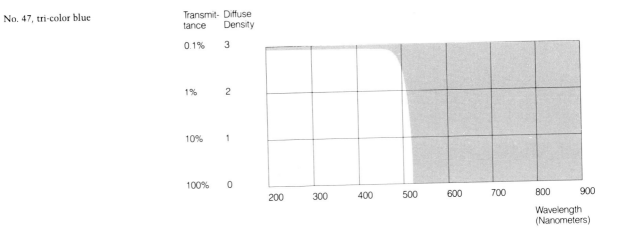

Wavelength
(Nanometers)

No. 47, tri-color blue

Transmit-tance	Diffuse Density
0.1%	3
1%	2
10%	1
100%	0

Wavelength
(Nanometers)

No. 58, tri-color green

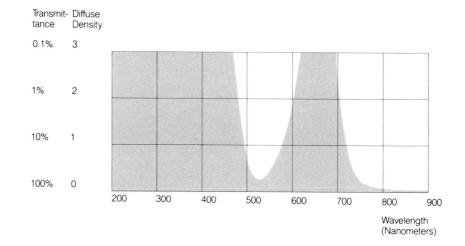

Transmit- Diffuse
tance Density

0.1% 3

1% 2

10% 1

100% 0

200 300 400 500 600 700 800 900

Wavelength
(Nanometers)

Appendix 5 Logarithms

Density and certain other quantities in photography are logarithmic values, and some readers may find this confusing. The following is a short description of logarithms, intended as a review rather than a complete discussion of the subject. Log values can easily be worked out with one of the inexpensive (about $20) pocket calculators that includes log functions, or they can be derived using log tables.

Logarithms can be considered a form of mathematical shorthand. The log itself is simply an exponent, that is, a power to which another number is raised. The common logs used in sensitometry are *base 10*, meaning they represent a power of 10. Consider the term 10^2; it signifies that 10 is squared, or raised to the second power, and its arithmetic value is 100. The exponent, 2, is the logarithm of 100. Thus the following sequence: 1 is the log of 10 ($10^1 = 10$); 2 is the log of 100 ($10^2 = 100$); 3 is the log of 1000 ($10^3 = 1000$); 4 is the log of 10,000 ($10^4 = 10,000$); and 0 is the log of 1 ($10^0 = 1$). Thus any log (a density value, for instance) between 0 and 1 must represent an arithmetic number between 1 and 10; any log between 1 and 2 must represent an arithmetic number between 10 and 100, and so on.

Density is a logarithmic unit. A density of 1 must equal an arithmetic value of 10 (10^1); a density of 2 has an arithmetic value of 100 (10^2); and a density of 3 has an arithmetic value of 1000 (10^3). The arithmetic number in this case is *opacity*. ◁ A negative area with density of 2 has an opacity of 100, meaning that it transmits 100 times less light than an area of zero density.

See page 85

Intermediate values are given in "fractional" logarithms. If we have a density of 1.30, it must represent an opacity between 10 and 100, since the logarithm is between 1 and 2. This much we learn from the number to the left of the "decimal" point (called the *characteristic*). To find the exact value, we look up the antilog of .30 (called the *mantissa*), and we find that the answer is 2. Since the characteristic has already indicated that the value

must be between 10 and 100, the antilog of 1.30 must be 20. Thus a density of 1.30 equals an opacity of 20; 1/20 as much light will pass through this area as through a zero density area.

If there can be said to be one "most important" log value, it is, for photographers, 0.30, since this represents the important 1:2 relationship that occurs so often. In terms of density, an increase of 0.30 in density represents a doubling of opacity; on the log E scale of the H&D curve, an interval of 0.30 corresponds to a doubling of exposure — a one-stop change on the camera, or a one-zone change in luminance on the exposure scale. Thus also a 0.10 change on the log E scale corresponds to a one-third stop exposure interval.

See page 115

Certain filters, such as the neutral density filters, ◁ are calibrated in units of density. A neutral density filter listed as ND 0.30 has a density of 0.30 or an opacity of 2; it thus reduces exposure by one-half. ND 0.60 reduces exposure by a factor of 4, etc. When two such filters are used together, the density values are *added*, while the exposure factors must be *multiplied*. Thus ND 0.30 plus ND 0.60 together give a total density of 0.90, with a reduction in exposure by a factor of 8.

It should be apparent how deftly logs represent arithmetic numbers. Two large numbers can be multiplied by adding their logs (and divided by subtracting them) and then determining the antilog of the sum. In preparing graphs, logs have the property that certain geometric functions that graph as a curve arithmetically appear as a straight line on a log scale. Such is the case with the density/exposure relationship of the H&D curve; if plotted in arithmetic units, instead of logarithmic ones, the characteristic curve has no straight line region, but appears as a continuous curve.

Exposure Record Form. The use of this form is discussed on page 67, and a smaller version appears on page 65. You may photocopy these forms for your own use.

Index